THE GREAT AGE OF
JAPANESE
BUDDHIST
SCULPTURE
AD 600–1300

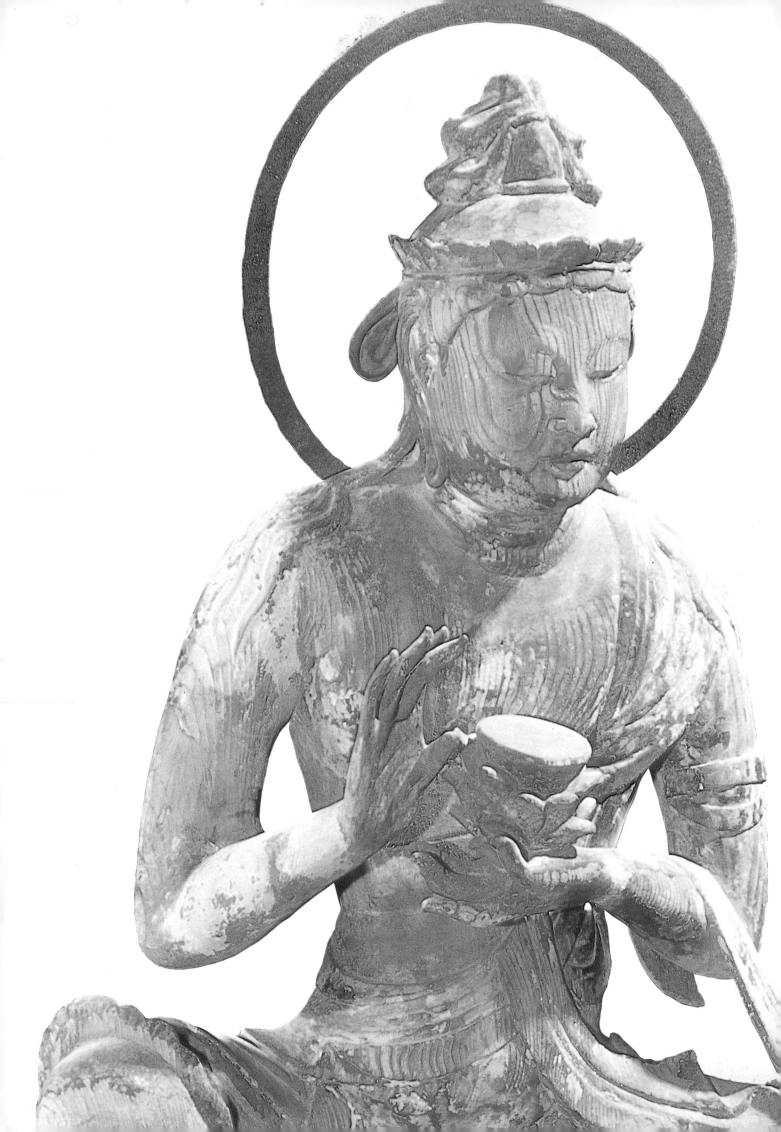

THE GREAT AGE OF
JAPANESE
BUDDHIST
SCULPTURE
AD 600–1300

Nishikawa Kyōtarō

Emily J. Sano

Kimbell Art Museum/Japan Society

This publication has been aided by a generous grant from the Anne Burnett and Charles D. Tandy Foundation, Fort Worth, Texas.

This catalogue is published on the occasion of an exhibition of Japanese Buddhist sculpture shown at the Kimbell Art Museum, Fort Worth, September 8–October 31, 1982, and at Japan House Gallery, New York, November 23, 1982–January 16, 1983.

THE GREAT AGE OF JAPANESE BUDDHIST SCULPTURE AD 600–1300 is an exhibition organized by the Kimbell Art Museum, Fort Worth, in cooperation with the Agency for Cultural Affairs (Bunka-chō), Tokyo, and in association with Japan Society, New York. It is supported by grants from the Tandy Foundation and Tandy Corporation/Radio Shack and by a federal indemnity from the Federal Council on the Arts and Humanities.

Library of Congress Catalogue Card Number: 82-82805
Cloth: ISBN 0-912804-07-6; Paper: ISBN 0-912804-08-4

Designed by DANA LEVY

Printed by NISSHA PRINTING COMPANY, Kyoto

Set in Goudy Old Style by CONTINENTAL TYPOGRAPHICS INC, Woodland Hills, California.

Printed in Japan

Cover illustration: Bodhisattva on Clouds (North 25) by Jōchō, dated 1053, Byōdō-in, Kyoto. National Treasure.

Back Cover Illustration: Ankoku Dōji, thirteenth century, Hōshaku-ji, Kyoto. Important Cultural Property.

CONTENTS

Lenders

Byakugō-ji, Nara
Byōdō-in, Kyoto
Chōfuku-ji, Shiga Prefecture
Daian-ji, Nara
Daigo-ji, Kyoto
Enryaku-ji, Shiga Prefecture
Hanshū-in, Kyoto
Hayashikōjicho, Nara
Hōryū-ji, Nara
Hōshaku-ji, Kyoto
Ishiyama-dera, Shiga Prefecture
Kōryu-ji, Kyoto
Myōhō-in, Kyoto
Nara National Museum
Ninna-ji, Kyoto
Onjō-ji, Shiga Prefecture
Renzō-in, Chiba Prefecture
Rokuharamitsu-ji Temple, Kyoto
Saihō-in, Nara
Seigan-ji, Kyoto
Shitennō-ji, Osaka
Tachibana-dera, Nara
Takisan-ji, Aichi Prefecture
Tenshū-ji, Saitama Prefecture
Tōdai-ji, Nara
Tōfuku-ji, Kyoto
Tokyo National Museum
Tōshōdai-ji, Nara

PREFACE

The Great Age of Japanese Buddhist Sculpture AD 600–1300 celebrates the tenth anniversary of the Kimbell Art Museum, which opened in October 1972. In the past decade the museum has continued to add significant works to its already distinguished small collection, and it has also worked with Japan Society and other institutions to bring many important loan shows to the southwest. The current exhibition follows other great exhibits of Asian art such as *The Tokugawa Collection of Noh Robes and Masks*, *The Great Bronze Age of China*, and *Treasures from the Idemitsu Collection*. This show marks the first such exhibition undertaken by the museum on its own, and it is the first of many such shows planned for the future.

Some years ago Richard Fargo Brown, later founding director of the Kimbell Art Museum, wrote in a catalogue of a loan exhibition from Japan that the Pacific had become a boundary between Japan and the United States, not a barrier. He was right, and good testimony to Dr. Brown's sentiment is to be found in this catalogue. The high quality of the level of exchange between the two great nations is exemplified by the works of art so generously provided our institutions in loan from across the Pacific. We celebrate this good exchange and thank the people and institutions of Japan for making it possible for us to bring this important exhibition to the United States.

Dr. Sano Bunichirō, Commissioner of Cultural Affairs, was an early and enthusiastic supporter of our plans. Dr. Nishikawa Kyōtarō, Counselor of the Agency for Cultural Affairs, made the selection of sculpture for the exhibition and provided the material for the catalogue. He gave untiringly of his time and effort to advance the exhibition process, and we are most grateful to him. Mr. Washizuka Hiromitsu and Mr. Matsushima Ken of the Fine Arts Bureau of the Agency for Cultural Affairs, helped us as well at every step of the project. Dr. Emily Sano, Curator of Asian Art at the Kimbell Art Museum, was the principal American organizer for the exhibition. She also translated and adapted the catalogue for publication. Dr. Sano's splendid skills insured easy progress in a necessarily complex process. We gratefully acknowledge her contribution to the success of this exhibition.

We are honored to participate in this superb exhibition. We appreciate the confidence placed in us by our Japanese friends in permitting us to make these rare cultural treasures available to the American public. The outstanding quality of these sculptures cannot help but inspire awe and respect for one of the world's great artistic traditions.

EDMUND P. PILLSBURY RAND CASTILE
Director Director
Kimbell Art Museum Japan House Gallery

ACKNOWLEDGEMENTS

It has been a great pleasure to work closely with the Agency for Cultural Affairs (Bunka-chō) in all aspects of planning and preparing this exhibition of Japanese sculpture. I am most grateful to Dr. Nishikawa Kyōtarō and his associates in the Fine Arts Bureau of the Bunka-chō for their kind assistance with my numerous requests for photographs and for the preparation of the catalogue manuscript. As the translator of Dr. Nishikawa's essay and the catalogue entries, it is, perhaps, inevitable that I may have introduced distortions, for which I offer apologies.

I wish to express my appreciation to Dr. Edmund P. Pillsbury, Director of the Kimbell Art Museum and Dr. William B. Jordan, Deputy Director, for their guidance and constant support of the project. I was fortunate to be able to work with Mr. Rand Castile on this exhibition and I am grateful to him and to the Japan House Gallery staff for advice, information, and encouragement at all stages of the project. The catalogue design is a tribute to the uncommon talent of Dana Levy, who patiently guided us through the preparation of this volume. Most of the work on the catalogue was done in Fort Worth. I wish to thank Betsy Colquitt for editing the manuscript with speed and grace. Above all, I am indebted to the special efforts of Kimbell staff members who were unstinting in their support and eagerness to see deadlines met. I am deeply grateful to Foster Clayton, Karen King, Marilyn Ingram, Ruth Ann Rugg, Adrian Martinez and Sharon Patterson for their help, their commitment to quality, and their friendship.

E.J.S.

FOREWORD

In the recent upswing in cultural interchange between the United States and Japan, it is now possible for the people of both countries to have access to each other's art exhibitions practically every year. It is a great pleasure for us to see such exhibitions promote better understanding between the two nations and develop the tie of friendship across the ocean.

This year happens to be the tenth anniversary of the establishment of the Kimbell Art Museum in Fort Worth, Texas. Its friends in Japan are happy to have the exhibition *The Great Age of Japanese Buddhist Sculpture AD 600–1300* shown there on this memorable occasion.

To be sure, Buddhist sculptures have been to the United States on several occasions. However, this is the first time we will send an entire exhibition devoted to Buddhist sculptures. The thirty-six items—fifty-two pieces in all—of masterpieces displayed in this exhibition are selected to represent the history of Japanese Buddhist sculpture from the early years of Japan's encounter with Buddhism until the Kamakura Period, when Buddhist sculpture burst into its final afflorescence. We are confident that this exhibition will be instrumental in contributing to a large public an ample understanding of and appreciation for the beauty of Buddhist sculpture, an outline of its history in Japan, and the opportunity to experience the style and craftsmanship characteristic of each historical period.

In closing this brief address, I should, as the representative of the Japanese organizer, like to express here my sincere gratitude for the dedicated work of Dr. Edmund P. Pillsbury and staff of the Kimbell Art Museum, Mr. Rand Castile and staff of the Japan House Gallery, and many other collaborators who assisted in the successful organization of this exhibition.

SANO BUNICHIRŌ, Commissioner-General
Agency for Cultural Affairs
Government of Japan

CHRONOLOGY

Asuka Period: 552–645 A.D.

Early Nara or Hakuhō Period: 645–710

Nara Period: 710–794

Early Heian Period: 794–894

Late Heian Period: 894–1185

Kamakura Period: 1185–1333

Nambokuchō Period: 1333–1392

Muromachi Period: 1392–1568

Momoyama Period: 1568–1600

Edo Period: 1600–1868

Meiji Period–present: 1868–

Japanese personal names are written in the Japanese fashion with
the family name first, followed by the given name.

INTRODUCTION

The introduction of Buddhism to Japan from Korea in the sixth century was the single most important cultural event in Japanese history. Buddhism brought to this isolated nation not only a comforting religion, but all the trappings of advanced civilization as well, including a written language (Chinese), and a sophisticated material culture. By the seventh century Buddhism was firmly established in Japan with temple complexes of continental design, various orders of priests and nuns, and a body of skilled artisans who made the icons and other accoutrements of faith for the church. The religion continued to flourish for several centuries, moving with the currents of theological change in China. During that time, it made rich contributions to the Japanese cultural fabric with advancements in architecture, sculpture, and painting. Due to its fragile nature, very little religious painting is extant from the early period of Buddhism. Therefore, the large quantities of sculpture that have survived the vicissitudes of time are the most potent expression of Japan's early artistic achievements.

The Great Age of Japanese Buddhist Sculpture AD 600–1300 is the first exhibition of classic Japanese sculpture to tour the United States. The period represented—the seventh to the fourteenth centuries—was the definitive age in the history of this art form, encompassing its introduction from Korea, its assimilation, flourishing, and decline. The fifty-two pieces included in the show were drawn from active temples and major museum collections. They were chosen to demonstrate how stylistic development over 700 years was effected by changing patronage and the advancement of Buddhist thought. Japanese sculpture is frequently regarded as an important reserve of the forms and techniques of Chinese sculpture, which is less well preserved on the continent. While that viewpoint is appropriate for works made in the seventh and eighth centuries when Buddhism was still new in Japan, this exhibition provides an American audience with the extraordinary opportunity to survey that development first hand and to observe the qualities that make this sculpture singularly Japanese.

The earliest statues in the exhibition (cat. nos. 1 and 2) are simple, naive forms with innocent faces and a good deal of charm. The sculptures reflect the fact that the Japanese understanding of Buddhism was not profound. Indeed, in the beginning they regarded the foreign doctrine simply as a possible source of benefit for the individual and the state. That phase was, however, soon superseded in the eighth century by a more advanced theological understanding, and by a type of statuary, represented by cat. nos. 3–7, that exhibited a naturalistic treatment of facial features, body proportions, and garments inspired by the sophisticated art of T'ang China. It is interesting here that the primary production of statuary remained in major icons, such as Buddhas and Bodhisattvas, those divine beings who postponed their own final nirvana to assist others. Other forms of Buddhist art, such as the narrative sculpture prominent on the continent, were never popular in Japan. Scenes from the life of the historical Buddha, Śākyamuni, or *jātaka* tales, stories about the Buddha's previous existences, which provided a rich visual iconography in India and China, are conspicuously absent, making one wonder if the Japanese were too far removed from the source of Buddhism to accept the idea of Śākyamuni as a re-incarnated, earthly being.

Japanese sculpture is distinguished from its continental counterpart primarily in its attitude toward and treatment of material. Extant sculptures show that the Japanese quickly acquired the skills necessary to produce Buddhist statuary. They learned bronze casting at an early date, and other media, such as clay and dry lacquer, enjoyed a brief vogue in the eighth century before dying out. But stone carving, which was common in China from the fifth century, never became a major sculptural method in Japan. The cutting of cave temples from natural mountainsides reflects an Indian practice that was transmitted to China through Central Asia in the early centuries of the Christian era. However, Buddhist sculpture reached Japan at a time when it was already established practice to install images in palatial structures of wood and tile. From the beginning of the ninth century on, Japanese sculpture was made entirely from wood. Wood was an obvious choice because it was convenient and abundantly available, but its use for sculpture probably persisted because the native sensitivity for the material was special.

The Japanese treatment of wood was to have a profound effect on the appearance of sculpture. As this exhibition shows, the statuary produced between the ninth and twelfth centuries, during the Heian Period, encompasses aesthetic extremes and demonstrates how technical ingenuity and innovation contributed to the development of style (cat. nos. 8–22). During the ninth century Buddhism became intensely intellectual, ritualistic, and remote from ordinary people. Esoteric Buddhism was introduced, together with a pantheon of fierce divinities like Fudō (Acala, cat. no. 17) and exotic multi-headed, multi-limbed forms such as the Eleven-headed Kannon (Ekadaśamukha Avalokiteśvara, cat. no. 12) and Nyoirin Kannon (Cintāmaṇicakra Avalokiteśvara, cat. no. 18). Sculpture reflected that mood with unforgettable statues that are heavy, brooding and austere in feeling. Carved from a single block, these massive works were sometimes hollowed to lighten the weight and promote even drying of the wood. The statue of Nichira from Tachibana-dera (cat. no. 9) and Miroku (Maitreya) from Tōdai-ji (cat. no. 10), for example, demonstrate how Early Heian sculptors took advantage of the volume of the block to explore the surface poten-

tial of sculpture. They produced the ubiquitous "wave" pattern of deeply carved drapery folds that alternates high ridges and small peaks, as well as decorative flourishes of gathers and spiral curls, that are called "baroque." Moreover, chisel marks visible on the hard wood surfaces were left uncovered to convey the feeling of the material directly.

In the Late Heian Period the emotional intensity of ninth century sculpture gives way to a completely opposite feeling. In this exhibition, a lovely Amida (Amitābha) Triad of eleventh century date from Shittennō-ji (cat. no. 15), which features Bodhisattva attendants artfully posed on one foot, heralds the appearance of sculpture that is gracious and beautiful. The popularity of Amida Buddha (Amitābhā) and the fervent faith in salvationist creeds that dominated religion at the time led wealthy patrons to build temples and order statuary by the hundreds of pieces in the hopes of earning merit and assuring themselves rebirth in paradise. This kind of demand necessitated rapid production that led eventually to hollow joined block construction and to assembly line production methods.

The creation of the temple called Byōdō-in and the carving of the main icon, the Amida Buddha by Jōchō in 1053 (see fig. 11), was a singular event that exhibits a pinnacle in the achievement of serene grace in sculpture, and the breathtaking perfection of form. It is of particular interest here because the technique of hollow joined blocks used to form the sculpture produced a thin shell that could not be deeply carved (see fig. 33). The drapery was treated as a thin garment with flat folds, and the body streamlined to produce a smooth look of graceful elegance. The Byōdō-in sculpture, the supreme masterworks of Late Heian art, are represented in the exhibition by three excellent Bodhisattvas on Clouds (cat. no. 20) from a group of fifty-two angelic attendants that encircle the Amida Buddha. The delicacy and charm of these Bodhisattvas reflect an aesthetic attitude that was pervasive in all the arts and even social customs of the eleventh and twelfth centuries. In sculpture in particular, however, these extraordinary qualities were not simply the result of stylistic sensibility, but they were made possible by the refinement of wood working technique. From the Byōdō-in Bodhisattvas we can see that the Japanese not only achieved perfection of form but they also achieved an expression of aesthetic individuality.

Although the endless repetition of Late Heian sculpture led to a certain sterility in style, new developments during the late twelfth and thirteenth centuries revitalized sculpture with creative energy and iconographic variety. New techniques such as crystal eyes inserted inside the head, and deeper, more energetic carving contributed to the production of statuary that is realistic in appearance, encompassing a broad emotional and expressive range. Among the works from the Kamakura Period in this exhibition (cat. nos. 23–36) are representative pieces by the Kei school artists, who were the major sculptors of the day. A pair of Bonten and Taishakuten statues recently discovered in a provincial temple in Aichi Prefecture (cat. no. 23) demonstrate the power of the great master Unkei (1151–1223) at mid-life. A standing Amida Buddha from Saihō-in (cat. no. 25) exhibits the refined, independent style developed by Kaikei (fl. ca. 1185–1220) and a pair of wonderful Ni-ō guardians from the Rengeō-in (cat. no. 30) display the elegant forms that are

associated with the hand of Tankei (1173–1256). Not to be overlooked in this exhibition are also a number of minor attendant figures such as the Ankoku Dōji, a clerk attendant of the King of Hell (cat. no. 26), that give Kamakura sculpture a lighthearted, humorous quality previously unknown in Buddhist art.

The special feature of Kamakura sculpture is, however, realism. Many images of Buddhas and other divinities reveal an interest in realism that makes it appear the sculptor used a living person as a model (cat. nos. 32 and 35). Appropriate to this new attitude toward realism is the appearance of large numbers of portrait sculptures that provide an added dimension to the sculpture of the period. The statues of Prince Siddhartha, who is Śākyamuni as a youth (cat. no. 29), and Prince Shōtoku, the first Japanese patron of Buddhism (cat. no. 27), are necessarily imaginary, since the subjects were long deceased. Nevertheless, they represent a type of idealized image that is regarded as a portrait because it conveys lifelike qualities. The priest portraits included in the exhibition (cat. no. 28 and 31) conform more closely to the western idea of portraiture in their depiction of personal idiosyncracies that emphasize their individualism.

The development of realism in Japanese sculpture is attributed to a revival of eighth century classical styles as well as the influence of newly imported styles from Sung China that began to filter into Japan from about the twelfth century. Surveying the sculptural tradition as a whole, the appearance of realism seems a natural outcome in the development of style that began with a simplified, abstract form in the seventh century and passed through several degrees of naturalism by the twelfth. Given the great quality displayed in the sculptures in this exhibition, the sudden decline of sculpture in the fourteenth century is curious and difficult to assess. Interest in religion was at a peak at the time, as itinerant priests preached salvationist creeds to the masses. However, the influence of patronage lay elsewhere, since the Kamakura Bakufu, or military government, supported the Zen sect whose major aesthetic interests were literature and ink painting. It is possible, too, that realism itself contained the seeds of decline. Realism is capable of inspiring great art, but not necessarily great icons. The overall flavor of Kamakura Period sculpture is one of human sensuality, a feature that makes them intriguing as objects but unbelievable as gods. Icons are created for worship, but sculpture, because of its dimensional presence, draws the viewer into a physical participation with the object. If a divine image takes on the appearance of humans, it can no longer be worshipped, for the viewer is forced into a human relationship with the god. One wonders, therefore, if the splendid accomplishments of Kamakura art did not inevitably spell the downfall of sculpture as a religious expression in Japan.

EMILY J. SANO
Curator of Asian Art

JAPANESE BUDDHIST SCULPTURE

By Nishikawa Kyōtarō

I. THE INTRODUCTION OF BUDDHISM IN JAPAN

The *Nihon Shoki* (*Chronicles of Japan*) is the first Japanese history compiled by imperial decree.[1] Dated in 720 A.D., the Chronicle records that in 552 during the tenth month of the thirteenth year of the reign of the Emperor Kimmei (r. 539–571), the ruler of the kingdom of Paekche on the Korean Peninsula presented a gift of some Buddhist scriptures and the image of a deity to the Japanese nation. This record of what is now regarded the official introduction of Buddhism to Japan, also marks the beginning of the history of Buddhist sculpture.

The *Nihon Shoki* states:

King Sŏng Myŏng of Paekche entrusted to the Japanese diplomatic envoy for presentation to his Emperor a gilt bronze statue of Shaka (Śākyamuni) and several Buddhist sculptures. Also attached was a document which explained in detail the reasons that made Buddhist law superior to all other philosophies. Because the faith commanded followers all the way from distant India to the three ancient kingdoms of the Korean peninsula — Koguryo, Paekche, and Silla — these teachings should also be transmitted to Japan and be propagated throughout the country.

The Emperor Kimmei, who had never before heard so sagacious a message, was pleased to receive these gifts. He gathered his ministers together and said, "The face of this Buddha, which was presented to us by our neighbor to the west, is very solemn, but it sparkles. I have never seen anything like it before, and I wonder if we should worship it."

In response to this question, the Soga Imane expressed the opinion that the new religion should be accepted, because all the countries on the continent had already done so and Japan was the only one that had not. On the other hand, Moronobe Okoshi and Nakatomi Kamako argued that because it was already established practice to worship 180 native deities during the four seasons of the year, it would anger the native gods to invite a heretical foreign god to the country. Thus these advisors strongly opposed the acceptance of the image.

The Emperor, who wanted nevertheless to test the worship of this god, gave the image to Imane. Delighted, Imane installed the image in his own home, making his house in Mukuhara a temple for the worship of the deity.

Although probably not accurate factually, the record of the *Nihon Shoki* indicates that the introduction of Buddhism to Japan in the first half of the sixth century surprised the imperial court. Japan's ancient religion was Shinto, which had no practice of revering images or of installing images in shrines. Shinto ("the way of the *kami* or gods") has as its central feature an animistic belief in the divinity of natural and living things, including rocks, trees, and streams, and in natural forces. The *kami* are fundamentally objects of devotion for family and local community groups. Polytheistic in character, Shintoism provides a rich mythology for the Japanese. However, prior to the introduction of Buddhism, the *kami* were not envisioned anthropomorphically.[2] Instead of images, objects could be placed in a shrine as a symbol of the divine. The mirror at the Grand Shrine of Ise and the sword at the Atsuta Shrine in Nagoya, for example, are two of the sacred regalia of the Japanese imperial family, which were so placed.

Given this kind of spiritual milieu, the surprise experienced by the Japanese upon encountering a glittering image of cast bronze and the foreign religion it represented is easy to understand. The statue was moreover a considerable achievement over sculpted objects produced by the Japanese at that time. The *haniwa* ("circles of clay"), for example, that surrounded the tombs of the nobility were cylindrical tubes of clay with tops modeled into a variety of forms, and then fired. Although the precise function of the *haniwa* is unclear, the representations on these *haniwa* of warriors, animals, and inanimate objects like boats and houses provide us with valuable information about the society of pre-Buddhist Japan. Moreover, these sculptures, made by a simple technique and of fragile materials, have the direct and ingenuous beauty of the primitive arts that attracts modern man. To sixth-century Japanese eyes, familiar only with such simple creations, an image cast in a hard material like bronze must indeed have made a striking impression.

The question of whether or not Buddhism should be accepted in Japan was, in fact, part of a larger debate on national reform that divided the court into two opposing camps. One faction, led by the Mononobe clan, who followed Shinto rituals, objected to the changes the new religion implied. The other faction, led by the Soga, favored Buddhism and national reform. By the late 580s, the Sogas prevailed militarily over their opponents, Buddhism was made the official religion, and Japan embarked on a new epoch of political and cultural reform. The political struggles that occurred in the sixth and seventh centuries in Korea also assisted the development of continental civilization in Japan. As the Kingdom of Silla rose to power and conquered Paekche and Koguryo, large numbers of Koreans arrived in Japan as refugees. Buddhist images were imported, and the immigrants played a vital role as scholars, artisans, and craftsmen who built the temples, made the sculptures, and created other accouterments of the faith.

In 593, when Prince Shōtoku (574–622) became regent under the Empress Suiko (r. 592–628), he emerged as the most important leader of the changes and reforms associated with the coming of

Buddhism. Shōtoku has been idealized in history, and correctly assessing his contribution to the many policies credited him is difficult. However, he seems to have genuinely loved learning and to have ardently promoted Buddhism. By calling for the reverence of Buddhism in his famous seventeen-article "Constitution" of 604, he gave the religion the firm support of the court. Thus Buddhism flourished and soon became firmly rooted in Japan. The *Nihon Shoki* records that in 623, forty-six temples had been constructed, and the religious community numbered 1385 people, including 618 priests and 569 nuns.[3] Over time, Buddhism cooperated with Shintoism even though Buddhism had sufficient power to overwhelm the native religion. Today Buddhism is the dominant religion in Japan.

Notes:

1. The *Nihon Shoki,* also called *Nihongi,* is translated into English by W. G. Aston as *Nihongi: Chronicles of Japan from the Earliest Times to 697,* 2 vols., London, 1896. In Japanese, Kokushi Taikei Henshukai is editor of *Nihon Shoki* in *Kokushi Taikei,* vol. 1, Tokyo, 1959.

2. Documents from eighth-century Japan indicate that Buddhist influence was strong enough to cause Shinto images to be made. See, for example, Oka Naomi, *Shinzō chōkoku no kenkyū (Researches into Shinto Sculpture),* Tokyo, 1966, pp. 30–34. The oldest extant Shinto sculptures date to the ninth century; these include the famous Hachiman triad from the Yasumigaoka Hachiman Shrine, Yakushi-ji at Nara, and a similar Hachiman triad from Tō-ji in Kyoto. See also the "Seated Male and Female Deities" from the Matsuno-o Shrine, Kyoto, No. 5, in an exhibition catalogue by Kageyama Haruki and Christine Guth Kanda, *Shinto Arts,* New York, 1976.

3. Aston, vol. II, p. 153.

II. HISTORICAL SURVEY

As Buddhism prospered in Japan, the arts also flourished. Beginning with the seventh century, architecture, religious painting, and sculpture occupied the mainstream of Japanese art history. Buddhist sculpture, in particular, maintained a high quality until the beginning of the fourteenth century. From that time, a variety of artistic expressions blossomed, and the Japanese art was taken over by painting, both religious and secular, and by other media, such as ceramics and lacquerwares. Buddhist sculpture continued to be made after the fourteenth century, and scholarly research offers increasingly detailed knowledge of the conditions governing the sculptural history. It is now known that growth, in terms of stylistic development and technical achievement, extended until the end of the Kamakura period. After that, the most interesting works created were not conventional icons but the masks used for Noh plays and the simple wood image sculptures made by eccentric priest/sculptors, Enkū (1628–95) and Mokujiki (1718–1810) in the Edo period.

The purpose of the present exhibition is to show masterworks of Japanese Buddhist sculpture selected to represent the development of this art form from the seventh century to the early fourteenth century. The exhibited pieces demonstrate the particular stylistic and technical features characteristic of each major stage in the development of Buddhist sculpture. These stages correspond generally to the periods designating the political history of Japan. A brief review of these major periods and their sculptural history follows.

Asuka Period (552–645 A.D.)
The Asuka Period begins with the introduction of Buddhism in 552 and concludes with the reform of the Taika era in 645. The period is named after a site near the Asuka river, where the seat of government was then located. The Taika Reform that ends the period refers to the Taika reign era, lasting from 645–49, and "Reform" refers to a major change in the organization of the state from an alliance of clans to a nation based on a system of laws and regulation. Essentially a land reform

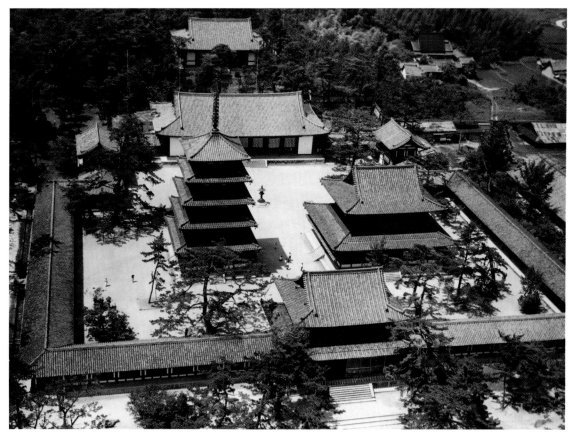

1. Aerial view of Hōryū-ji, seventh century

patterned on the governmental institution of T'ang China, the "Great Change of Taika," was intended to nationalize agriculture and redistribute land and, thereby, to establish a central government with the Emperor as head.

As was mentioned above, the *Nihon Shoki* records that forty-six temples were built in Japan by 623. Of the Buddhist temples constructed by the Soga in the late sixth century, none survives. A small temple called Asuka-dera now stands on the site of the Hōkō-ji, which was originally a splendid monastery built by the Soga family in 588 to commemorate their political successes. In the Asuka-dera, a large but heavily restored bronze image, cast in 606, of the historical Buddha Shaka (Śākyamuni) is now the only reminder of the early patronage of this first influential pro-Buddhist family.

The great temple compound of Hōryū-ji, on the other hand, which is located in the village of Ikagura near Nara, stands as a monument to the enlightened patronage of Prince Shōtoku. Originally constructed in 607, the temple compound contains structures that, in spite of some rebuilding, still stand as the oldest wooden buildings in the world. Central to the Hōryū-ji complex, for example, is a rectangular roofed gallery, with an entrance gate on its southern side. The gallery enclosed several buildings, among these a Lecture Hall, a Golden Hall for the principal devotional images, and a Pagoda originally intended to house relics of the Buddha or of a Buddhist saint. With their raised stone bases, broad upper roofs of grey tiles, and woodwork painted cinnabar red, these buildings reflect Chinese architectural styles of the Six Dynasties Period (ca. 222–589 A.D.).

The sculptors who made the statues for these temples were principally craftsmen from China or Korea, or their descendants. For example, the sculptor Tori, who made the bronze Shaka Buddha for Asuka-dera, as well as the famous Shaka Triad dated 623 A.D. for Hōryū-ji, was a descendant

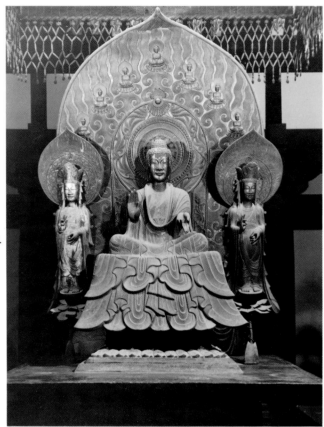

2. Shaka Triad (Shaka Nyorai and two attendant
Bodhisattvas) Golden Hall, Hōryū-ji, 623 A.D.

of naturalized citizens, as was the sculptor Yamaguchi no Atai Ōkuchi, who made the set of Four
Guardians for the Golden Hall of Hōryū-ji.

The most representative sculptor of the day, Tori apparently enjoyed high esteem as a specialist
because he was given the title of *Busshi* (Master Craftsman of Buddhist Images). The Hōryū-ji
preserves several pieces from the workshop of Tori Busshi which are illuminating about the Asuka
style. The Shaka Triad, for example, consists of a seated Buddha flanked by two standing atten-
dants. Presented with strict frontality, the three were cast as a single sheet of bronze relief with no
attention given the back or sides of the figure. Nevertheless, these images are admirable for their
precise forms. The Buddha sits erect, his robe hanging down in broad, emphatic planes in front of
his throne. The robes of the attendants are schematic, and the folds are symmetrically arranged on
the right and left. The face and hands are enlarged in proportion to the bodies, and the austere
expression of the faces evoke a sense of mystery.

The formal elements of this Asuka style, which derived from sculptures produced during the
Northern Wei (385–535) and Eastern Wei (534–550) Dynasties in China, were transmitted to
Japan through the Korean peninsula. Other extant examples of this style include a lifesize image of
Kannon (Avalokiteśvara), located in the octagonal Hall of Visions (Yumedono) at Hōryū-ji, and
a statue called Kudara Kannon that is notable for its elongated proportions. Also in this style is a
Bodhisattva made of wood from Hōrin-ji, a small temple located just a half mile from the Hōryū-ji.
The treatment of the Bodhisattva's garment shares some similarities with the Kudara Kannon,
though the short proportions and enlarged head and hands of the Bodhisattva reveal its archaic
spirit. In addition, numerous small gilt bronze statues now in Hōryū-ji and in the Tokyo National
Museum are excellent examples of the period. One of these included in this exhibition is a gilt
bronze Kannon (cat. no. 1) from Hōryū-ji. The statue shows the dominant characteristics of the
period and is therefore an especially important example of the Tori style.

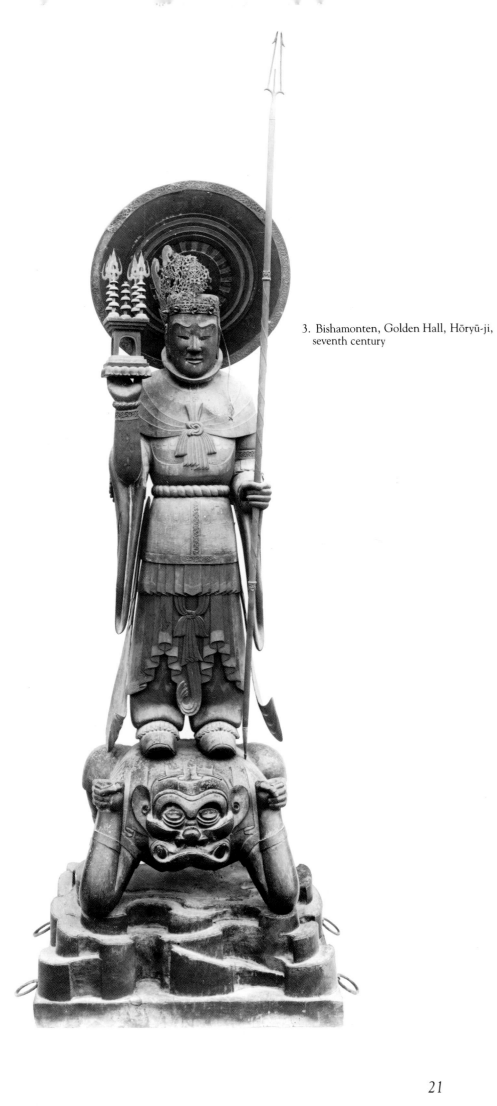

3. Bishamonten, Golden Hall, Hōryū-ji,
seventh century

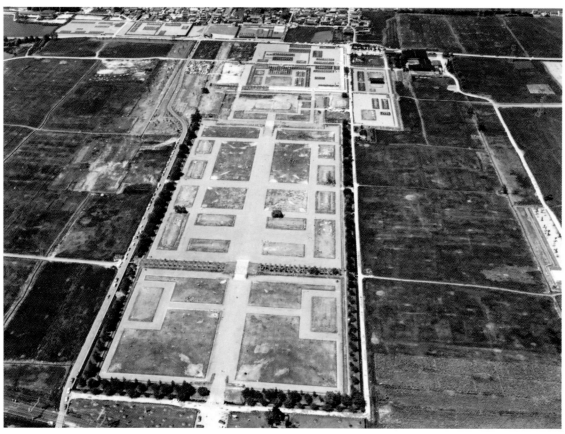

Aerial view of Heijō palace site, 710 A.D.

Early Nara or Hakuhō Period (645–710)

The Early Nara Period begins with the Taika Reform of 645 and continues to the founding of the Heijō-kyō, the great capital city which is now Nara. Also known as the Hakuhō Period, from the name of the reign era of the time, the era saw the rise of a powerful imperial family and the advancement of Buddhist faith as the major religion. Particularly during the reign of the Emperor Temmu (r. 673–86), Buddhism received the official patronage of the court, which sponsored construction of many great temples in the late seventh and eighth centuries. Among the nobility, the building of family or clan temples was also popular. Yakushi-ji, dedicated to the worship of Yakushi (Baiṣajyaguru), the Buddha of Healing, was originally built by the Emperor Temmu in the Asuka district and then was moved to the Nara capital. The Kōfuku-ji, also relocated from the Asuka district to its present site in Nara, was a private temple of the wealthy Fujiwara clan. Because of the enormous prestige of the family, the temple ranked with the official state temples as one of the main sanctuaries in Nara, and the temple remains one of the most important in Japan in the history of Buddhist art.

Buddhist images of the Early Nara Period advanced beyond the stylistic accomplishments of Asuka sculpture. In the Nara Period, the stern face softened and was replaced by a gentle, pure, childlike expression. The body became more naturally rounded to suggest a soft fleshiness. This new style, which follows the developments in Chinese sculpture during the Northern Ch'i (550–77), Northern Chou (557–80), and Sui (ca. 581–618) Periods, was transmitted to Japan as relations developed with China and Korea during the late seventh century. In addition, some sculptures of the Early Nara Period exhibit the fresh, more advanced features characteristic of the Sui to Early T'ang (618–ca. 907) Periods, such as the well-balanced compositions and naturalistic proportions and clothing.

From a purely technical point of view, as well, Early Nara statuary is colorful and varied. Asuka

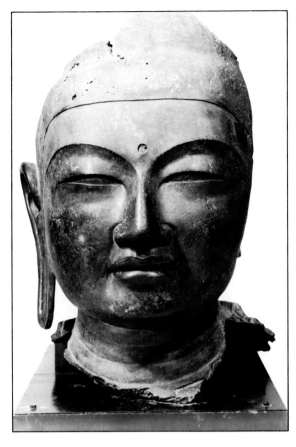
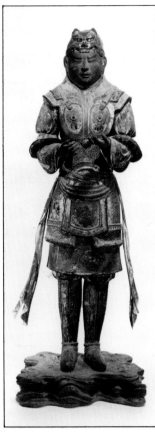

4. Head of a Buddha, Kōfuku-ji, 685 A.D.

5. Kendatsuba (One of the Eight Heavenly Beings), Kōfuku-ji, eighth century

sculptures are limited to works in bronze and solid camphor wood; in the Early Nara Period, however, dry lacquer and clay were also used. Because these different media affect the appearance of statuary, the section on Technique in this essay reviews these production methods.

The best examples of Early Nara sculpture reflect the varied media used. The Miroku (Maitreya), or Buddha of the future, seated in a meditative pose at the Chūgū-ji nunnery in Nara, is made of a single block of wood; its surface, darkened by incense smoke, is polished to a high sheen. The serene and gentle expression and simplified body show the influence of Chinese Northern Ch'i sculpture. That this pose enjoyed widespread popularity at that time is demonstrated by a small but excellent example of the same form in gilt bronze (cat. no. 2). More developed in appearance is the Miroku Buddha from Taima-dera, a full-bodied, seated figure in clay dated to about 681. Also at Taima-dera, a set of the Four Guardians (Lokapāla), made of dry lacquer, is one of the oldest such sets of these deities in Japan. Second in age only to the set in wood in the Golden Hall of Hōryū-ji, these statues represent a comparatively large stylistic advance over the archaic Hōryū-ji group.

A number of bronze sculptures are also extant from this period. A large head of a Buddha, a fragment dated to 685 of a Yakushi Buddha from a temple called Yamada-dera has the open, optimistic expression and feeling of naturalism characteristic of Early Nara art. The best works of the mature T'ang Chinese style are the several works in bronze dating to the latter half of the period from the Temple of the Healing Buddha, Yakushi-ji. The handsome triad in the Golden Hall, consisting of a seated Buddha flanked by two standing Bodhisattvas, and the Shō-Kannon (Ārya Avalokiteśvara) in the Tōin-dō, are mature, sensuous statues that have all the grace and finesse of classic T'ang art.

Nara Period (710–794)
The Nara Period, which lasted for about eighty years, is defined by two major moves by the court.

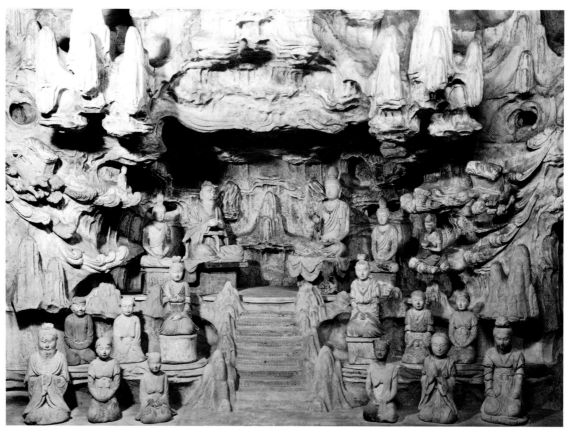

6. The Confrontation of Yuima and Monju, from the Five-story Pagoda, Hōryū-ji, 711 A.D.

In 710 the capital, called Heijō-kyō, was established in Nara, and in 794 a new capital, called Heian-kyō, was built in Kyoto. The Heijō capital, which took three years to build, was the symbol of the newly established centralized government. The city was laid out in an orderly plan modeled after the layout of the T'ang capital Chang-an. The Imperial Palace was centered in the northern part of the city, and from it a grand boulevard 3,800 meters long and 85 meters wide ran south to the city's main gate. Regular streets 28 meters wide ran in all four directions to form a grid pattern. It is said that all the buildings and temples in the capital were constructed and decorated in Chinese fashion with blue tile roofs and red pillars. The city was moreover a true urban center. While the total population of Japan at that time is thought to have been 5,000,000 people, the residential population of Heijō-kyō is estimated at 200,000.

As previously mentioned, a few large temples originally built in the Asuka district, such as Kōfuku-ji and Yakushi-ji, were gradually relocated in the new capital. The most impressive monument to the power of the central government, however, was the building of the great temple Tōdai-ji, in the mid-eighth century. Tōdai-ji was built by the Emperor Shōmu (r. 724–49) who, as a convert to Buddhism, firmly instituted the religion for the protection of the state and inspired the most brilliant achievements in the developments of the arts. In 741 he ordered that each province in the country build a temple and nunnery to propagate the faith. The great Tōdai-ji was to become the center for this network of temples, thus making it a national cathedral for Buddhism. Still the largest wooden structure in the world, the Tōdai-ji houses a large cast bronze image of Roshana (Mahāvairocana), the supreme Buddha, that measures some fifty feet in height. At the eye-opening ceremony for this great Buddha which took place in 752, an Indian monk painted in the eyes of the Buddha to give it life. Witnessed by some 10,000 priests and numerous foreign visitors, this ceremony was one of the greatest events of early Japanese history.

Eighth-century Nara must have been an extraordinarily cosmopolitan city. At that time, T'ang

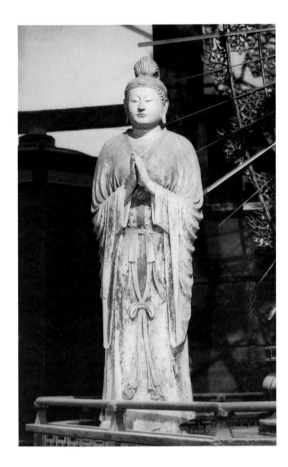

7. Gakkō, Sangatsu-dō, Tōdai-ji, eighth century

China was the greatest civilization in the world. Japanese travellers to the continent, as well as visitors from abroad, were able to bring to Japan elements of a culture that had great influence on this isolated country. Exotic *objets d'art* brought from remote places along the overland caravan route known as the Silk Road enriched daily life. The most profound cultural transplant was, however, the adoption of the Chinese written language. The Japanese had never devised their own script, and although the use of Chinese ideographs was not well suited to the structure of spoken Japanese, Japanese scribes were able to adapt the ideographs to communicate and record their own history.

In Japan during the Nara period, numerous distinguished sculptures of the mature T'ang style were made. The T'ang style is recognized as a new mode for sculptural form featuring a substantial fullness in the modeling of the body and in the naturalistic treatment of the drapery. Sculptures were created fully in the round; consideration was given the sides and the back of each object, and a sense of movement was achieved. By the mid-eighth century, workshops for making Buddhist statuary were established. The facilities set up for casting the Great Buddha at Tōdai-ji were extremely large, with numerous sculptors and craftsmen employed to handle the requests for images that numbered as many as five hundred at a time.

The sculpture of this period is best represented by a number of superb works now called Japan's classical art. Most of the pieces, which are located at the major Nara temples, date to the first half of the eighth century. The five-story pagoda at Hōryū-ji contains four sets of small clay figures dated to 711 that depict scenes from the life and teachings of Shaka, the Historical Buddha. A set of Ten Disciples of Shaka, as well as a set called the Eight Heavenly Beings (*Hachibushū; Dharma-pāla* in Sanskrit), who are a group of fierce demigods pledged to the protection of the Law, were made for the Kōfuku-ji. Dating to 734, these two sets are among the finest examples of dry lacquer statuary extant in Japan. At Tōdai-ji, a small structure called the Sangatsu-dō, or Hokke-dō,

located to the east of the Great Buddha Hall contains a large number of sculptures dating to about 746 that are made of dry lacquer and clay. Also, the Tōshōdai-ji, a monastery built for the Chinese monk Chien-chen (Ganjin in Japanese), who had arrived in Japan in 753 to found one of the six Nara sects, contains several Buddhas and Bodhisattvas made of dry lacquer and wood that are dated after 759. Taken together, these sculptures provide a representative survey of the expressive range of Nara Period sculpture.

Images made of dry lacquer and clay are extremely fragile and not transportable. Catalogue numbers 3, 4, and 5 are, however, excellent examples of the gilt bronze statuary of the period. The statue of Shaka at Birth is a very important monument of the Nara Period. Among the several surviving images of this type, only this one is complete with the bowl for holding the perfumed water used in the ceremony celebrating this deity. This statue is believed to have been used first in the eye-opening ceremony of 752 that marked the completion of the Great Buddha of Tōdai-ji. Together with the two wood sculptures from the set of Four Guardian Kings from Daian-ji (cat. no. 6) and the head of a large wood-core dry lacquer image originally made for Tōshōdai-ji (cat. no. 7), these gilt bronzes demonstrate the forms, techniques, and styles of eighth-century sculpture.

As the foregoing survey shows, the centuries from the introduction of Buddhism in Japan to the end of the eighth century coincide with the initial 250 years of Japanese sculptural history. These sculptures can also be viewed as remains of the development of Buddhist sculpture in China. At this same time China passed through the Six Dynasties and the flourishing T'ang Periods, and enjoyed its golden age of Buddhist sculpture. The Buddhist faith and its attendant culture passed like a great wave from China through Korea before being received and assimilated in Japan. However, Japanese works from this time reveal notable differences from comparable pieces out of China or Korea. The Japanese were not imitators of continental works, and these sculptures evidence artistic details and sensitivities that are distinctively Japanese.

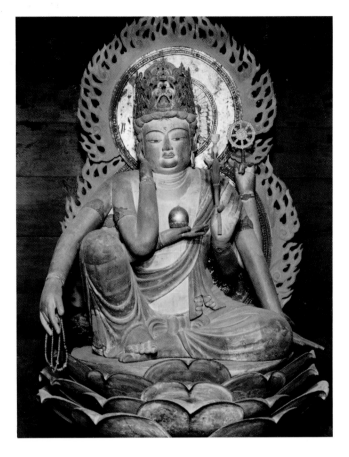

8. Nyoirin Kannon, Kanshin-ji, ninth century

Early Heian Period (794–894)

The Early Heian Period begins in 794 when the court moved again from Nara to the new capital called Heian-kyō, which is modern Kyoto. The period ends in 894 when the court severed its relations with China. Like the Nara capital, Heian-kyō was built with wide streets forming a grid pattern, according to the plan for the Chinese T'ang capital, Chang-an. The Kyoto site is surrounded by mountains on the north, east, and west that formed a basin open on the southern end; the Emperor's palace was positioned at the northern edge of the basin. The site was advantageous according to rules of Chinese geomancy, which required a favorable arrangement of hills and auspicious deposition of "wind and water." Kyoto was also desirable because it permitted freer access to the rest of the country than did Nara.

The primary reason for the move was to effect a change in relations between the court and the Buddhist church. Through lavish state support, the clergy had become arrogant, and some members had come to exert too much influence on the throne. Thus, unlike the previous transfer of the government from Asuka to Nara, the large, established temples were not permitted to move to the new capital. Instead, Heian-kyō was built with only two temples located within the city. The East Temple and West Temple (Tō-ji and Sai-ji respectively), on either side of the main south gate of the city, were pledged to the protection of the capital.

The corruption in the Buddhist circles persuaded some church leaders to build remote sanctuaries in the mountains to escape the atmosphere of the capital. At the same time, the rise of Esoteric Buddhism, different from the traditional Buddhist sects in Nara, also prompted the building of mountain temples. Esoteric Buddhism, *Mikkyō* in Japanese, first developed in India as a faith embracing both Buddhist and Hindu creeds. It was established in China in the seventh century by missionaries who translated numerous esoteric texts and produced a new and varied religious iconography. Esoteric Buddhism permitted its mysteries to be revealed only to a few initiates.

Using magical charms, special incantations, and ritual gestures to bring about exalted religious states, the sect worshipped a vast number of deities. The new Esoteric sects also valued regulation and order, and their services and practices were strictly controlled, as were the forms of the images. One of the best examples of this concern is the mandala, the diagram that schematically defines the relationships among deities. Within the mandala, the complex Esoteric pantheon — all of which was conceived as an emanation of the primary creative principle, the Buddha Mahāvairocana — was divided into two parts, the "Diamond World" and "Womb World," which arranged all deities into a strict, grid-like frame work.

The sudden prominence of the Esoteric doctrines in Japan in the ninth century is in large measure due to the efforts of two monks, Saichō (posthumously called Dengyō Daishi, 767–822) and Kūkai (Kōbō Daishi, 774–835). These two gifted priests travelled to T'ang China in 804 to study, and both returned steeped in Esoteric doctrines. Since the court favored the activities of priests who devoted their attention to spiritual rather than worldly concerns, Saichō prospered when he returned from China. The Tendai sect of Buddhism that he founded at the Enryaku-ji, located on Mount Hie northeast of Kyoto, became the center for a wide range of spiritual and secular studies that ultimately spawned various popular Buddhist sects throughout Japan.

Esoteric Buddhism was more specifically introduced to Japan in the Shingon sect, founded by Kūkai who built a monastery atop Mount Koya near modern Osaka. Shingon was a demanding faith that required its adherents to experience the path of Buddhist teachings by undergoing extreme austerities rather than by seeking assistance from the outside. Nevertheless, perhaps because of the importance given to solemn devotions and rituals, the Shingon sect was supported by the nobility of the day and thus gained great power. Tendai too had a strong esoteric character, and these two groups provided a powerful stimulus to culture, particularly to the arts of the ninth and tenth centuries.

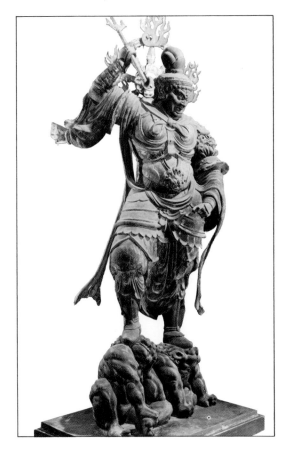

9. Jikokuten (One of the Four Guardian Kings), Tō-ji, 839 A.D.

The mandala and numerous theoretical treatises imported to and studied in Japan inspired the manufacture of a variety of images based on Esoteric iconography. *Mikkyō* images, which often have multiple heads and arms and fierce expressions, reflect the influence of Hinduism. For example, the several forms of the Bodhisattva Kannon popular in the Early Heian Period, such as one with eleven heads and a thousand arms, and the fierce images such as Fudō Myōō, reflect this complex theology.

Against this background of new ideas and intense religious faith, Buddhist sculpture achieved a bold and masculine expression and thus differs from the well-composed style of the Nara Period. The Early Heian figures are heavy, even obese, with broad strong shoulders, large hips, and thick bulging thighs. Because of their swollen, often exaggerated forms and deeply cut drapery patterns with decorative flourishes, the sculptures of the Early Heian Period are characterized as "baroque" and are in contrast to the classical Nara style.

In the Early Heian Period, the use of dry lacquer and clay techniques ceased, and little statuary of bronze was made. Instead, sculptors increasingly used wood, which was abundant in Japan. Carved from a single block, these massive statues demonstrate sharp cutting techniques that contribute to their feeling of vigor and sense of volume. By the latter half of the period, the single block technique matured, and many refinements on the method were established. (See Part III of this essay.)

Several excellent sculptures from the Early Heian Period survive. Among the works finished with polychrome or lacquer, a group of deities made for the Lecture Hall of Tō-ji temple in 839 is important for the mandala-like arrangement of deities. This sculptural group of twenty-one images includes five Buddhas placed in the center of the altar, who are surrounded by five Bodhisattvas on the east, five Myōō (Vidyārāja) on the west, Bonten (Brahmā), Taishakuten (Indra), and a set of the Four Guardian Kings at the four corners. The 837 Nyoirin Kannon (Cintāmaṇicakra Avalokiteśvara) at Kanshin-ji, and the set of Five Great Kokūzō Bosatsu at Jingo-ji dated to 850

29

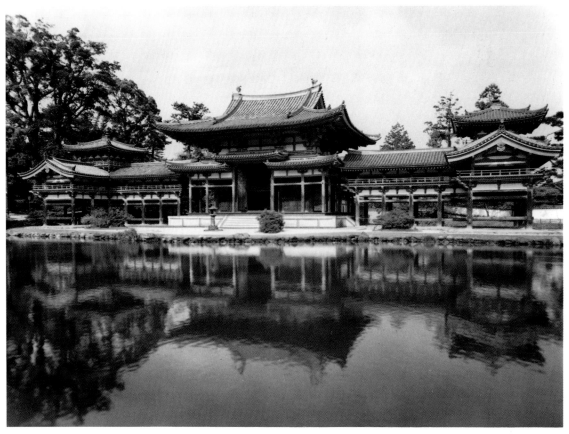

10. Phoenix Hall of the Byōdō-in, 1052 A.D.

express a sensuous feminine beauty. Outstanding examples of plain wood sculptures include the standing Yakushi Buddha at Jingo-ji and the striking Eleven-headed Kannon (Ekadaśamukha Avalokiteśvara) from Hōkke-ji. The works effectively show the power of the wood sculptures made by the sharp-cutting technique.

Such sculptures produced during the ninth century (cat. nos. 8–13) are superior works of the period and, moreover, exhibit the variety of expression produced during that age. In particular, the Torso of a Buddha from Tōshōdai-ji (cat. no. 8) features the thick body and heavy thighs characteristic of the period. The seated Miroku Buddha from Tōdai-ji (cat. no. 10) is a small work that exhibits a generous feeling in the sharply cut drapery and oddly flattened legs. The Yakushi Buddha from the Nara National Museum (cat. no. 11) and the Eleven-headed Kannon (cat. no. 12) are superior works reflecting an exotic, Indian flavor.

The new Buddhism, which was centered in Kyoto, flourished as the priests of the period pursued T'ang philosophies and progressed in the study of the new texts and iconography from China. However, a new confidence began to assert itself within the court. Around the mid-ninth century, the Japanese began to feel that T'ang China was in decline and unsafe for travel. A court decision of 894 to suspend the dispatch of envoys to the Chinese court marks the end of the Heian Period and of two-and-a-half centuries of cultural borrowing. The Japanese were then prepared to consolidate their progress and to develop a *wayō* or native culture expressive of Japanese sentiments.

Late Heian Period (894–1185)

The Late Heian Period lasted for about three centuries, from 894, when official relations with the continent ceased, until 1185 when a military government was established in Kamakura. A glorious aristocratic age, the Late Heian Period is also called the Fujiwara Period, after the Fujiwara family who through marriage controlled the court and effectively wielded political authority over the

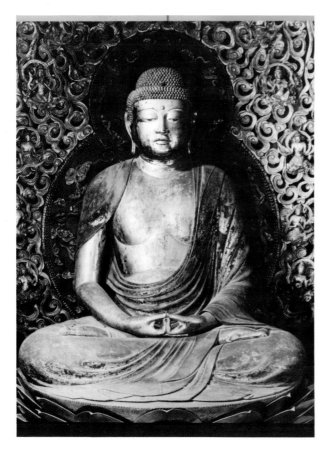

11. Amida Buddha, by Jōchō, Byōdō-in, 1053 A.D.

entire country throughout most of the tenth and eleventh centuries. During the Fujiwara Period, the continental culture transmitted until the ninth century to Japan was assimilated, and an indigenous Japanese culture evolved.

Although Heian culture owed much to its Chinese antecedents, the Japanese produced works of pronounced elegance and refinement which differed from the cultural products of China. For example, art and poetry flourished during the Fujiwara Period, largely because the development of a Japanese syllabary (*kana*), which was derived from Chinese characters (*kanji*). The syllabary permitted Japanese authors to produce literary masterpieces in their native tongue. Poetry became a primary preoccupation of the court. Both on private occasions as well as official public gatherings, poetry teams were organized and competitions devised that required a knowledge of poetic allusions and the ability to extemporize. The use of *kana* also stimulated the development of native prose literature, both in fiction and in diaries and journals. The period is distinguished by the Japanese masterpiece, *The Tale of Genji (Genji Monogatari)*, a long novel completed about 1000 by Murasaki Shikibu, a lady-in-waiting at court. Interesting by its presentation of the manners and mores of the Heian court, *The Tale of Genji* reflects the emotional and æsthetic character of the Heian Japanese better than any other work from the time. In the visual arts, the development of a native style of painting, called *yamato-e*, led to the creation of narrative picture scrolls in the twelfth century that are masterpieces of secular arts. Although little of the early *yamato-e* painting survives, it is known that these paintings depicted landscapes with figures, and used as major themes the season of the year and the famous scenic spots of Japan.

During the Late Heian Period, court society reached an unusual level of sophistication, even as the court became increasingly isolated. Control of affairs outside Kyoto was left to the management of provincial families, who, in order to maintain themselves against lawless elements, resorted to arms. By the late tenth century, a provincial warrior class emerged that was to reshape the character of Japanese political history. Though many of the warrior — or samurai — families had once

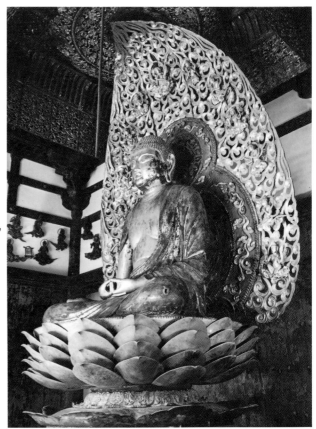

12. Amida Buddha and interior of the Phoenix Hall, Byōdō-in, 1053 A.D.

had connections to the court, they had by now left Kyoto to take up posts in provincial administrations and remained in the provinces to develop a band of supporters and vassals. In the eleventh century, two great clans, the Taira and Minamoto, became principal contenders for supremacy over the land. By the late eleventh century, however, the Fujiwara power over the court weakened and the imperial house reasserted its power through a system of abdicated sovereigns, that is, emperors who would retire from official duties but still manipulate power behind the scenes, and through alliance with the Taira family. By the mid-twelfth century, this complex political condition resulted in a series of armed struggles between the Taira and Minamoto, from which the Minamoto emerged victorious in 1185. The Minamoto then established a military government away from Kyoto and effectively ended the political control of the imperial family.

In the history of Buddhist sculpture, the Late Heian Period saw the development of a purely Japanese expression that is gentle and calm. The culmination of this new style coincides with the development of Pure Land Buddhism (Jōdō in Japanese), which was central to Tendai religious teachings. Pure Land Buddhism taught that faith in Amida (Amitābha), the Buddha of the Western Paradise, and the diligent recitation of his name, permitted the soul to enter a heavenly Pure Land after death and to avoid hell. While the nobility of the previous age thought spiritual fulfillment belonged to this world, religion of the Late Heian Period taught that salvation came after death. Faith in Amida Buddha spread rapidly. Especially during the eleventh and twelfth centuries, the nobility competed in building new temples dedicated to Amida Buddha and furnished them with large gilt statues of the deity, who was believed to assure the donor's rebirth in paradise.

Such intense devotions produced voluminous requests for Buddhist statuary and necessitated organized production methods. Sculptors formed groups and opened workshops. One of the leaders of the day was the celebrated sculptor Jōchō, who took commissions for statuary from the most powerful of the day, notably from the heads of the Fujiwara family. Jōchō is famous for perfecting a new technique for making wood statuary. Instead of carving an image from a single block of wood,

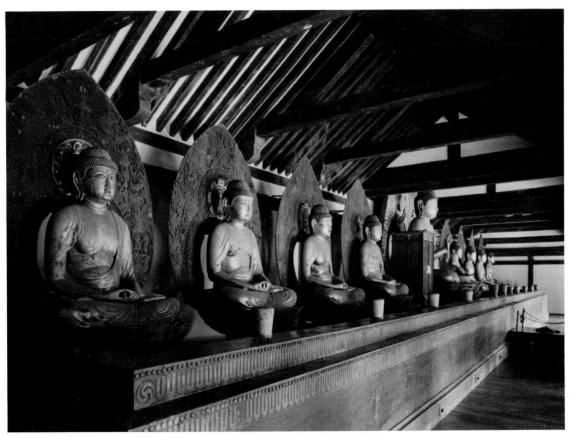

13. Nine Amida Buddhas, Jōruri-ji, early twelfth century

Jōchō and other Late Heian sculptors devised a joined block technique in which a figure was assembled from several pieces of wood. Since requests for sculpture groups of a hundred or even a thousand figures were not uncommon, the development of mass production methods was fortunate indeed.

Jōchō's great masterwork is the Amida Buddha at the Phoenix Hall of the Byōdō-in in Uji, near Kyoto, dated 1053, and the fifty-two small Bodhisattva figures that hang on the walls surrounding the Buddha. The Byōdō-in was built by Fujiwara Yorimichi (992–1074) as an attempt to recreate the beauties of a Pure Land paradise. A light, elegantly designed structure, the temple is one of the finest extant examples of Late Heian architecture. In later times, the building came to be called Phoenix Hall because the side wings and a tail-like structure extending to the back of the building resembles a bird. The Amida Buddha, which measures nearly ten feet high, is the supreme example of the gentle elegance and grace that are the hallmarks of Late Heian art. The face is round; the features are clear though rather shallowly cut, and the expression is meditative and serene. The legs of the figure, broad in proportion to the rest of the body, suggest stability.

The nobility of the day were enchanted by Jōchō's Amida. Comments from contemporary diaries record admiring sentiments, such as, "This noble face is as beautiful as the full moon" and "This image indeed sets the standard for all Buddha images." Throughout the twelfth century, Jōchō's Amida was revered and copied as the classical Japanese Buddha.

Yet as Buddhism spread to the provinces, a new regional style in Buddhist images evolved in eastern Japan and differed notably from the classical style of the capital. This sculpture, called *natabori* (ax-carved), has a rough surface with traces of chisel marks. Though the term has etymological connections to the Japanese word for ax, *natabori* referred to the rough-cut surface much admired in some Buddhist sculpture of the time, and it represents a stage in working a wood surface before it is finished. The clean traces of flat and round chisel marks leave an impressionistic

flavor different from the sensation evoked by finished works of the traditional sculpture workshops. Outside the mainstream of Japanese sculptural history, these *natabori* works are eccentric works that appeared in the provinces only in the eleventh and twelfth centuries and then disappeared (See cat. nos. 21 and 22). The fact that the Heian Japanese accepted this expression in a major iconic form suggests their æsthetic character could embrace many levels of expression.

Among the major examples of Late Heian sculpture, tenth-century works are characterized by a feeling of volume similar to ninth-century styles, yet these later works also show trends toward softening and gentleness. A Yakushi Triad dated 907 and made for Daigo-ji in Kyoto; an Eleven-headed Kannon from Rokuharamitsu-ji; and a Yakushi Triad in the Lecture Hall of Hōryū-ji exemplify these trends. In addition to Jōchō's Amida Buddha at the Byōdō-in, outstanding sculptures include similar Buddha figures, such as the Amida at Hōkai-ji, and a powerful, energetic set of Four Guardian Kings at the Jōruri-ji in Kyoto.

This exhibition includes several Late Heian works (cat. nos. 15–22). The Amida Triad from Shittennō-ji (cat. no. 15), the Jizō Bosatsu (Kṣitigarbha) from Kōryu-ji (cat. no. 16), and the Nyoirin Kannon from Daigo-ji (cat. no. 18) are tenth-century works that evidence both the thick, masculine characteristics of ninth-century sculpture and the tenth-century qualities of gentleness. The Bodhisattvas on Clouds from the Byōdō-in (cat. no. 20), dated 1053, are National Treasures and supreme examples of the classical Fujiwara style.

Kamakura Period (1185–1333)

When Minamoto Yoritomo seized political power in 1185, he established his Shogunate, or military government, at a fishing village called Kamakura near modern Tokyo. The Kamakura Shogunate dissolved the former system of centralized power based on ancient laws and regulations and created instead a revolutionary government controlled by a new class of warrior elite related by feudal ties. Yet the new military government was hardly a rebel regime. It was established with the

34

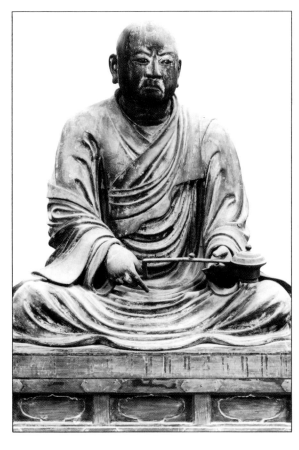

14. Zenshu (One of the Six Patriarchs of the Hossō Sect), by Kōkei, Kōfuku-ji, 1189 A.D.

approval of the imperial household, and it was to last for five centuries. After Yoritomo's death, the Hōjō family, once the leading vassals of the Minamoto, emerged as the new rulers of the Shogunate. On the whole, the Hōjō rulers are regarded as good and just administrators, but their power eroded in the late thirteenth and early fourteenth centuries following the threat of the Mongol invasions. In 1333 a loyalist revolt briefly restored the power of the throne, brought the Hōjō rule to an end, and marked the close of the Kamakura period.

During Kamakura, the elegant aristocratic culture of the earlier Heian nobility persisted within court circles, but a lively, popular culture developed as well, in part because Buddhism became the faith of people of all classes. Throughout the thirteenth century, many priests became itinerant evangelists, bringing Pure Land Buddhism to the masses. Also introduced in the Kamakura Period was Zen Buddhism. Zen, literally "meditation," was unlike the Pure Land salvationist sects, such as Amida Buddhism, which required the individual to place complete faith in something outside himself; Zen encouraged the worshipper to seek enlightenment through personal discipline and effort.

In the long history of Japanese religious art, particularly of sculpture, the Kamakura Period stands as Japan's Renaissance. The period saw the rebuilding of the great eighth-century temple Tōdai-ji, which had been deliberately destroyed by fire in the hostilities between the Taira and Minamoto. Shortly after the establishment in 1185 of the new regime in Kamakura, funds were raised for rebuilding the temple, and the ancient capital bustled with activity as artists and craftsmen focussed their attention on the treasures of the Nara Period. Among these craftsmen was a group of sculptors called Nara *Busshi* (Buddhist sculptors of Nara), who were descended from the eleventh-century master Jōchō. The Nara *Busshi*, who had originated in Kyoto as one of the offshoots of Jōchō's expanded workshop, made the Kōfuku-ji in Nara the center of their activity and contributed as well to large projects at Tōdai-ji. The Nara *Busshi* are best known as the Kei school sculptors, because all used the character read "kei" in their names.

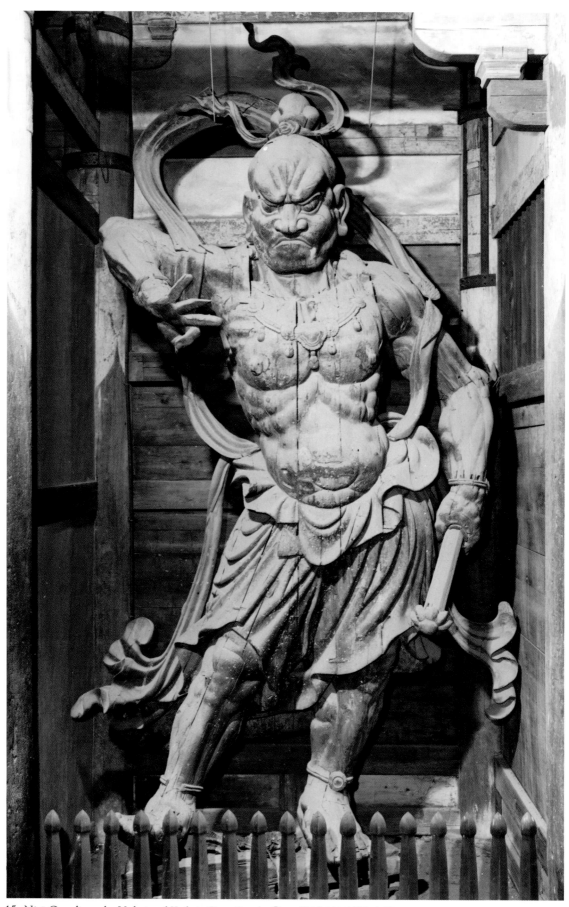

15. Ni-ō Guardians, by Unkei and Kaikei, Great South Gate, Tōdai-ji, 1203 A.D.

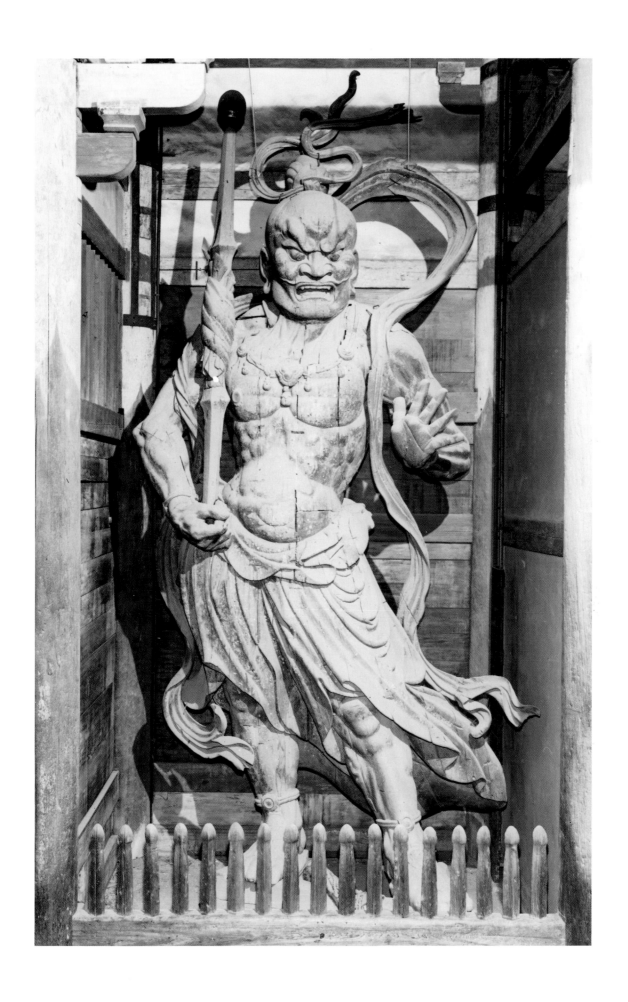

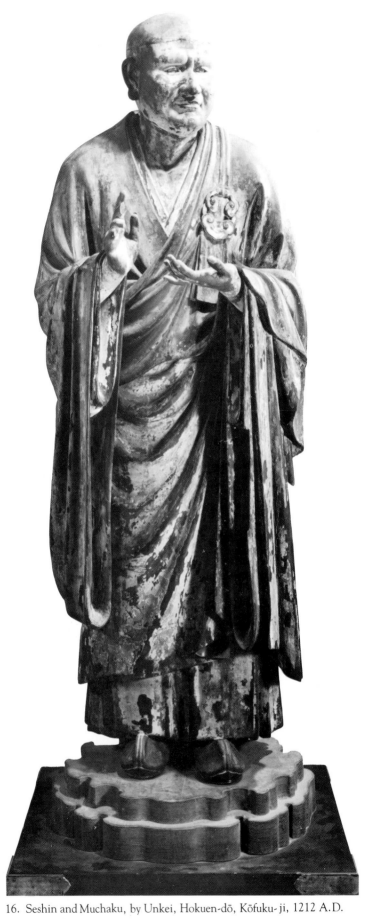

16. Seshin and Muchaku, by Unkei, Hokuen-dō, Kōfuku-ji, 1212 A.D.

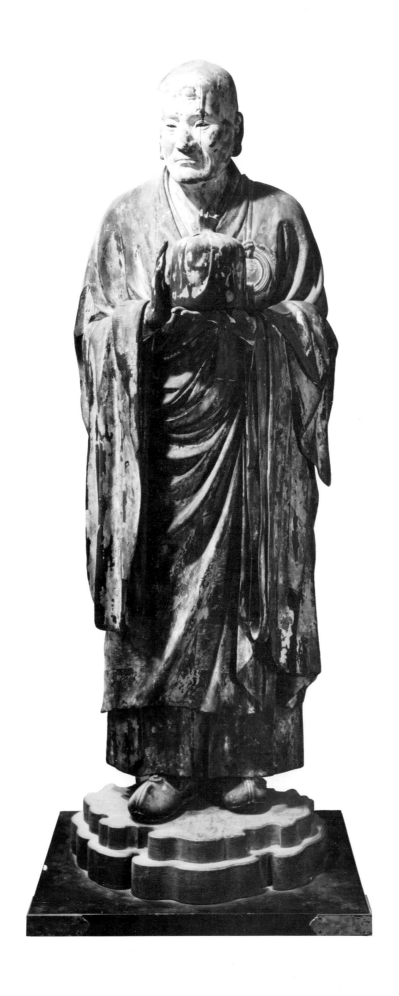

Led by Kōkei (fl. late 12th-c.) and bolstered with the talents of Kōkei's son Unkei (1151–1223) and of an apprentice Kaikei (fl. ca. 1185–1220), the Kei school created fresh new works that also show influences from eighth-century sculptures. Once the restoration of the Nara temples was complete, the Kei sculptors accepted commissions in the Heian capital and in the provinces, particularly from the military government in Kamakura, and produced a large number of energetic and lively sculptures. Other sculptors, active since the twelfth century in Kyoto, continued to make beautiful works in a refined and conservative style, but these works do not reflect the major contemporary movement.

Indeed, another mood prevailed in the sculpture of Early Kamakura. After several generations of repeating the Jōchō formula for Buddhist images, sculpture was revitalized by new influences, which derived from sculpture of the Nara Period and also from paintings and other cultural objects from Sung China. For example, numerous sculpted deities and portraits of Zen masters were created for the temples built by the newly imported Zen sect. But whatever the source of patronage, the sculpture of the Kamakura Period contrasts with the stylized and contemplative elegance characteristic of the Late Heian Period and exhibits vitality, masculinity, and vivid realism.

In its techniques, Kamakura sculpture consolidated numerous methods and media earlier developed. In addition to wood, then the primary material for images, there was a revival of clay and bronze techniques popular in the Nara Period. Also, *kirikane* decoration (cut and pasted gold strips) became common in a variety of geometric and stylized patterns, and a revival of motifs such as the *hosoge* floral pattern, which had been popular in the eighth century, added decorative dimension to Kamakura sculpture. Sculptural realism was encouraged by such practices as inserting crystal into the eyes of Buddhist images. This particular practice began about the mid-twelfth century and is an important feature of Kamakura works. Also doll-like images, i.e., nude sculptures dressed like dolls appeared in the second half of the period, and their crystal fingernails and

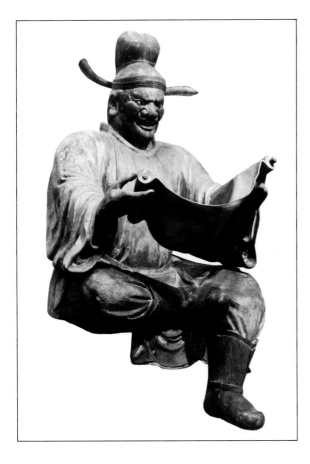

17. Guseijin, attendant to the King of Hell, Hōshaku-ji,
thirteenth century. See cat. no. 26

teeth, and animal fur for hair attest to the realistic quest of the sculptor. Such practices resulted, however, in a degeneration, for the sculpture comes to exhibit less concern with excellence of carving and modeling and more devotion to decorative detail. During the fourteenth century and after, much Buddhist sculpture was created, but its quality is generally not high. Thus, this exhibition, which demonstrates the merit and achievement of Japanese Buddhist sculpture, concludes with works of the Kamakura Period.

Of Kamakura sculpture, the most exciting works come from the Kei school, which flourished early in the period. Of particular interest are the statues made by Kōkei for the Nanen-dō of Kōfuku-ji. Kōkei's set of the Six Patriarchs of the Hossō Sect of Buddhism is dated in 1189 and is important as an early attempt at realistic and individualized figures. The pair of large and dramatic door guardians, or Ni-ō (Dvārapāla), made in 1203 by Unkei and Kaikei for the Great Southern Gate of Tōdai-ji, exhibit the heroic qualities and vigorous spirit of the age. The sculpture produced by Unkei in 1212 for another hall at Kōfuku-ji, the Hokuen-dō, includes a pair of statues representing imaginary portraits of the Indian theologian Muchaku (Asaṅga) and Seshin (Vasubandhu). The sensitively carved faces, the hand gestures, and the clothing create a living presence; these two masterworks represent the finest of Kamakura realistic art.

Excellent works from the Kei school, from the early thirteenth century to the end of the period are extant. Among these are numerous pieces signed by Kaikei, as well as works associated with Unkei's son Tankei (1173–1256). Current scholarship is ample enough to permit the identification of sculptures produced by artists belonging to the In and En schools. In addition to the major artists already named, the selection includes portraits of real and imaginary divinities (cat. nos. 27, 28, 29, 31) and of divinities that signal the appearance of new cults or of popular interpretations of the Buddhist pantheon (cat. nos. 26, 34).

41

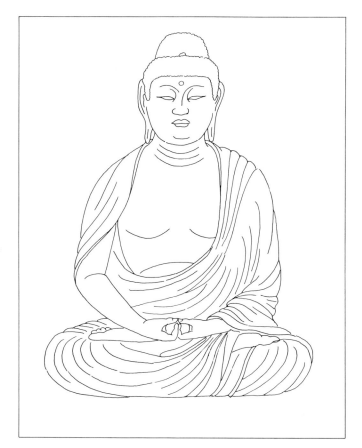

18. Amida
Dhyāni-mudrā (gesture of concentration)

III. BUDDHIST IMAGERY

The Buddhist Pantheon contains countless types of deities depicted in a seemingly endless variation of forms. The rules concerning the form and significance of this statuary are contained in Buddhist scriptures and in specialized works such as *giki*, which list regulations regarding Buddhist doctrine and the form of images, as well as other studies and commentary on iconography. Such material was collected into several separate works, such as the *Jūkkanshō* and *Bessonzakki*, which date to the twelfth century, and the *Kakuzenshō* and *Asabashō*, which belong to the thirteenth century. These texts are now contained in a multi-volume section on iconography (*Zuzō*) that is part of the Tripitaka in Chinese, the *Taishō shinshū daizōkyō*.[1] Even more readily available and easier to understand, however, are modern iconographies now being published in Japanese, such as *Butsuzō zuten* by Sawa Ryūken.[2] Most Buddhist divinities fall into one of the following four categories: Buddhas, Bodhisattvas, fierce divinities, and heavenly beings. A brief introduction to the most representative examples of the images and to their distinguishing forms follows.

Buddhas
Buddhahood (Nyorai), meaning "the enlightened one" or "awakened one," is the highest level of existence within Buddhism and denotes a being who has achieved complete enlightenment. Such Buddha figures wear priestly robes, which usually covers the left shoulder and partially drapes the right shoulder, thus leaving the chest and the right arm exposed (see fig.18). However, this basic formula has many variations, such as having the right shoulder and arm completely exposed, or conversely, having shoulders, arms, and chest completely covered. While all Buddhas appear in

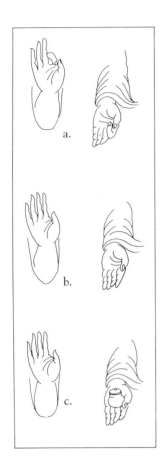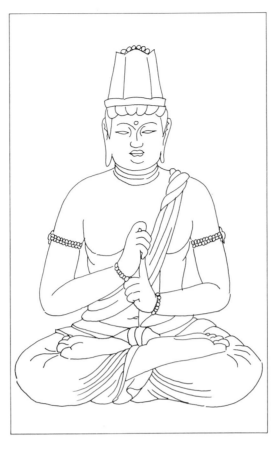

19. Common hand gestures for
major Buddha forms
(FROM TOP)
a. Amida
Raigō-in (gesture of
welcoming to paradise),
a variant of the *Vitarka-
mudrā*
b. Shaka
Right hand: *Abhaya-
mudrā* (do not fear)
Left hand: *Vara-mudrā*
(charity)
c. Yakushi
Right hand: *Abhaya-
mudrā* (do not fear)
Left hand holds medi-
cine jar

20. Dainichi

this characteristic depiction, the hand position sometimes distinguishes the various types of Bud-
dhas (see fig. 19).

Shaka Buddha (Śākyamuni) is the historical founder of the Buddhist faith and lord of the present
world. Born into a princely family in north-central India around 560 B.C. he is believed to have
died around 480. Siddhartha is his given name and refers to his life before he became a Buddha.

Amida (Amitābha) is the Buddha who reigns over the Western Paradise, the heavenly Pure Land
of a previous existence. Personification of eternal life, compassion, and boundless light, Amida
was one of the most fervently worshipped deities in China and Japan.

Yakushi (Baiṣajyaguru), popular as the healing Buddha able to cure all ills and sickness, had devout
worshippers, especially among the earliest Japanese Buddhists who hoped to obtain Yakushi's favor
in this world.

Miroku (Maitreya), the Buddha of the future, was expected in some distant time to appear on
earth and to lead mankind to salvation. In the early history of Indian Buddhism, it was believed
that a disciple of Śākyamuni named Maitreya would rise to the Tuṣita Heaven and remain there as
a Bodhisattva until it was time to return to earth and take up his messianic role.

Dainichi Nyorai, or Roshana (Māhavairocana) is the supreme deity of Esoteric Buddhism and is
the cosmic origin of all things. His appearance and dress is not always the same as other Buddhas
(see fig. 20). Worship of this deity was especially popular in Japan during the seventh and eighth
centuries, when his appearance followed standard forms.

Bodhisattva (Bosatsu in Japanese)
A Bodhisattva is a candidate for Buddhahood who undergoes austerities so as to become a Buddha
in the future. Though the Bodhisattvas possess the wisdom and power necessary to enter *nirvana*,

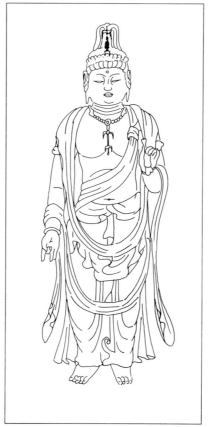

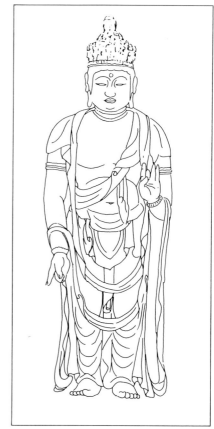

21. Shō-Kannon 22. Eleven-headed Kannon

they voluntarily refrain from so doing to help others find salvation. Most Bodhisattvas embody spiritual principles, such as compassion or wisdom and only Maitreya is related to a historical person.

The form of a Bodhisattva is that of the Indian prince Siddhartha before he left his home in search of the Four Noble Truths. His hair is piled high on his head, and he wears rich jewelry, such as a crown, necklace, and bracelets. The lower half of the body is clothed in a skirt; the upper torso is either bare or adorned with a scarf-like garment of thin silk worn diagonally across the torso or draped around the shoulders.

Kannon (Avalokiteśvara), the most widely worshipped Bodhisattva in Japan, embodies divine compassion and limitless powers. Though Kannon is believed capable of assuming any form to carry out his mission of assistance and salvation, he is customarily said to have thirty-three major guises. In the history of Japanese art, he appears most frequently as Shō-Kannon (Ārya Avalokiteśvara) (see fig. 21), as an Eleven-headed Kannon with small Buddha heads appearing on the top of the main head like a crown (see fig. 22) or as a multi-armed form called the Thousand-armed Kannon. The extra heads and arms symbolize the manifold powers of the deity.

Another Bodhisattva popular with the masses for his compassion, Jizō (Kṣitigarbha) is a guardian, particularly of children, travellers, and pregnant women, and he also intervenes to save those suffering in hell. Unlike other Bodhisattvas, he is generally dressed like a priest, and he carries a staff in the right hand (see fig. 23).

Kannon, Jizō, and Miroku, mentioned above, are the three Bodhisattvas who are worshipped as independent deities. Bodhisattvas can also appear as flanking a Buddha in a triad formation. In this case, the identities of the Bodhisattva attendants are always fixed. Kannon and Seishi (Mahāsthāmaprāpta), the latter a deity of wide-ranging wisdom, appear with Amida. Shaka is

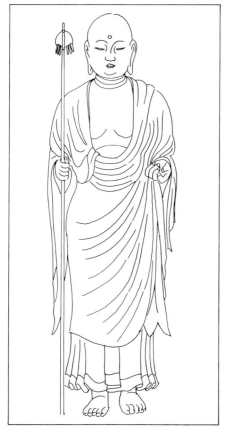

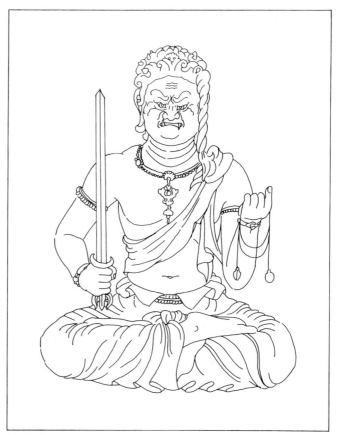

23. Jizō 24. Fudō Myōō

always accompanied by Monju (Mañjuśri), the Bodhisattva of wisdom and guardian of the sacred doctrines, and by Fugen (Samantabhadra), who embodies goodness. In visual representation, Fugen is shown seated on an elephant, and Monju rides a lion. The healing Buddha Yakushi is always flanked by Nikkō (Sūryaprabha) and Gakkō (Candraprabha), the Bodhisattva of the sun and of the moon, respectively.

Myōō (Vidyārāja)
The Myōō, a class of fierce divinities prominent in Esoteric Buddhism, manifest the Buddha Dainichi's wrath against evil. Introduced to Japan during the Heian Period, the Myōō commonly appear in sets of five, but Fudō Myōō (fig. 24), who is always at the center of the group, is the most familiar of the five.

Heavenly Beings
The Heavenly Beings (*tenbu* in Japanese) are divinities from other Indian religions who enter Buddhism and become protectors of the Buddhist world. Typical of the Heavenly Beings is the group of Four Guardian Kings (Lokapāla) placed at the four corners of a Buddhist altar. Dressed in armor and carrying military weapons, they protect the four quarters of the Universe (see fig. 25). Jikokuten (Dhṛtarāṣṭra) is the Guardian of the East; Zōchōten (Virūḍhaka), the South; Komokuten (Virūpākṣa), the West, and Tamonten (Vaiśravaṇa), the North. Tamonten, also called Bishamonten, is worshipped as an independent deity and thus is sometimes separated from the group.

In addition, many other individual deities, worshipped separately or as part of other groups, commonly appear in sculptural representation. From the eighth century, Kichijōten (Śrī Lakṣmī), goddess of wealth, beauty, and good fortune (see fig. 26) was popular as was Benzaiten (Sarasvatī),

25. One of the Four Guardians 26. Kichijōten

goddess of music and learning. Both these deities are important Hindu goddesses absorbed into Buddhism, as were Bonten (Brahmā) and Taishakuten (Indra). Brahmā, the lord of creation, is one of the supreme figures in the Hindu pantheon. With Indra as his attendant, Bonten appears in Japanese temples and thus indicated the superiority of Japanese Buddhism over the ancient Indian expression of the faith.

Among the groups of deities notably represented in the early history of Japanese Buddhism are the Ten Disciples and Eight Classes of Beings, who were part of the audience for Shaka's preaching. From the Kamakura Period, new iconography is introduced, and larger groups appear, such as the Twenty-eight Bushū, who attend the Thousand-armed Kannon; the attendants to the Ten Kings of Hell; and the attendants to Bishamonten. Such groups demonstrate the variety and depth of the Mahāyana pantheon.

Also, among Buddhist images, some are male in form, and others are female. As a rule, however, there is no sexual differentiation among Buddhist deities.

Notes:

1. Takakusa Junjirō and Watanabe Kaigyoku, eds., *Taishō shinshū daizōkyō zuzō*, (The *Tripitaka* in Chinese, Picture Section), 12 vols., Tokyo, 1932–34. The *Jūkkanshō* is in vol. 3; the *Bessonzakki* is in vol. 3; the *Kakuzenshō* is in vol. 4; and the *Asabashō* is in vol. 9.

2. Sawa Ryūken, "*Butsuzō zuten*" (*Illustrated Dictionary of Buddhist Images*), Tokyo, 1963.

IV. MAKING OF BUDDHIST SCULPTURE

In the history of world art, Japanese sculpture is a most valuable repository of media and techniques for religious icons. When the 2390 works of sculpture designated as National Treasures or Important Cultural Properties are classified by media, the following figures are obtained:

wood	2115
bronze and other metals	181
dry lacquer	48
clay	20
stone	20
other	6

In Japanese sculpture, works in wood predominate. However, because many of the techniques represented are rare, it is worthwhile to review the processes for making traditional Japanese sculpture.

Bronze

All the bronze sculptures produced from the sixth to the twelfth centuries were cast by the lost-wax method which involves the following steps:

a. A model of the image is made of clay as a core.

b. Over this core a layer of beeswax is poured, on which the surface features of the image are modeled.

c. After the wax hardens, another layer of clay is added to make an outer shell, and holes are created between the outer and interior clay layers.

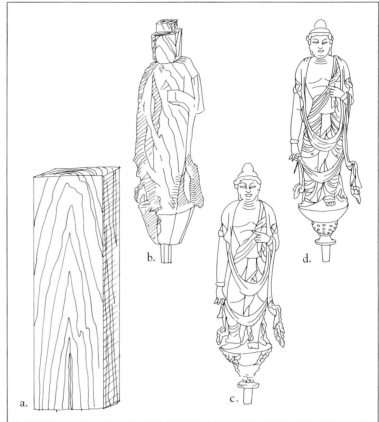

27. a. Wood-cutting (kidori)
A block of wood of an appropriate size to make the sculpture is cut from the tree and prepared.

b. Rough cut (arabori)
The general form of the image is shaped with an ax or round chisel.

c. Fine cut (kozukuri)
The sculpture is given a definite shape and the surface is made smooth.

d. Finishing (shiage)
Fine details are cut and refined.

d. The entire mold is then fired. As the wax melts and runs out, a space is created between the inner core and the outer shell. Pins inserted through the mold hold the separate pieces in place.

e. Melted bronze is poured into the mold between the core and shell.

f. After the mold cools, the outer shell is broken off, the image is freed, and the interior core is dug out.

g. The surface is then finished with a chisel, and details such as the eyes, mouth, jewelry, and drapery patterns are cut or trimmed into shape. The sculpture is often gilded with an amalgam of gold and mercury applied to the surface before the piece is fired.

The Japanese used this lost-wax technique in Japan until the twelfth century at which time the technique changed.

In the twelfth century and after, the lost-wax method used was the following, which is the standard technique for casting bronze statues today: First a model is made of clay or wood, which is covered with clay to make the outer mold. The outer mold is cut into front and rear halves and removed from the core. When the two halves are joined, an inner core is fixed in the center, and the piece can be cast.

Dry Lacquer
In the dry lacquer technique, the sculptor first makes a general form of the sculpture in clay. Over this form, three or more layers of hemp cloth soaked in lacquer are applied. After these layers of lacquered cloth dry, the resulting lacquer shell is cut open, and the interior clay is removed. Then a separate wood frame is built and inserted into the hollow interior. The surface of the piece is finished with a paste (called *kokuso urushi* in Japanese), made of lacquer mixed with incense

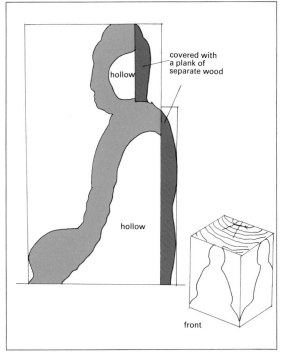

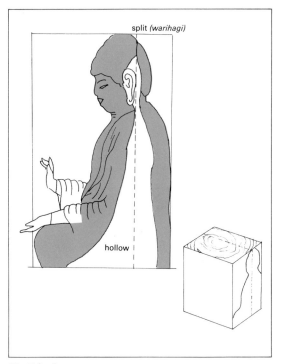

28. Miroku
 892 A.D.
 H. 91.0 cm
 Jison-in, Wakayama

29. Yakushi
 Second half of the ninth century
 H. 141.8 cm
 Shōjō-ji, Fukushima Prefecture

powder, earth, kaolin (porcelain clay), or sawdust. The features of the face and other fine details are modeled with this layer of paste.[1]

The many steps in this procedure make the dry-lacquer technique cumbersome. By the second half of the eighth century, a new technique called wood-core dry lacquer developed. The general shape of the image was first made of wood; then the surface was covered with the lacquer paste and was modeled as in the older process.

This latter method was simpler, but whichever method was used, the artist's chief advantage in dry lacquer statuary was the pliability of the lacquer paste, which permitted a sensitive modeling of the surface and an ease in achieving a symmetrical, balanced form. However, lacquering is a costly and time-consuming art. Raw lacquer is obtained from the sap of a tree (*Rhus vernicifera*), which is kin to the poison ivy plant. The sap is prepared for use by evaporation and filtration. Raw lacquer is toxic, and its handling requires great care. Moreover, for best results, lacquer is applied in layers, each of which hardens before the next is applied. Because months of intermittent labor were required to make a lacquer sculpture, only the large temples in the capital could afford these statues. Thus, although widely used in the mid-eighth century, the technique died out soon thereafter.

Clay

The production of clay sculpture first requires a wood core, which is then covered with a layer of coarse clay mixed with straw. Then a second layer of finer clay is added, and finally a third layer of very fine clay mixed with fibers of hand made paper complete the sculpture.

Like dry lacquer, the soft clay provides an excellent surface for free and delicate modeling. However, clay statuary is heavy, and because such statues are not fired, these works lack durability and are easily broken. Clay sculpture was made principally in the eighth century, but the technique

covered with
a plank of
separate wood

hollow

hollow

30. Yakushi
907 A.D.
H. 176.5 cm
Daigo-ji, Kyoto

died out thereafter. Clay was used again in the thirteenth century, particularly for Zen portrait sculpture, but these works represent a new technique imported from Sung China and using methods different from those of the eighth-century sculptors.[2] The later sculptures were made of two layers of clay, and before being painted, were finished with a lacquer coating.

Wood

In Japan, a variety of wood suitable for sculpture existed in abundance. Japanese cypress (*hinoki*) was the most commonly used, but sculptures were also made of Japanese nutmeg (*kaya*), the needle leaf tree, *katsura* tree, zelkova (*keyaki*), camphor (*kusu*), cherry (*sakura*), and the broadleaf tree. Even during the seventh and eighth centuries when bronze, dry lacquer, and clay were the principal media for sculpture, wood was also used, and after the eighth century, it became the principal material. The Japanese steadily developed new techniques for woodworking. Varied methods for preparing wood, new types of joinery and glue, and particularly, the development of the assembly or joined-block technique contributed to the appearance of the sculpture and allowed the development of new styles.

Single-block construction (*ichiboku zukuri*)

Single-block construction refers to the method of carving an entire sculpture from a single block of wood. This carving technique has been used throughout the world; for example, the major part of wood statues of ancient Egypt and of Medieval European churches are carved from a single block of wood. In Japan, virtually all of the wood sculptures of the ninth century, and many from the tenth century, were made by this method. In this exhibition, two sculptures are carved entirely, including the hands and scarves, from a single block: the Eleven-headed Kannon from the Nara National Museum (cat. no. 12), and the Yuima (Vimalakīrti) from Ishiyama-dera (cat. no. 13). Sculptures largely carved from a single block but with separate pieces for the hands that project from the body and for parts of the legs on seated images are also common.

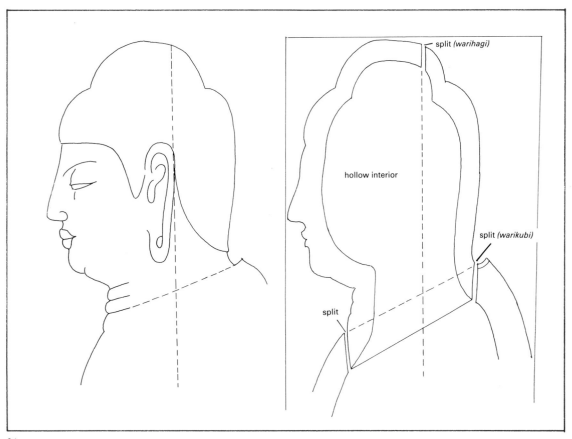

31.

The process of making a single-block sculpture is shown in the four stages of fig. 27. First, the size of the image is determined, and the wood block cut and prepared. (This stage is called *kidori* in Japanese.) The rough form is shaped with an ax or hatchet; then the initial modeling of the form is achieved with curved and flat chisels that give a rhythmical undulation to the surface, a stage called "rough-carved" (*arabori* in Japanese). Catalogue nos. 21 and 22, called *natabori* sculptures, exemplify this "rough-carved" stage. Finally, the surface is whittled or pared to produce the proper shape and finish the fine details.

Sculptures could then be painted or were left bare.[3] In the ninth and tenth centuries, wood statuary was often finished with lacquer in a manner resembling the woodcore dry lacquer techniques of the previous Nara Period. A paste called *sabi urushi*, which consisted of lacquer juice mixed with a ground stone powder, was applied to the sculpture as a ground coating, and then details were modeled with regular lacquer paste. Among single-block sculptures of the ninth century, many strong works reveal the feeling of tension and concentration of the artist as he cut each stroke. These sculptures often suggest massive power because of their bulk, exaggerated features, or asymmetry.

Interior carving (*uchiguri*)

Though a very convenient material for the production of sculpture, wood dries slowly from the outside. The application of dry lacquer to the surface of a solid block caused cracks to appear, a common feature of pieces made in the woodcore, dry lacquer technique. To prevent these cracks, Japanese sculptors began to cut hollow spaces into the back of the piece, a procedure that is called "interior carving" (*uchiguri* in Japanese). When large hollow spaces are cut into the interior of a solid wood sculpture from the back or from the bottom (as shown in figs. 28 and 29), the wood will shrink after the lacquer is applied without splitting the outer surface. The hole cut into the body of the sculpture is covered with a separate piece of wood. This technique is useful not only to prevent

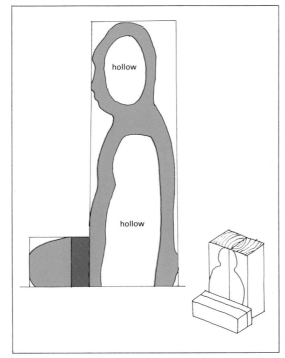

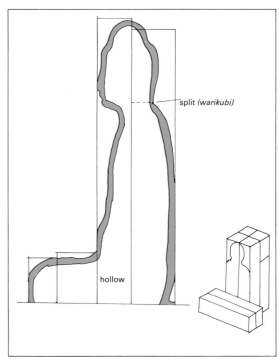

32. Yakushi
 Late tenth century
 H. 163.7 cm
 Rokuharamitsu-ji, Kyoto

33. Amida
 1053 A.D.
 H. 283.9 cm
 Byōdō-in, Kyoto Prefecture

cracks, but also to lighten the weight of the sculpture and to hasten the hardening of the dry-lacquer layer. The *uchiguri* technique, used as early as the eighth century, is evident at the back of the head of the Buddha from Tōshōdai-ji (cat. no. 7).

Split and join (*warihagi*)

In this technique a hollow is produced in a single-block sculpture by splitting the piece along the vertical wood grain to produce halves. These two sections, the right and left halves or the front and back, are then liberally hollowed out and rejoined. This method is both simpler than the interior carving method, which creates a window in the back of the piece, and also permits the size of the hollow to be larger. The Yakushi Buddha from Shōjō-ji (fig. 29), an excellent example of this method, indicates that this split-and-join technique was already in use in the second half of the ninth century. Among the sculptures in this exhibition, the Bodhisattva on Clouds from the Byōdō-in (cat. no. 20) are made by the split-and-join technique. In spite of the fact that these pieces look like small reliefs, they are still hollow.

A widely used refinement of the split-and-join technique is "split neck" method (*warikubi*). As shown in figure 31, a split is made laterally behind the ears, and the piece hollowed out. By cutting the neck around the base with a chisel the sculptor separates the neck from the torso. When this section is hollowed out, the pieces are refitted and joined. This particular step is used even among pieces constructed in the more advanced "joined block" method.

Hollow joined block (*yosegi zukuri*)

In the joined block method, the main part of the figure, including the head and the body, is constructed from more than two pieces of wood. This technique, perfected by the mid-eleventh century, was especially suited for images over two meters in height. The joined-block method allows the form of an image to be composed of several blocks. Each block is prepared individually, hollowed out, and then assembled to form a full sculpture; the method permits the making of a

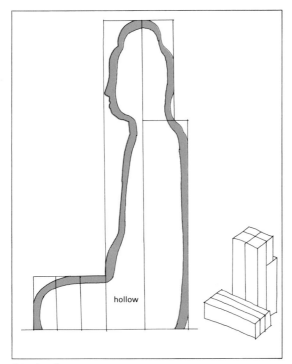

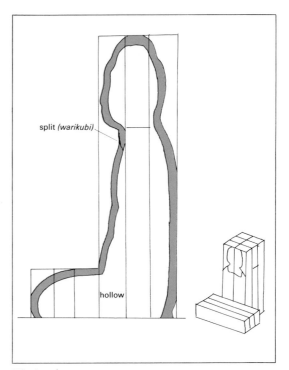

34. Amida
 Ca. 1130 A.D.
 H. 224.0 cm
 Hōkongō-in, Kyoto Prefecture

35. Amida
 Late eleventh–Early twelfth century
 H. 280.0 cm
 Hōkai-ji, Kyoto

large statue from small pieces of wood. Figure 32 shows a tenth century example of the joined-block technique. Figures 33-35 illustrate typical examples of the method used in extant sculptures in its developed form and the number of blocks employed. These diagrams show the extensive hollow and the thin shell that is the body of the sculpture.

Hollow joined-block construction, an especially logical and economic technique, never developed in Europe, and no Chinese examples involving so many small pieces of wood are known. The making of the so-called jo-roku (sixteen foot) Buddha figure by joined-block technique required only a third the wood that single-block construction would have required. In fact, a single block of wood of the necessary size is almost impossible to find. Statuary of the joined-block technique had to be planned and the materials prepared from the start. The technique was appropriate for the large sculptural commissions of the Late Heian Period because the production process could be divided into separate, specialized steps, allowing an assembly-line efficiency. However, the convenience of this procedure also led to standardized expressions in the sculptures; countless works from the period have the same gentle expressions and well-composed, stable posture, but they lack individualized characteristics. The hollow joined-block construction, which developed at major workshops in the capital, was used in workshops in the provinces in the eleventh and twelfth centuries. For small works, regardless of their origin, the single block or split-and-join technique prevailed.

In this exhibition, a number of the pieces from the Kamakura Period (cat. nos. 23–36) are examples of the hollow joined-block technique. However, Kamakura sculpture, in contrast to Heian works, depicts the contorsions of the body, the strong sense of movement, and large, deep, free-flowing drapery patterns. Also, because the walls of the sculpture are thick to allow deep-cut patterns in the surface, the hollow spaces in Kamakura statuary are less extensive than in Heian works. Thus, the technique of joined block statuary directly effected both style and the surface treatment of the work.

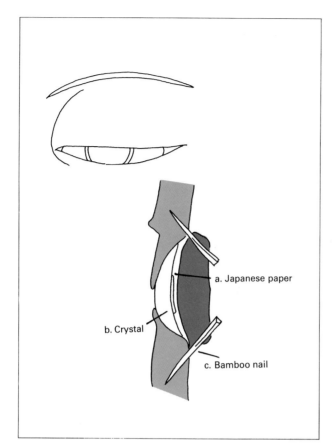

36. Crystal Eye Technique

a. Japanese paper

b. Crystal

c. Bamboo nail

The hollow joined-block technique and the practice of inserting crystal eyes are both original in Japanese sculpture. The practice of inserting a different material into eyes of sculptures was common in several cultures. For example, Greek statues had enamel eyes or eyes made of metal, Egyptian sculpture used colored stones and some Chinese examples use a black stone or a kind of pitch just for the pupil of the eye. But only the Japanese made eyes of transparent lens-shaped crystal, with a pupil painted in black on the underside. The crystal was inserted inside the head (see fig. 36). To make the eye appear white, a bit of handmade paper was placed between the crystal and the surface of the wood. This technique reflects the logical quality of Japanese scuptural techniques and exemplifies the independent development characteristic of Japanese art.

Notes:

1. For a detailed account of the dry lacquer technique, see Sherwood F. Moran, "Ashura, a Dry Lacquer Sculpture of the Nara Period," *Artibus Asiae*, vol. 27, (1966), pp. 91-133.

2. A discussion of the thirteenth century clay technique can be found in Nishikawa Kyōtarō, *Chinzō chōkoku, (Zen Portrait Sculpture)*, Nihon no Bijutsu, no. 133, Tokyo, 1976.

3. The surface treatment of Buddhist sculpture of the period in polychrome and surface coating is considered in detail in the following publications: Nishikawa Kyōtarō and Emoto Yoshimichi, "Colouring Technique and Repair Methods for Wooden Cultural Properties," *Proceeding of International Symposium on the Conservation and Restoration of Cultural Property – Conservation of Wood*, Tokyo National Research Institute of Cultural Properties, Tokyo, 1978, pp. 785–793; Nishikawa Kyōtarō, "Chōzō no saishikihō ni tsuite" ("Polychromed Technique of Japanese Sculpture") *Bukkyō Geijutsu* No. 86, Tokyo, 1972, pp. 24–35.

CATALOGUE

1. Kannon

Asuka Period, first half of the seventh century
Gilt bronze
H. 26¾ in (67.7 cm)
Hōryū-ji, Nara
Important Cultural Property

This statue of Kannon, the Bodhisattva of mercy, is an outstanding example of the archaic Tori style. The Bodhisattva stands on an inverted lotus pedestal in a firmly frontal pose. The hands hold a wish-granting jewel (*cintāmani* in Sanskrit) in front of the chest. The head, hands, and feet of this image are large in proportion to the torso. The face is square, with almond-shaped eyes, triangular nose, and lips that form a slight smile. The skirt falls in flat folds against the legs, and the scarves hanging on the forearms flare out to the sides in an exaggerated "fish tail" pattern. The three peaked crown incised with a design of birds, wings, a sun, and a crescent moon adds a handsome decorative touch and a shape that echoes the inverted petals of the god's dais. A prong at the back of the head indicates that a halo originally made for the piece is now lost.

Among gilt bronze statuettes of the same period this example is rather large. The entire figure, including the pedestal, was cast at one time using the lost-wax method. A small hole in the head suggests that the molten bronze was poured into the mold at that point. Since the walls of the sculpture are thin but of uniform measurement, the pour was very successful. Visible at the back of the hips are pins that were inserted through the mold to hold the interior core in place during casting.

The stylistic features of this statuette bear close resemblance to the Bodhisattva attendants that flank the Shaka Buddha in the Golden Hall of the Hōryū-ji. That triad, dated 623, is the master Tori's finest work. Although the drapery is thinner on the two Bodhisattvas, the enclosed back of this Kannon represents a technical advancement in the casting of bronze images and suggests a slightly later date.

REFERENCES:
Mizuno Seiichi, "Asuka Hakuhō butsu no keifu" ("A Lineage for Asuka and Hakuhō Period Buddhas"), *Bukkyō Geijutsu*, 4, 1949. Mizuno Keizaburō, "Bosatsu ryūzō" ("Standing Bodhisattva Images"), *Nara Rokudaiji Taikan (Survey of the Six Great Temples of Nara)* vol. 2, Hōryū-ji 2, Tokyo, 1968.

*EXHIBITIONS:
Los Angeles County Museum of Art, September 29–November 7, 1965; Detroit Art Institute, December 5, 1965–January 16, 1966; Philadelphia Museum of Art, February 13–March 27, 1966; Toronto, The Royal Ontario Museum, April 24–June 5, 1966, *Art Treasures from Japan*. Leningrad, Hermitage Museum, May 13–June 22, 1969; Moscow, Pushkin Museum, July 15–August 24, 1969, *Japanese Sculpture*. New York, Japan House Gallery, *Hōryū-ji: Temple of the Exalted Law*, September 18–October 25, 1981.

*References in this catalogue refer only to those exhibitions held abroad.

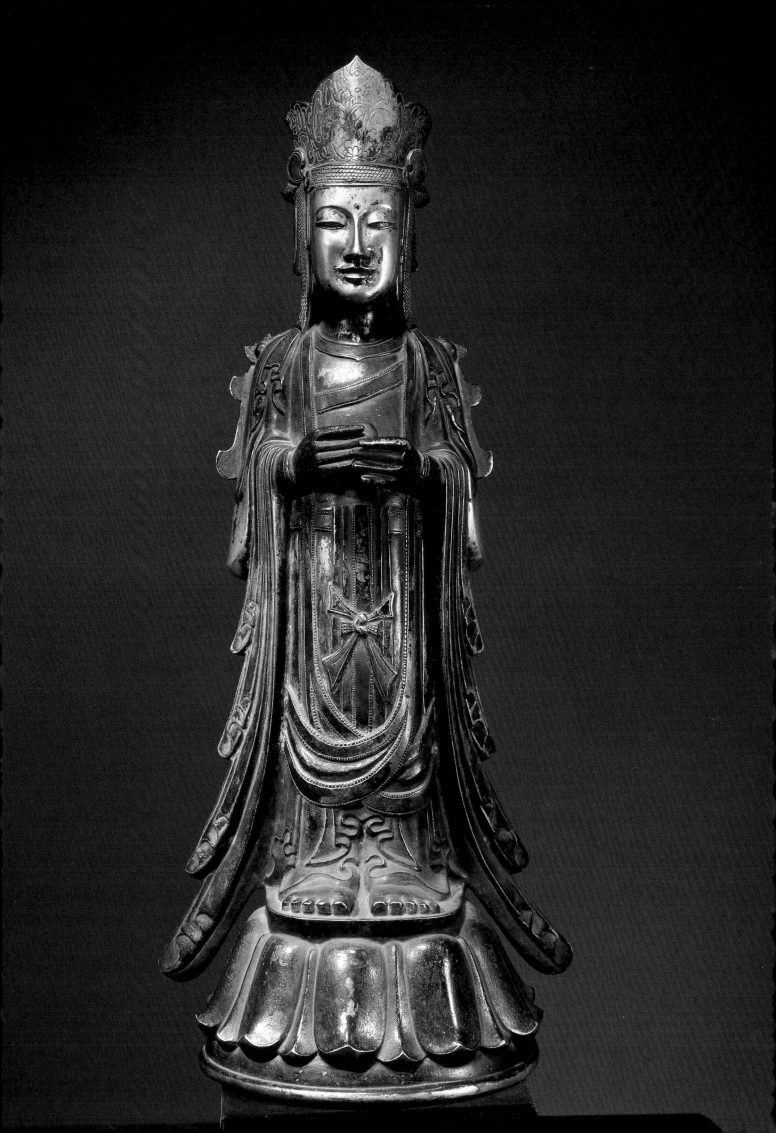

2. Bodhisattva in Meditation

Nara Period, seventh century
Gilt bronze
H. 12¼ in (31.2 cm)
Tokyo National Museum

This small gilt bronze is believed to have been made as an image of Miroku Bosatsu, the Bodhisattva of the future. The meditative pose (*hanka shi-i* in Japanese)—with the right hand touching the cheek, the left leg pendant, and the right foot placed on the left knee—was a popular one in Chinese Northern Wei sculpture for representation of Bodhisattvas and of Prince Siddhartha before his enlightenment.

A number of fine sculptures in Korea further attest to the popularity of the pose on the continent when it was transmitted to Japan, where several important example of sculptures using this pose were made during the Asuka and Nara Periods. The most famous of these, a Bodhisattva in wood is at the Chūgū-ji nunnery at Hōryū-ji. The hair pulled into a topknot of two round bundles, an oval face with a serene expression, and the taut, firmly modeled flesh all suggest that the Chūgū-ji statue could have been a model for the present work. The treatment of the body of this small bronze is more schematic than in the Chūgū-ji work, but compared to one highly attenuated example made in the Asuka Period, this figure represents an advancement of the style. The pleasant roundness of the flesh, the balance of physical form, and the simplified skirt all reveal an independent expression that suggests a date in the mid-seventh century.

The history of this sculpture is distinguished for having been discovered in a sutra mound. During the Late Heian Period, people believed that the apocalyptic "latter days of the law" (*mappō*) were at hand. During this period of lawlessness, faith in the saving power of Miroku, the Buddha to be, became widespread. In order to gain merit and prepare for Miroku's reappearance on earth, scriptures and images were buried in mounds. This statuette was discovered in a sutra mound at Nachi in Wakayama Prefecture, the site of an important Shinto shrine and an area where religious devotion flourished from ancient times.

EXHIBITIONS:
Montreal, Expo Art Gallery, *International Exhibition of Fine Arts*, April 28–October 27, 1967. Zürich, Kunsthaus, *Kunstschätze aus Japan*, August 30–October 19, 1969; Cologne, Museum für Ostasiatische Kunst, *Kunstschätze und Tempelschätze aus Japan*, November 15, 1969–January 11, 1970.

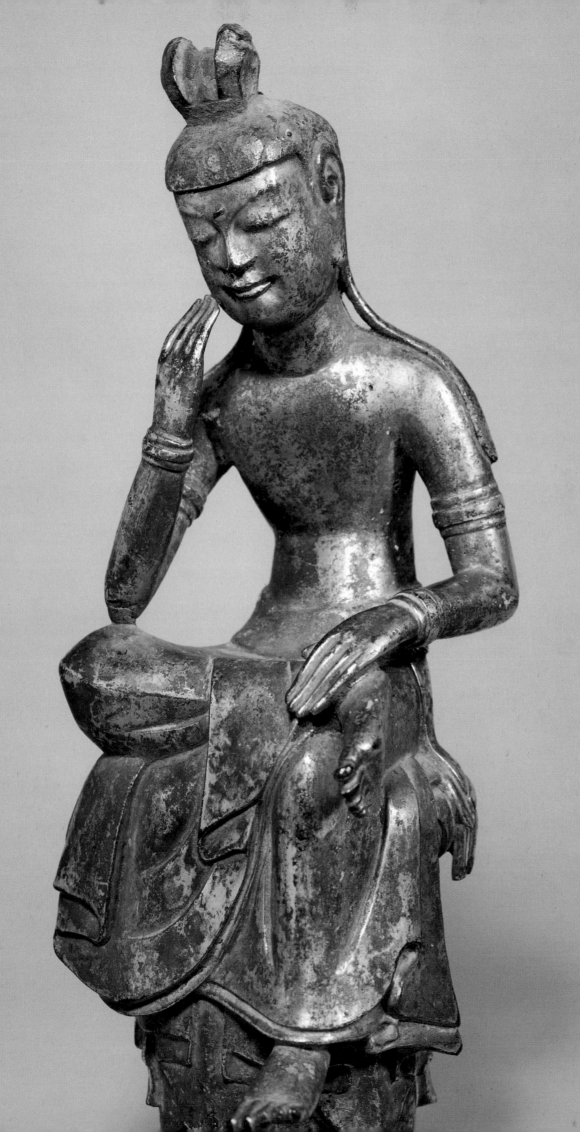

3. Shaka at Birth

Nara Period, 752 A.D.

Gilt bronze

H. of Shaka image 18½ in (47.0 cm)

Diameter of bowl 35¼ in (89.4 cm)

Tōdai-ji, Nara

National Treasure

The birthday of Shaka, the historical Buddha, is celebrated every year on April 8. This ceremony, which was also celebrated in China, has been observed in Japan since the early seventh century. Numerous examples of Shaka statues made for this purpose are known from the eighth century.

As described in the scriptures, the Prince Siddhartha was born on the eighth day of the fourth month while his mother, Māyā, was walking in the gardens of her home. When she stopped to pick flowers from a tree, the future Buddha emerged from her right side. Immediately he took seven steps, and raising his right hand, pronounced himself lord over all that was above and below heaven.

Sculptures representing the Queen Māyā with a small child emerging from her side or sleeve are also known, but the images of a half-nude child, one arm pointing up, are the more common. Two types of ceremony for employing the child Shaka are known. One, like the example here, uses a large bowl which contains a fragrant, colored water to pour over the figure. It is now common in Japan to use sweet tea as the pouring liquid, a practice that dates to the late nineteenth century. In the second type of ceremony, the statue is wiped repeatedly with a piece of white silk.

The Tōdai-ji Shaka exhibits the half-nude child-like form that is typical for this kind of statue. The face of the figure is round and full, and the body is plump, marked with deep ridges on the torso and arms to emphasize the fleshiness of the body. Although the smiling face has an innocent, child-like character, the head covered with snail-shell curls, the long ears, and treatment of the body are all characteristic of the naturalistic T'ang style that was the primary inspiration for sculpture during the Nara Period. The same cheerful, open expression displayed by this sculpture is also evident on another magnificent bronze object, the large octagonal lantern that stands at the front of the great Tōdai-ji. The sides of this lantern, which are cast as openwork relief, are decorated with plump, music-making Bodhisattvas that are very close in style to the Shaka at Birth. Although, like the bronze lantern, the statuette is not inscribed, it is believed to date to the eye-opening ceremony of the Great Roshana Buddha in 752. Also, among statues of the birthday Buddha, this example and the accompanying bowl are conspicuous for their large size, which suggests their most appropriate use in a large temple on the scale of the Tōdai-ji.

The bowl in which the statue of the Buddha stands is engraved on the outer sides with a lively pattern of real and imaginary birds and animals, floral patterns, and human beings. Certain motifs, such as hermits riding on the backs of birds, barbarians astride Chinese lions, and hunters chasing tigers can be found on several other works of metal in the Shōsō-in collection, but the treatment of the images is different. Instead of distinguishing between primary motifs against a ground filled with secondary floral motifs, the designs on the Tōdai-ji bowl are equal in size and are mixed in a random fashion. Many of the motifs are purely secular and have no Buddhist connotations. Nevertheless, this work demonstrates the Japanese absorption of ancient Chinese patterns and the free-spirited decorative taste in the crafts of the time.

Both the statue of the youthful Shaka and the bowl were produced by a single cast using the lost-wax method of bronze casting, and both were gilded. The right hand of the Buddha and the wood dais on which he stands are replacements.

REFERENCES:
Inoue Tadashi, "Tanjō Shakabutsu ryūzō oyobi kambutsuban" ("Shaka Buddha at Birth and Libation Basin"), *Nara Rokudaiji Taikan (Survey of the Six Great Temples of Nara)* vol. 10, Tōdai-ji 2, Tokyo, 1968, pp. 57–58.

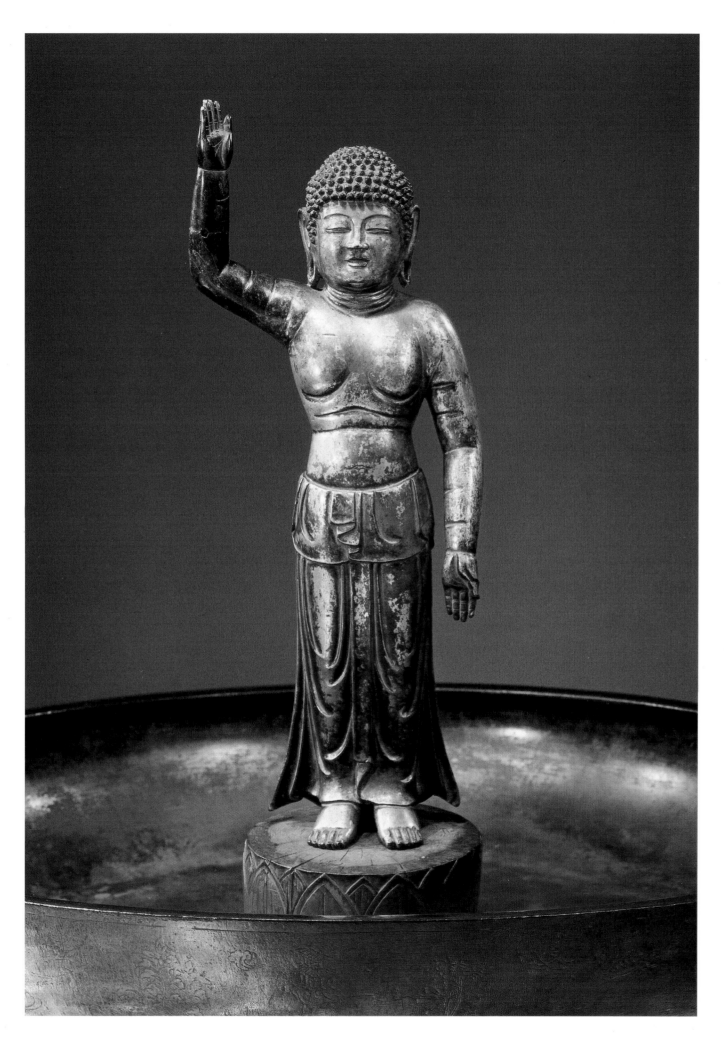

4. Yakushi

Nara Period, eighth century
Bronze
H. 20 in (38.8 cm)
Nara National Museum
Important Cultural Property

Although this statue is called a Buddha of healing, the identification cannot be confirmed. The medicine bottle in the left hand and the wooden tip of the right are restorations. The figure was cast using the lost-wax method. The surface of the sculpture is rough because of damage from a fire, and whether the statue was originally gilded is unclear. With the exception of the right hand, this image, including the skirt that covers the pedestal, was produced in a single pour of molten bronze. The casting of this piece is very fine; the bronze layer is of a uniform thickness that demonstrates a superior casting technique.

This small statue exhibits clearly the stylistic features of Nara sculpture. The face with full round cheeks, the narrow, clearly defined eyes and nose, and the fleshy appearance of the body are all features of the mature T'ang style that dominated sculpture of the Nara Period. Both the decorative cascade of fabric over the petals of the lotus pedestal as well as the treatment of the hair as a smooth surface without curls are also typical to gilt bronze images of this period.

This is an exceptional work with features of great visual interest. The drapery folds are strong and complex. The feeling of tension in the cheeks and the sweet expression created by the dimples at the corners of the mouth are remarkably naturalistic. Judging from these features, this bronze appears to be a work of the late eighth century. Unquestionably, it is a superior piece made at a time when the production of small bronzes was very limited.

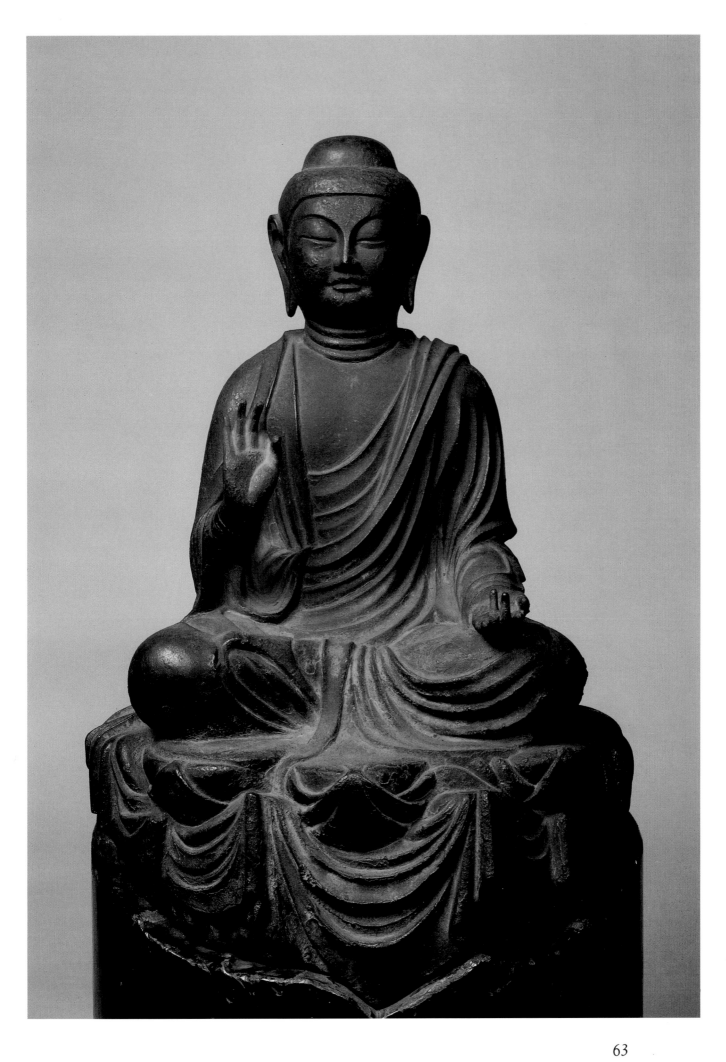

5. Yakushi

Nara Period, eighth century
Gilt bronze
H. 14 in (35.7 cm)
Hōryū-ji, Nara
Important Cultural Property

According to temple tradition, this small gilt bronze Buddha was found inside a larger dry lacquer Yakushi image that was the main icon of the Saien-dō, a sub-temple at Hōryū-ji. No records have been found, however, to confirm this story. The Buddha is seated on a tall, octagonally shaped lotus pedestal, the edge of his robe decoratively draped over the rim. Although the image is called a Yakushi Nyorai, the original identity of the deity is not clear. Resting on the knee, the left hand is turned with the palm upward, as though it were to hold a medicine bottle, but no traces of the bottle exist.

The mandorla was made separately, but the main image and pedestal were cast by the lost-wax method as a single piece and were then gilded. The cast was excellent, and the sculpture, including the original gilding, maintains its original appearance.

The head of this Yakushi is large in comparison to the body. The hair and *uṣṇīṣa* (protuberance on top of the head) in particular seem disproportionately thick and heavy. It is speculated that the rough surface of the hair may indicate a stage in the preparation of the piece before snail-shell curls were inserted. The child-like features of the face, the wide arched eyebrows that extend across the face, the short nose and small mouth are characteristic of the Early Nara or Hakuhō sculptural styles. On the whole, the body of the Buddha is also presented very simply. However, other details of the piece make a date in the late seventh century unlikely. Because of the busy, somewhat complex pattern of drapery folds and because of the curved shape of the eyes, the date of this statue is placed at the turn of the eighth century, between Hakuhō (673–80) and Tempyō (729–48).

The mandorla that is attached to the pedestal is somewhat large in proportion to the rest of the statue, and some experts feel that the patterns decorating the surface are not harmonious with the sculpture. The flame shape of the mandorla and the specific decorative patterns on its surface—lotus, scrolling vine, and flame—belong to the vocabulary of seventh-century works. Thus it is believed that the mandorla is of an earlier date than the Yakushi and was originally made for another image.

REFERENCES:
Hasegawa Makoto, "Yakushi Nyorai zazō, den Mine Yakushi tainai butsu" ("A Yakushi Buddha Image Originally Installed Inside the Mine no-Yakushi Statue"), *Nara Rokudaiji Taikan (Survey of the Six Great Temples of Nara)* vol. 2, Horyu-ji 2, Tokyo, 1968, pp. 67–68. Matsubara Jirō and Tanabe Saburōsuke, *Shō kondō butsu (Small Gilt Bronze Buddhas)*, Tokyo, 1979.

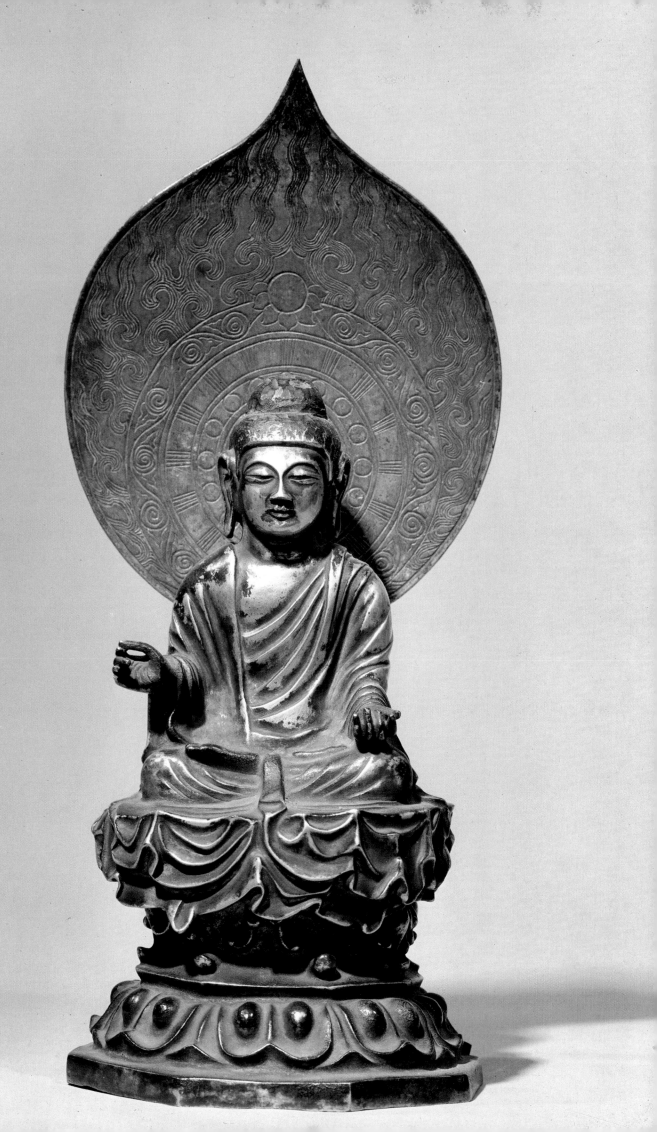

6. Komokuten and Tamonten

Nara Period, eighth century
Wood, single block construction
H. Komokuten, 53¼ in (135.0 cm); Tamonten, 56 in (142.0 cm)
Daian-ji, Nara
Important Cultural Property

The Four Guardian Kings are ancient Indian gods of the cardinal points of the compass. Their role evolved out of the position of ministers to a king, and in ancient Indian Buddhism they were devotees and protectors of Śākyamuni. During the passage of Buddhism through Central Asia to China, the Four Guardians took on military dress and attributes, and their role as mighty protectors of the law became pronounced.

The set of Four Guardians at Daian-ji is an important early example of these sculptures. Komokuten is the ruler of the West; Tamonten, an alternate name for Bishamonten, rules the North. From the head down to the rock dais underneath the feet, the statue of each Guardian is carved completely from a single block of wood. These sculptures have suffered damage. On each figure, the hands are replacements, and additional sections of repair are extensive. On the sculpture of Komokuten, decorative motifs carved on the front of the head and the chest have worn away, and the skirt and the right side of the face have been repaired. The statue of Tamonten also shows repair on the skirt and on the dais. However, the decorative patterns carved onto the piece, such as the chrysanthemum patterns on the helmet, the *karakusa* (Chinese grass), and *hosoge* floral patterns on the armor, remain in comparatively good condition.

Komokuten stands with his mouth open in a shout, his right arm raised in front of the chest, and his left foot lifted. Tamonten scowls, his upper teeth biting into his lower lip in a gesture of fierce anger. He raises his right arm and stomps the dais with his right foot. In spite of the exaggerated anger in the faces and movement implied in the poses of their massive, stout bodies, the Guardians suggest a relaxed and quiet mood.

Scholars who have examined the Daian-ji set of Four Guardians have questioned the production of the four figures as a group of the same date. However, the eighth-century dating for the Komokuten and Tamonten is based on a comparison between these figures with a pair of late eighth-century Guardians in the Lecture Hall of Tōshōdai-ji. The fine, careful carving of the decorative patterns of both Guardians show marked similarities. It has been suggested that these sculptures at Daian-ji may reflect the influence of Chinese T'ang Dynasty sculpture that was introduced in Japan in the late eighth century. Yet the balance and the modeling of the figures suggest the tradition of the Late Nara Period.

REFERENCES:
Kobayashi Takeshi, "Daian-ji no mokuchōgun ni tsuite" ("Concerning the Group of Wood Sculptures at Daian-ji"), *Nihon chōkokushi kenkyū (Researches into the History of Japanese Sculpture)*, Tokyo, 1947. Tanabe Saburōsuke, "Shitennō ryūzō" ("Standing Images of the Four Guardian Kings at Daian-ji"), *Yamato Koji Taikan (Survey of Old Temples of Yamato)* vol. 3, Tokyo, 1977, pp. 75–77.

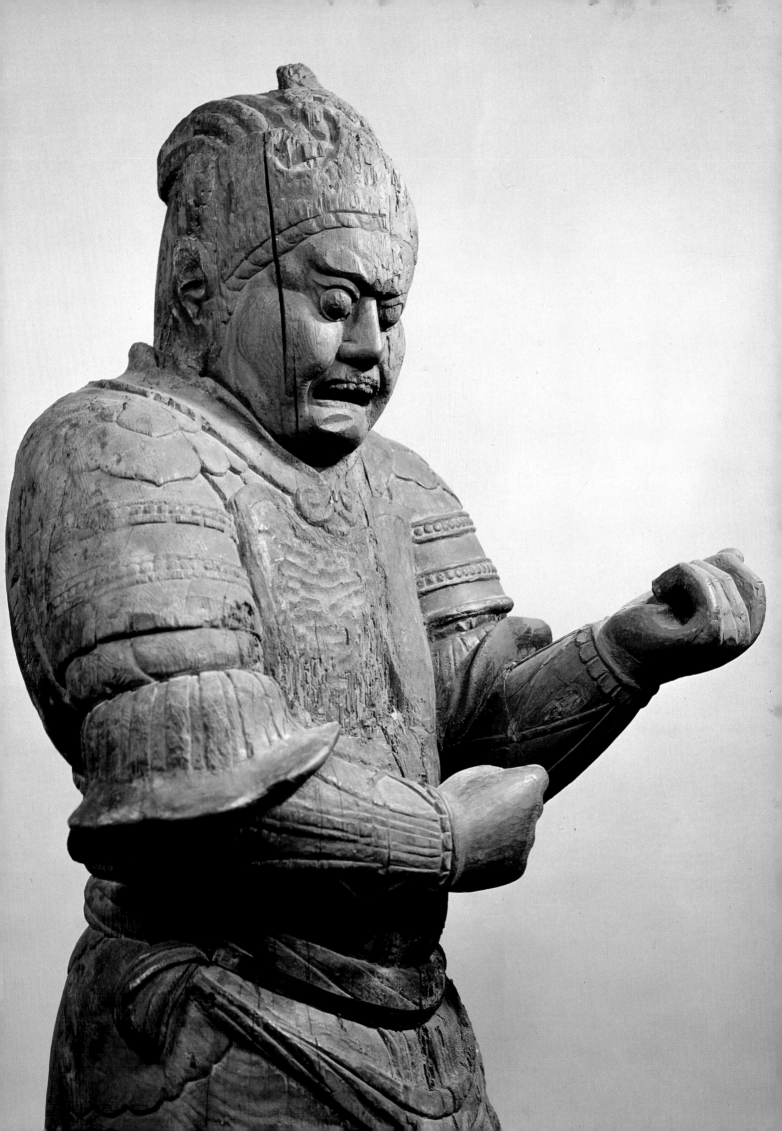

6. Komokuten and Tamonten

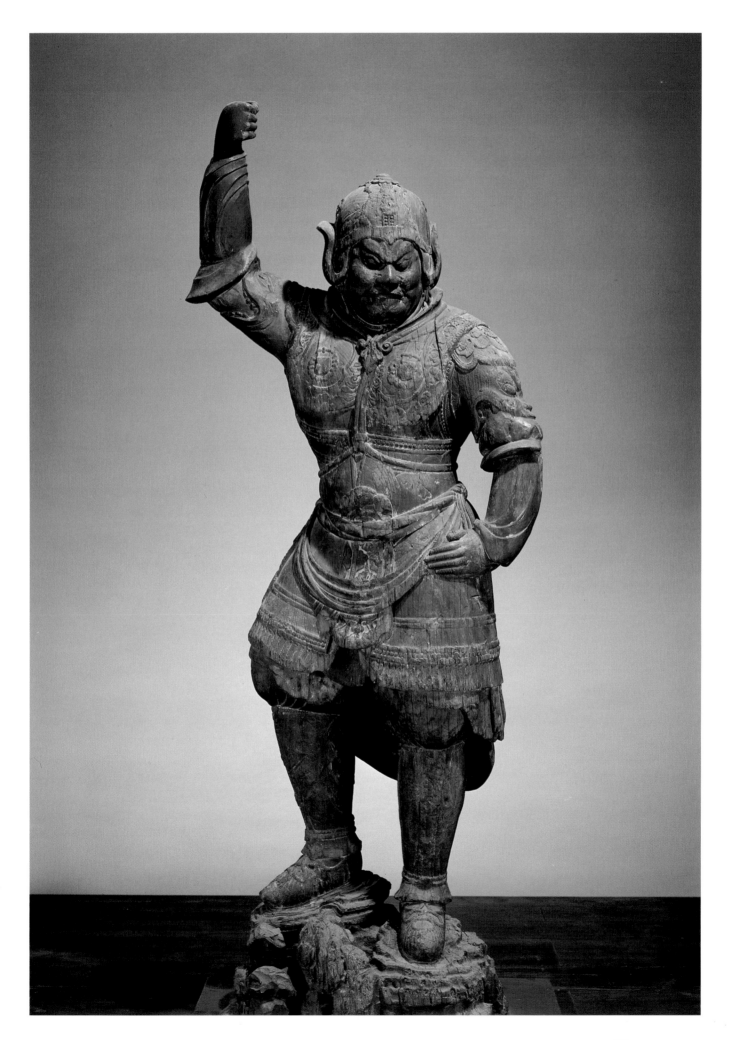

7. Head of a Buddha

Nara Period, eighth century
Wood-core dry lacquer
H. 32¼ in (81.5 cm)
Tōshōdai-ji, Nara
Important Cultural Property

Judging from its proportions, this head of a Buddha belonged to a statue approximately sixteen feet in height. Although a fragment, this head is an important example of the wood-core dry lacquer technique used during the Nara Period. This fragment indicates that the head and body were carved from a single block of wood. Deep cavities were then cut into the back of the head and the body, and the hollow spaces were painted with a red pigment. The exterior surface was then finished with a coating of dry lacquer.

Although most of the lacquer finish has fallen off, the sizable amount remaining on the right side of the head demonstrates several technical features of dry lacquer statuary. The thickness of the lacquer paste varies. Around the eyes, mouth, neck, and ears, the layer is between 1–1.6 cm, but over the cheeks it is but a thin coating. Generally in wood-core dry lacquer images, the form of the figure is largely shaped on the wood. On this piece, the eyes were almost completely modeled in lacquer, but other parts of the head were carved close to the finished form.

In spite of its fragmented condition and the severe damage to this piece, the form exhibits a gentle expression and harmonious feeling that appear to be stylistic holdovers from the classic Nara sculpture. However, the generous proportions to the head, the flat features of the face, and relatively unaccented flesh look forward to the distinctive characteristic of the Early Heian Period. For these reasons, the date of production is placed at the end of the eighth century or possibly the very beginning of the ninth.

Nothing is known about the history of this piece, and whether the statue was originally made for the Tōshōdai-ji is unclear. Because certain technical details of this head also appear in a Bodhisattva head that belongs to Tōshōdai-ji, it is speculated that these images may have once formed a group or triad.

REFERENCES:
Inoue Tadashi, "Buttō" ("Head of Buddha"), *Nara Rokudaiji Taikan (Survey of the Six Great Temples of Nara)* vol. 13, Tōshōdai-ji 2, Tokyo, 1972, p. 57.

EXHIBITIONS:
Paris, Petit Palais, *L'au-dela dans l'Art Japonaise,* October 18–December 17, 1963. Zürich, Kunsthaus, *Kunstschätze aus Japan,* August 30–October 19, 1969; Cologne, Museum für Ostasiatische Kunst, *Kunstschätze und Tempelschätze aus Japan,* November 15, 1969–January 11, 1970.

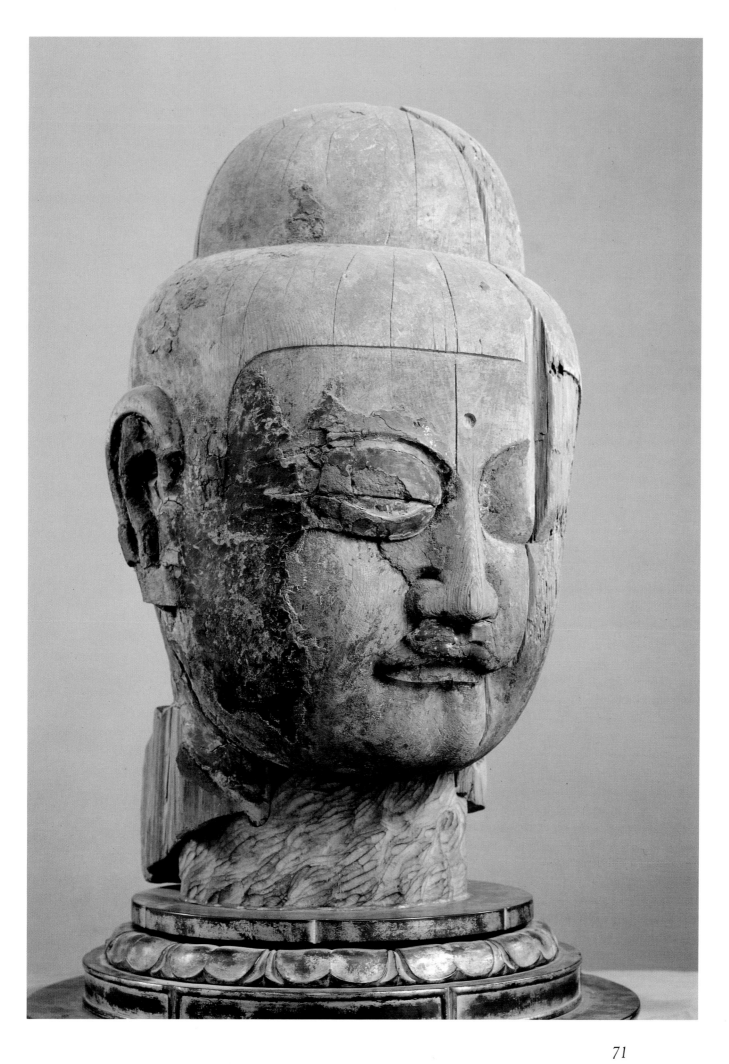

8. Torso of a Buddha

Early Heian Period, ninth century
Polychromed wood, single block construction
H. 60¾ in (154.0 cm)
Tōshōdai-ji, Nara
Important Cultural Property

Though the history of this remarkable statue, preserved until recent times in the Lecture Hall of Tōshōdai-ji, is not clear, it is one of the most striking of the early Japanese wood sculptures. Although only the torso survives, the bent arms and the robe that covers both shoulders indicate that the torso is that of a Buddha. The position of the arms suggests that possibly this image was made as a Yakushi Buddha, who held a medicine jar in the left hand and made the "do not fear" gesture with the right hand.

The entire sculpture, from the head through the main part of the body to the feet, was carved from a single block of *kaya* wood. In order to prevent surface cracking and lighten the weight of the sculpture, the sculptor then hollowed the back of the head and the upper and lower portions of the torso. Remaining pigments indicate that the wood surface of the image was finished with lacquer, over which color was applied. This sculpture is technically interesting as an early example of statuary with surface details made of clay. In certain spots, such as the outside of the left sleeve, the drapery folds were built up with a thin layer of modeling clay.

The fleshiness of the chest is notable, and the carving here shows sensuous modulation and rhythm. The swollen, thick thighs bulging through the robe are strong and eye-catching, yet these major forms of the body are balanced and symmetrical, and the separate parts are well arranged. The drapery is treated as a thin garment clinging to the fleshy body. The robe is gathered into orderly, regular folds that mix with the decorative "rolling wave" (*hompa shiki*) in a pattern characteristic of ninth-century wood sculpture. This pattern, with its deep rounded folds interspersed with smaller pointed folds, is a consistent clue to the dating of Early Heian works.

The strong thighs and the hollowing of the back of the statue are also features that date this work to the Early Heian Period. Yet the rhythmical treatment of the body and the refined execution of the work suggests that the classicism of the Nara Period still lingers.

REFERENCES:
Kuno Takeshi, "Tōshōdai-ji no chōkoku" ("Sculpture of Tōshōdai-ji"), *Tōshōdai-ji*, Kinki Nihon Sōsho vol. 9, Osaka, 1960, pp. 79–120. Machida Kōichi, "Ganjin wajō no raichō to Tōshōdai-ji no chōkoku—Tōshōdai-ji no chōkoku ni kansuru kenkyū no hitotsu" (Ganjin's Visit to Japan and the Buddhist Sculpture in the Tōshōdai-ji—Studies on the Buddhist Images in the Tōshōdai-ji Temple—1"), *Kokka* 858, September 1963, pp. 7–21. Mizuno Keizaburō, "Nyorai-gyō ryūzō" ("Torso of a Buddha"), *Nara Rokudaiji Taikan (Survey of the Six Great Temples of Nara)* vol. 13, Tōshōdai-ji 2, Tokyo, 1972, pp. 54–55.

EXHIBITIONS:
San Francisco, M. H. de Young Memorial Museum, *Art Treasures from Japan*, September 6–October 5, 1951. New York, The Asia House Gallery, *The Evolution of the Buddha Image*, May 6–June 30, 1963. Leningrad, Hermitage Museum, May 13–June 22, 1969; Moscow, Pushkin Museum, July 15–August 24, 1969, *Japanese Sculpture*. Berlin, Staatliche Museum, May 3–June 16, 1974; Dresden, Staatliche Kunstsammlungen, July 1–August 14, 1974, Japanische Kunst aus Drei Jahrtausenden. Paris, Petit Palais, *Tōshōdai-ji—Tresors d' un Temple Japonais*, April 6–May 22, 1977.

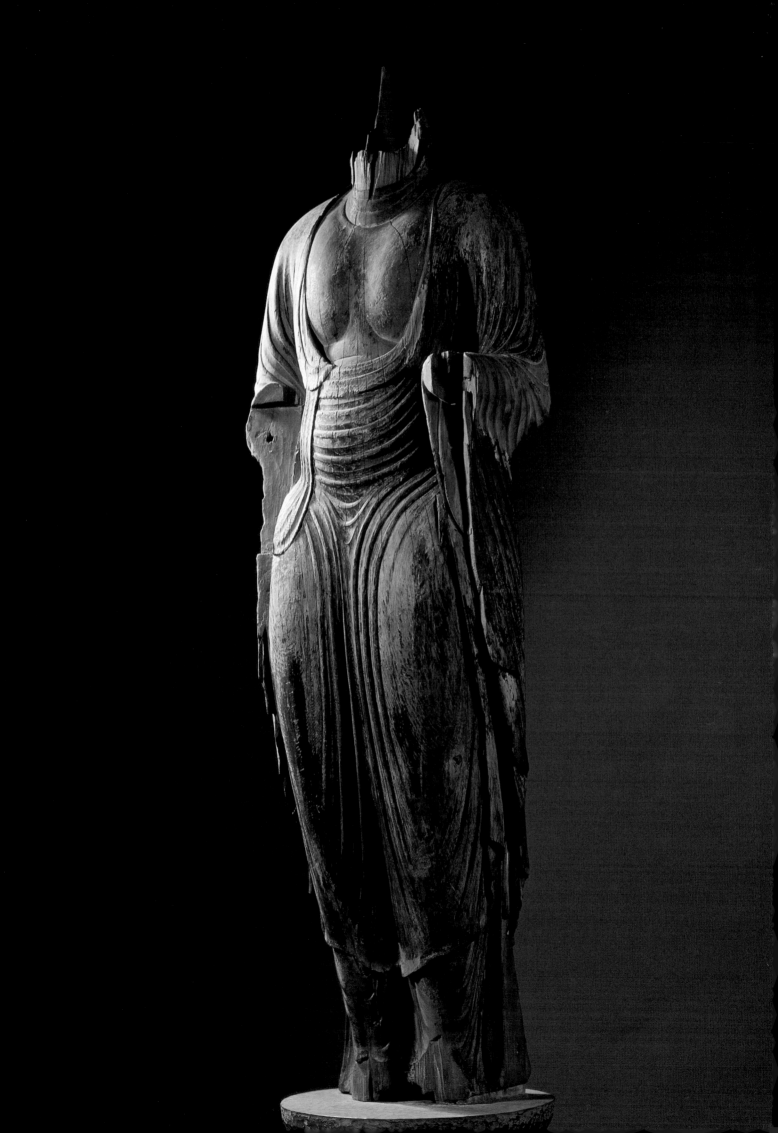

9. Nichira

Heian Period, ninth century
Wood, single block construction
H. 57 in (145.7 cm)
Tachibana-dera, Nara
Important Cultural Property

This striking image is commonly called Priest Nichira, who is traditionally identified as a teacher of Prince Shōtoku. One mention of Nichira exists in historical records, though his nationality is unclear and that he was a priest is uncertain. According to the *Nihon Shoki,* Nichira was a native of the ancient province of Higo, which is modern Kumamoto Prefecture on the island of Kyushu. He is believed to have travelled to Kudara (on the Korean peninsula) about 537, but was invited to return to Japan in 583 as an advisor on political, diplomatic, and military matters. Late in the same year, he was killed by an associate from Kudara.

The historical tradition of the Tachibana-dera may account for the association of Nichira's name with this sculpture. The Tachibana temple is said to have been built on the site of Prince Shōtoku's birthplace, and possibly images made for a temple sacred to his memory became identified with events in the life of the Prince. Modern scholars think it likely that this image was originally made as a Jizō Bosatsu. Because the hands of this figure are replacements, it is not possible to know the precise form of the original carving. However, the shaved head and the simple robes of a Buddhist priest are traditional in representations of Jizō. Commonly too, Jizō holds a priest's staff in his left hand and a *cintāmaṇi* jewel in his right hand, but the gestures shown on this work, especially the *vara-mudrā* of charity, in which the left arm is extended down with palm outward, are also characteristic of Jizō statues of the Early Heian Period.

The entire statue, including the head, torso, and lotus pedestal, is carved from a single block of Japanese cypress. Only the hands were added separately. The sculpture was originally painted, but the pigments are entirely lost, leaving a nearly bare surface. The face of this figure is individualized. The squarish head, thick arched eyebrows, and long narrow eyes form a strong contrast to the small nose and lips. The substantial body with thick shoulders, chest, and thighs conforms to the Heian canons of style. The beautifully draped robe, thick with folds and circular gathers, produces a decorative effect characteristic of the period that Japanese refer to as "baroque."

In spite of its stylized characteristics, the statue suggests human qualities, both by its facial expression and by its hipshot pose, which implies movement. Such suggestions distinguish this work from other Buddhist images of the day and may account for the name Nichira being associated with the sculpture.

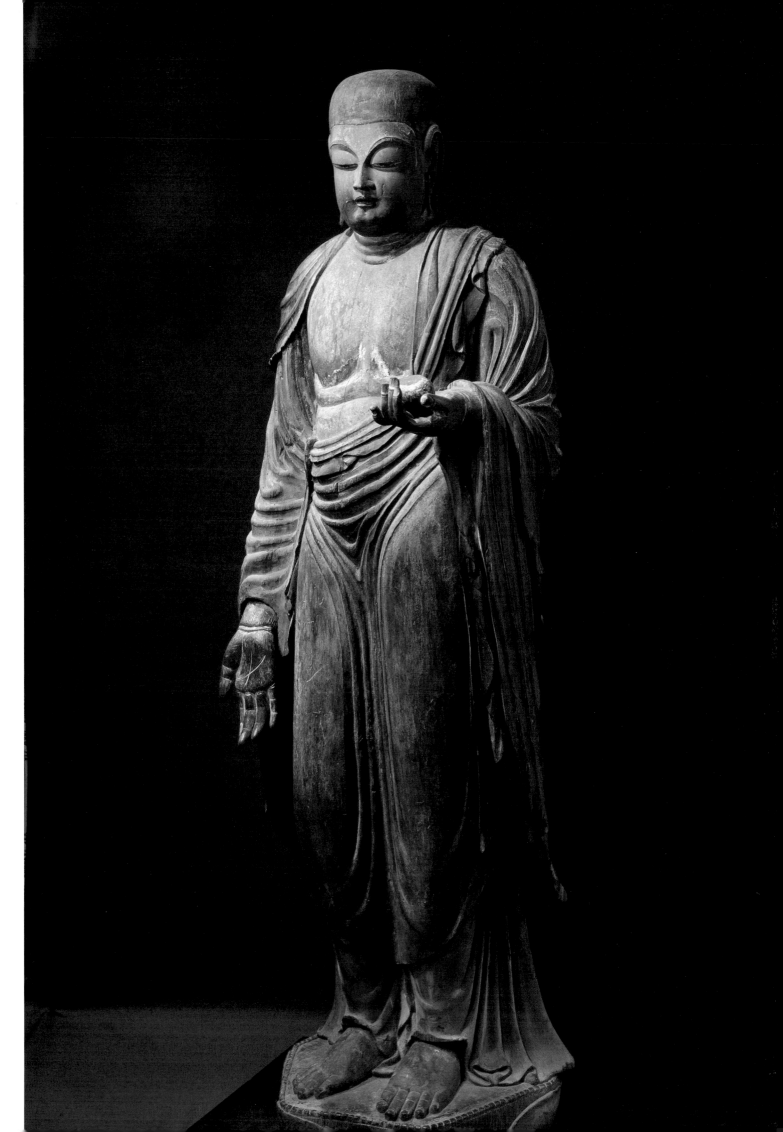

10. Miroku

Early Heian Period, ninth century
Wood, single block construction
H. 15½ in (39.0 cm)
Tōdai-ji, Nara
Important Cultural Property

This small but striking seated Buddha is outstanding in ninth-century sculpture. The figure sits with his back hunched, leaning forward. The shoulders are broad, and the chest is thick. The head is proportionately large in relation to the rest of the body, and the weight of the head and torso seems to press down and flatten the legs and feet. The composition of this statue violates the naturalistic proportions of eighth-century sculpture and consciously produces a bold effect through asymmetry and imbalance.

The proportions alone do not account for the intensity of the image. The features of the face, particularly the eyes, eyebrows, and mouth, are large, obvious forms with clearly defined, sharp edges. The smoothly swollen cheeks, the modeling of the small chin, and the irregularly shaped flesh of the chest all suggest the fullness of life. The simple priest's robe, carved as a layer of thick cloth, is generously folded and draped. The large, undulating "wave" patterns project a sense of power and volume that contributes greatly to the impression of a stalwart, monumental form.

This image was carved from a single block of Japanese cypress. Only the hands and the large snail-shell curls on the head were carved separately and attached. The statue was hollowed out from the bottom, but the back and head are solid. Touches of color—black eyebrows, blue-green eyes, and red lips—are the only additions to the surface of the sculpture. The rest of the head and body is in the so-called *danzō* manner of plain wood images that came into vogue in the ninth century. Indeed, the characteristics exhibited by this piece are shared by other larger sculptures of the early ninth century, such as the outstanding Yakushi Buddha from Jingo-ji.

Nothing is known about the origin or history of this work. Until it was moved to the Nara National Museum some twenty years ago, this sculpture was kept in a small closed shrine in the Hokke-dō at Tōdai-ji, but the date of its installation there is unclear. The legend that this sculpture was a model for the Great Buddha cast for Tōdai-ji in 752 is testimony to its impressive visual qualities. The identification of this Buddha as Miroku, who is to appear in the future, is also traditional.

REFERENCES:
Uehara Shōichi, "Miroku butsu zazō" ("A Seated Image of Miroku Buddha"), *Nara Rokudaiji Taikan (Survey of the Six Great Temples of Nara)*, vol. 10, Tōdai-ji 2, Tokyo, 1968, pp. 64–65.

EXHIBITIONS:
Paris, Musée National d'Art Moderne, April 15–June 1, 1958; London, Victoria and Albert Museum, July 1–August 15, 1958; The Hague, Gemeentemuseum den Haag, October 1–November 15, 1958; Rome, Palazzo delle Esposizione, December 15, 1958–February 1, 1959, *Art Treasures from Japan*. Los Angeles County Museum of Art, September 29–November 7, 1965; Detroit Art Institute, December 5, 1965–January 16, 1966; Philadelphia Museum of Art, February 13–March 27, 1966; Toronto, The Royal Ontario Museum, March 24–June 5, 1966, *Art Treasures from Japan*. Zurich, Kunsthaus, *Kunstschätze aus Japan*, August 30–October 19, 1969; Cologne, Museum für Ostasiatische Kunst, *Kunstschätze und Tempelschätze aus Japan*, November 15, 1969–January 11, 1970.

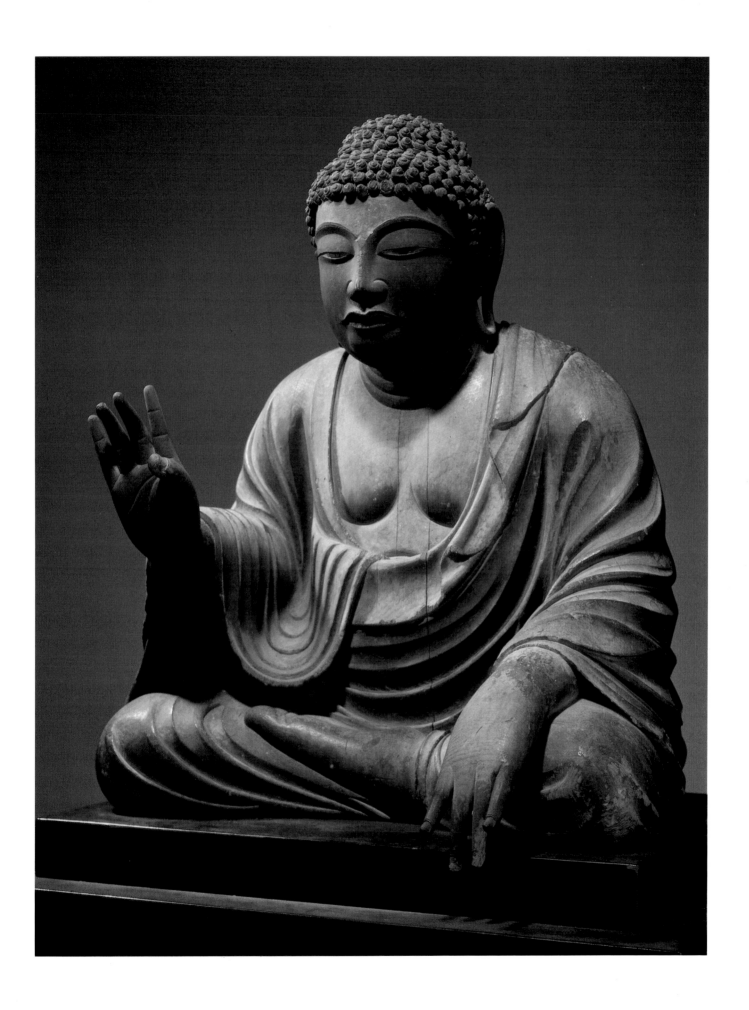

11. Yakushi

Heian Period, ninth century
Wood, single block construction
H. 19¼ in (49.7 cm)
Nara National Museum
National Treasure

This excellent statue of the Buddha of healing was originally worshipped as a *honchi,* a Buddhist counterpart of a Shinto god. Until the late nineteenth century it belonged to the Nyakuōji Shrine in Kyoto. The sculpture was made public in the Early Meiji Period (1868–1912) when, as part of the movement to restore the Emperor to power, the traditional associations between the two religions ended, and Shinto *kami* were separated from Buddhist divinities. The sculpture passed into national ownership after World War II.

This unhollowed image is a solid piece of Japanese cypress from the head through the lotus pedestal. The hands were carved separately and attached, as were the snail-shell curls of the hair which are made of dry lacquer. The surface of this piece is now covered with a coating of yellow clay which is a later addition. It is believed that the sculpture originally had a bare wood surface.

In certain compositional details, this image resembles the Miroku Buddha from Tōdai-ji (cat. no. 10). The body leans forward, and the shoulders are slightly rounded. However, the body is not as consciously distorted as in the Miroku figure, and the facial features of the Yakushi are very distinctive. The fullness of the face is emphasized by plump cheeks, deep dimples at the corners of the mouth, and the small pointed chin. The downcast, protuberant eyes, the strong curve of the upper eyelids, and the sharp edges of the lips all contribute to the highly independent, austere, and exotic expression of this image.

The skillful carving of the statue is also evident in the treatment of the body and robe. The "wave" patterns cut into the drapery are beautifully arranged to the shape of fabric folds, and the carving of the torso conveys the tension in the body. Again, like the Miroku from Tōdai-ji, the inherent qualities of this small image make it appear monumental. Because of the scrupulous care and refinement of the workmanship, this sculpture is one of the most accomplished works of the Early Heian Period.

REFERENCES:
Mainichi Shimbunsha, ed., *Genshokuban kokuhō (National Treasures in Full Color),* Heian II, Tokyo, 1967. Uehara Shōichi, "Mokuzō Yakushi Nyorai zazō" ("A Seated Wood Image of Yakushi Buddha"), *Nara Hakubutsukan Meihin Zuroku (Catalog of Treasures from the Nara National Museum),* Nara National Museum, 1979.

EXHIBITIONS:
San Francisco, M. H. de Young Memorial Museum, *Art Treasures from Japan,* September 6–October 5, 1951.

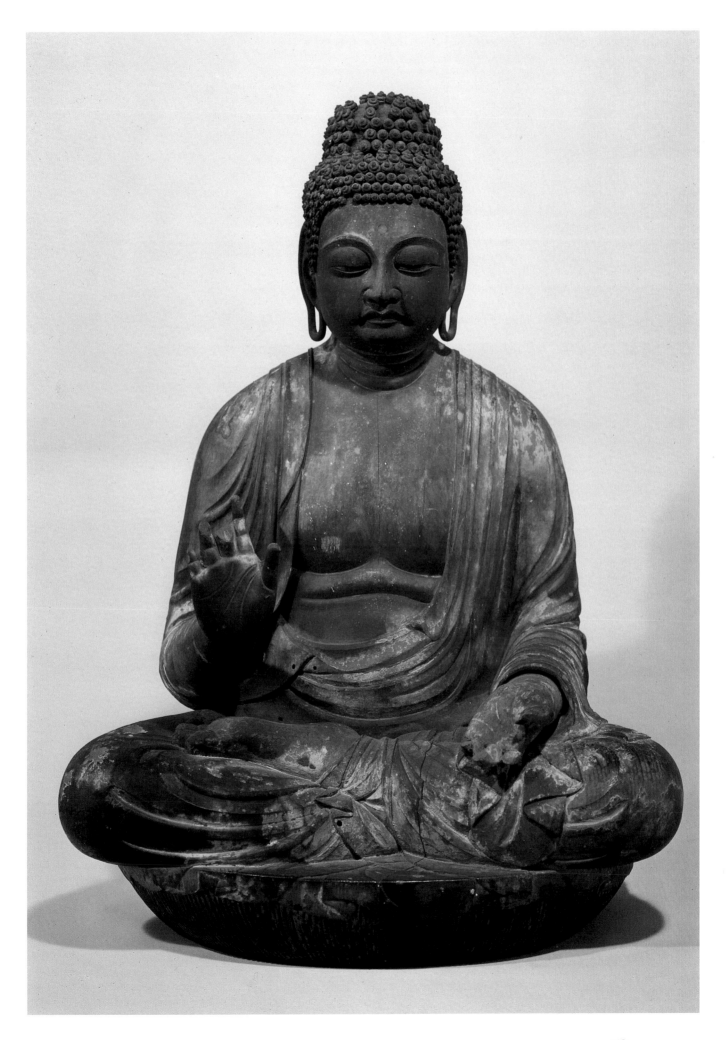

12. Eleven-headed Kannon

Heian Period, ninth century
Wood, single block construction
H. 16½ in (42.8 cm)
Nara National Museum
Important Cultural Property

The Bodhisattva Kannon was the most popular Buddhist deity in Asia. Renowned for infinite compassion and mercy, Kannon is capable of manifestation in as many as thirty-three different forms to assist mankind. The Eleven-headed form of Kannon is one such manifestation of the Bodhisattva, and is the first Esoteric form of the deity to be produced in Japan. Although seventh century examples of this form survive, the direct influence of orthodox Esoteric teachings brought to Japan by the priests Saichō and Kūkai in the ninth century stimulated the Japanese devotion to this god.

Kannon's eleven heads originate in the despair he experienced at seeing the countless individuals who had not yet found salvation from worldly suffering. Buddhist scripture records that Kannon's great grief caused his head to split into ten fragments, whereupon Kannon's spiritual father, the Buddha Amida, shaped each fragment into a new head, attached the heads to Kannon's body, and at the top, added one of his own. Thus the heads symbolize the many ways Kannon can assist mankind.

Though the number and the attitude of the eleven heads are not consistent in painted or sculptural representation, the regulations governing iconic form require that three heads be Bodhisattva heads, three heads have tusks protruding at the corners of the mouth, three heads show anger, and the head farthest to the back be laughing. The head of Amida Buddha, which is placed at the top, brings the total to eleven.

This statue of the Eleven-headed Kannon is a superb example of a type of sculpture called *danzō*, or sandalwood images. Carved from a block of fragrant, fine-grained sandalwood, which is a type of cedar, these statues exhibit precision cutting and exquisite detailing on a hard wood surface. On this image, only the topknot and part of the jewelry were added separately. The decorative elements of the body and clothing and the small heads that crown the main head were produced from the same block. The wood is completely plain except for touches of color—blue for the hair, red for lips, and black for eyebrows and mustache. The gold-leaf decorations on the skirt and pedestal are later additions.

The stylish, even distinguished expression on the face of this statue is produced by the shape of the eyes and by the high, straight nose that is shaped in a graceful line from the base of the arched brows. Moreover, the plastic undulation of the drapery and the individualized faces of the eleven heads emerging from the crown of the main head are produced with remarkable skill.

Danzō statuary was popular in China during the T'ang Period, and a number of Chinese examples were imported to Japan. Because of its quality and exotic flavor, it is possible that this wood too is an imported piece. However, because of the special character of the "wave" drapery pattern that decorates the skirt below the knees, this sculpture is thought to have been made in Japan and to have followed the model of such famous T'ang statues as the Nine-headed Kannon that belongs to the Hōryū-ji in Nara.

REFERENCES:
Kurata Bunsaku, "Mokuzō Jūichimen Kannon ryūzō" ("Standing Wood Image of the Eleven-headed Kannon"), *Nara Kokuritsu Hakubutsukan Meihin Zuroku* (*A Catalog of Treasures from the Nara National Museum*) Nara National Museum, 1979.

EXHIBITIONS:
Cologne, Museum für Ostasiatische Kunst, January 12–March 11, 1979; Zürich, Helmhaus Museum, April 1–May 6, 1979; Brussels, Musées Royaux d'Art et d'Histoire, May 24–June 25, 1979, *Plastik aus Japan*.

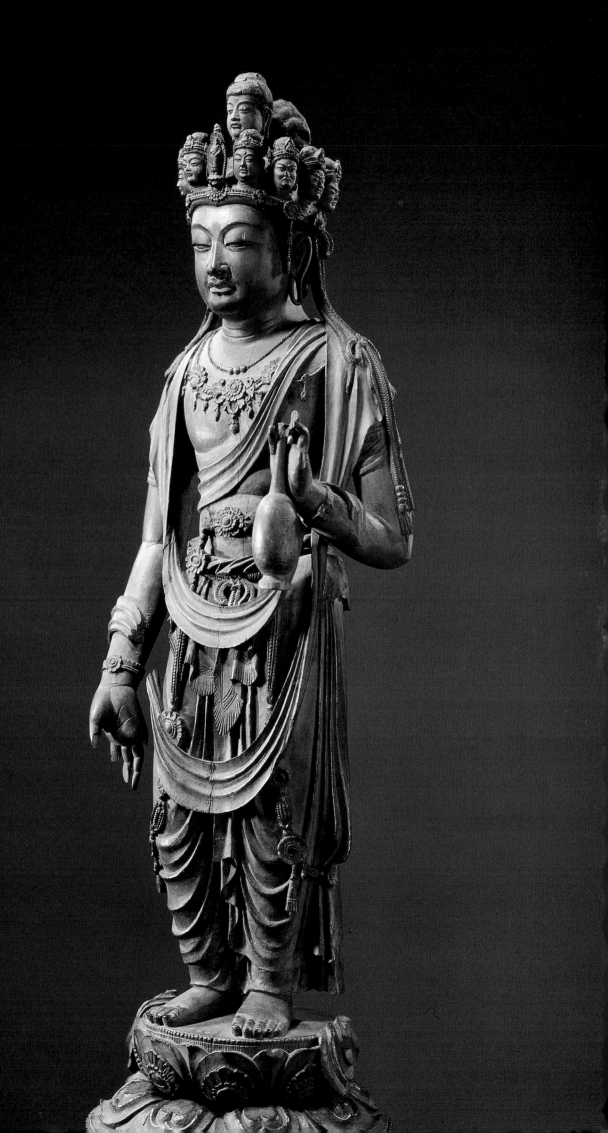

13. Yuima Koji

Heian Period, ninth century
Polychromed wood, single block construction
H. 20 in (51.5 cm)
Ishiyama-dera, Shiga Prefecture
Important Cultural Property

Yuima, whose name is Vimalakīrti in Sanskrit, is said to have lived in north-central India during the lifetime of the historical Buddha. A devotee of Buddhism, Yuima reached the height of spiritual understanding, but he remained a layman and never became a monk. Nevertheless, his insight and wisdom were such that, among all of the Buddha's disciples, only Monju, the Bodhisattva of wisdom, was confident enough to debate with Yuima.

The scriptures that describe Yuima, the *Vimalakīrti-nirdeśa-sutra*, were composed in the second century A.D., and present a concept of lay Buddhism that was greatly appreciated first in China and then in Japan, especially by Prince Shōtoku, who wrote a commentary on the *Vimalakīrti sutra*. While the dramatic debate between Yuima and Monju was a favorite subject in sculpture and painting in China, the only known Japanese example of this scene is the group of clay figures dated 711 on the east side of the Hōryū-ji Pagoda.

In Japanese sculpture and painting, Yuima is customarily represented as an old man dressed in secular robes, his head covered by a hood or cap. The armrest frequently included in these depictions alludes to Yuima's apparent illness during his debate with Monju. This Yuima from Ishiyama-dera follows the iconic standard of Yuima as aged. The head of the figure, which is apparently bald, is covered with a soft cap. The peculiar absence of a chin or neck is attributable to the beard that covers the lower part of the face. Although Yuima's elbows are on the armrest, sickness is not suggested. Indeed, Yuima is plump, the modeling of the flesh makes him appear healthy, and his friendly expression gives him a humorous appearance.

This sculpture was carved from a single block of Japanese cypress. Both the technique and composition of the work reflect the special characteristics of ninth-century sculpture. The dominance of the large head and body over small, seemingly compressed legs makes this sculpture an example of the consciously imbalanced form favored in the ninth century. The strong drapery folds are mixed with deftly cut "wave" patterns that still show traces of the chisel marks. A few remains of polychrome indicate that the sculpture was originally painted.

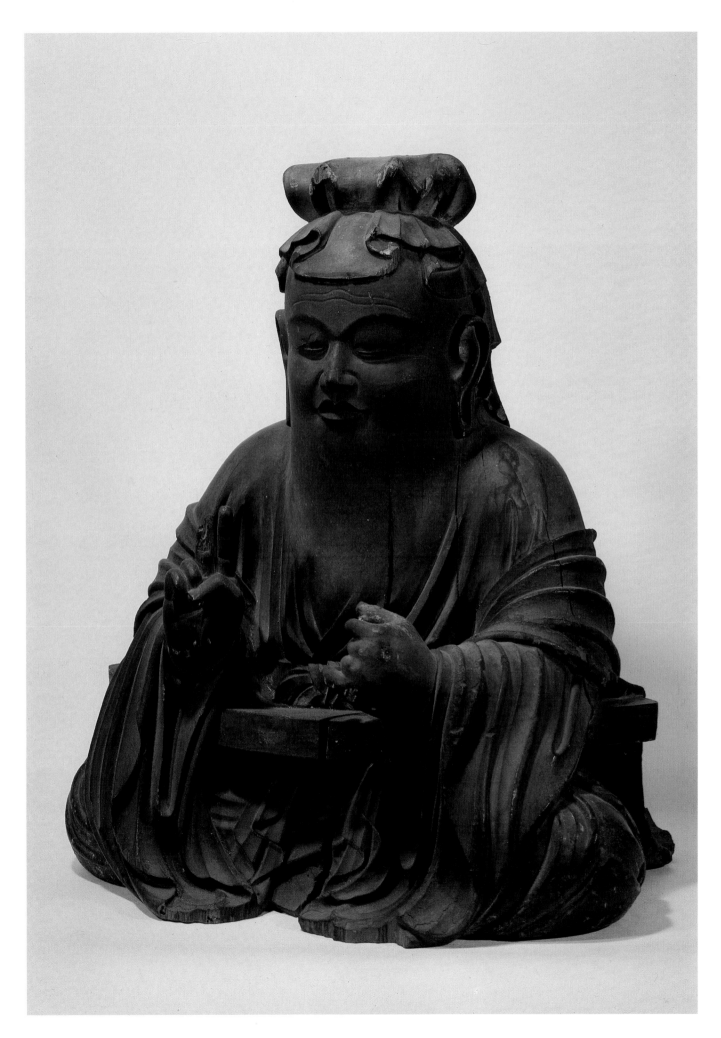

14. Bodhisattva (Monju?)

Heian Period, ninth century
Wood, lacquer finish, single block construction
H. 39¾ in (101.5 cm)
Byakugō-ji, Nara
Important Cultural Property

According to temple tradition, this figure, usually identified as Monju, the Bodhisattva of wisdom, is said to have been installed originally in a pagoda at the Byakugō-ji. Because the date ascribed to the pagoda is later than is the date of the sculpture, it seems apparent that the statue was moved to the pagoda from another location. On the present statue both hands are replacements, and thus certain identification of this statue is impossible. A smooth, unarticulated portion of hair at the front of the head above a scalloped ridge indicates that this Bodhisattva wore a jeweled crown, which is now lost.

Except for the hands, the entire figure, including the feet and the scarves that hang from the shoulders, was carved from a single block of Japanese cypress. The statue is unhollowed. The smooth surface of this piece is attributed to the thin layer of lacquer paste that covers the statue.

This statue has a broad face with well-modeled features and long eyes. The hair is piled in a tall topknot. The ample breadth of the chest and hips, and the wide but thin legs contribute to the feeling of volume characteristic of Heian sculpture. The scarves cover the back and shoulders and drape the front of the body. The treatment of the scarves, especially as they hang on the arms, provides an important decorative feature. Aside from the proportions of the body, such details as the wide brow, drooping eyes, and full cheeks are reminiscent of other famous Esoteric images, for example, the Nyoirin Kannon at Kanshin-ji or the Five Kokūzō Bosatsu at Daigo-ji. The Kanshin-ji and Daigo-ji sculptures are dry lacquer works dating to the first half of the ninth century. Compared to these works, the Byakugō-ji Bodhisattva exhibits a stiffness in body treatment that makes a date in the latter half of the ninth century appropriate. It is, nonetheless, an excellent sculpture that demonstrates the development of the Esoteric sculpture of Japan.

REFERENCES:
Hasegawa Makoto, "Bosatsu zazō den Monju Bosatsu zō" ("Seated Bodhisattva, Traditionally Called Monju"), *Yamato Koji Taikan, (Survey of Old Temples of Yamato)* vol. 4, Shinyakushi-ji, Byakugō-ji, Enjō-ji, Tokyo, 1977, p. 68.

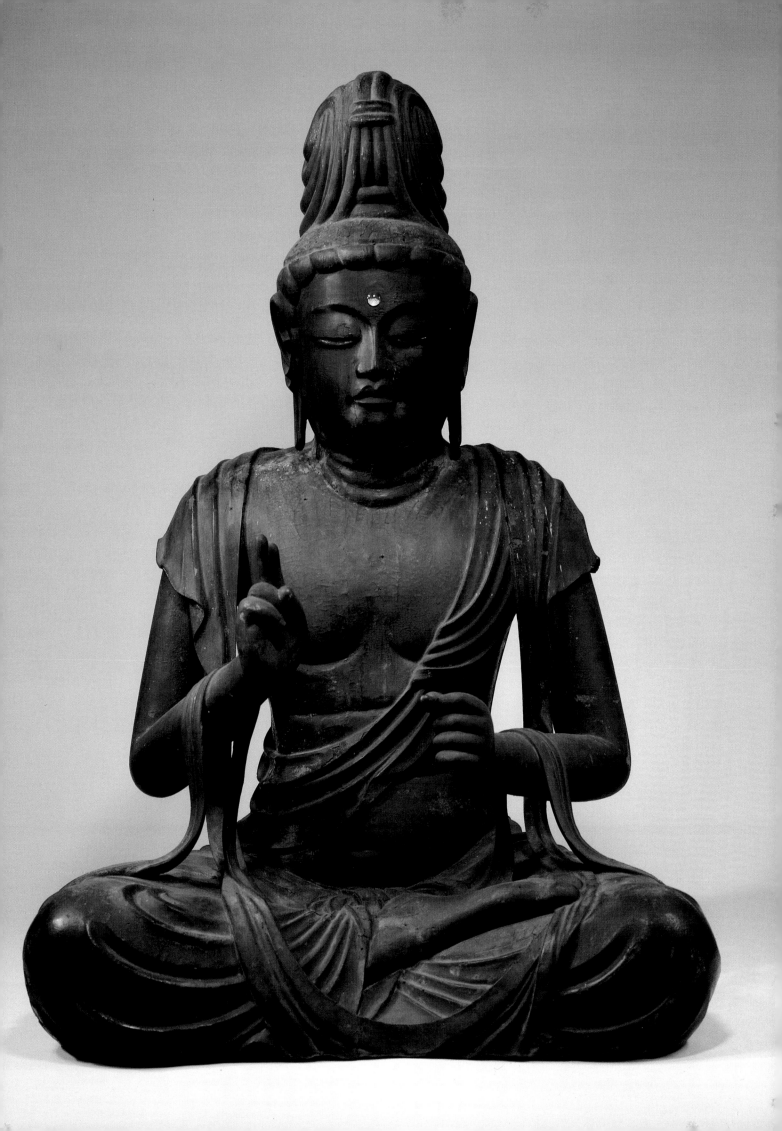

15. Amida Triad

Heian Period, tenth century
Polychromed wood, single block construction
H. Amida, 19¾ in (49.8 cm); left attendant, 23 in (58.5 cm); right attendant, 22 in (56.2 cm)
Shitennō-ji, Osaka
Important Cultural Property

These three statues represent a sculptural interpretation of the scene called Amida *raigō*. According to the teachings of the Pure Land cult of Amida Buddha, when a faithful devotee is on his deathbed, the Buddha appears with his attendant Bodhisattvas, Kannon and Seishi, and leads the dying soul to the western paradise. Amida sits on a tiered lotus pedestal, his hands forming a variation of the *vitarka-mudrā,* the "gesture of welcoming to paradise" (*raigō-in* in Japanese). Kannon stands to the left, his hands forming a base for a small lotus that will bear the soul of the deceased. To the right, Seishi stands with his hands forming the gesture of adoration.

Although these images were originally polychromed, this surface has worn away, and the present condition openly shows the wood skin. Aside from Amida's hands, which are replacements, the central image including the lotus pedestal is carved from a single block, which is unhollowed. This image is very striking for the tall topknot, to which snail-shell curls were once attached. The drapery folds are skillfully arranged, and the edges of the robe fall naturally over the top of the pedestal. In its construction, technique of manufacture, and composed and easy posture, the figure closely resembles the ninth-century Yakushi Buddha at the Nara National Museum. However, unlike the Yakushi, the Amida has shallowly carved eyes and nose, and the over-all expression is refined, gentle, and quiet. The tension in the shoulder and back, which is notable in the Yakushi, is not pronounced in the treatment of the Amida. Such characteristics indicate that the Amida was made sometime after the Yakushi, and the Amida is dated to the first half of the tenth century.

Each attendant is made from a single block of wood. Although the forearms, hands, and toes are replacements on both figures, the bodies are otherwise original. The attendants are distinguished by their rounded faces, the heavy rings of flesh on the necks, and the strong modeling of the upper body. The drapery is naturalistic and differs somewhat from the deep, sharp folds on the garments of the Amida image. Yet despite individualizing differences, the three statues clearly exist as a triad, as their aesthetic harmony establishes.

The attendants stand on one foot as though they were dancing, and their pose resembles that of some of the Bodhisattvas on Clouds that decorate the Byōdō-in Phoenix Hall of 1053 (cat. no. 20). Thus the Amida Triad, which dates from the first half of the tenth century, is very novel indeed.

EXHIBITIONS:
Los Angeles County Museum of Art, September 29–November 7, 1965; Detroit Art Institute, December 5, 1965–January 16, 1966; Philadelphia Museum of Art, February 13–March 27, 1966; Toronto, The Royal Ontario Museum, March 24–June 5, 1966, *Art Treasures from Japan.*

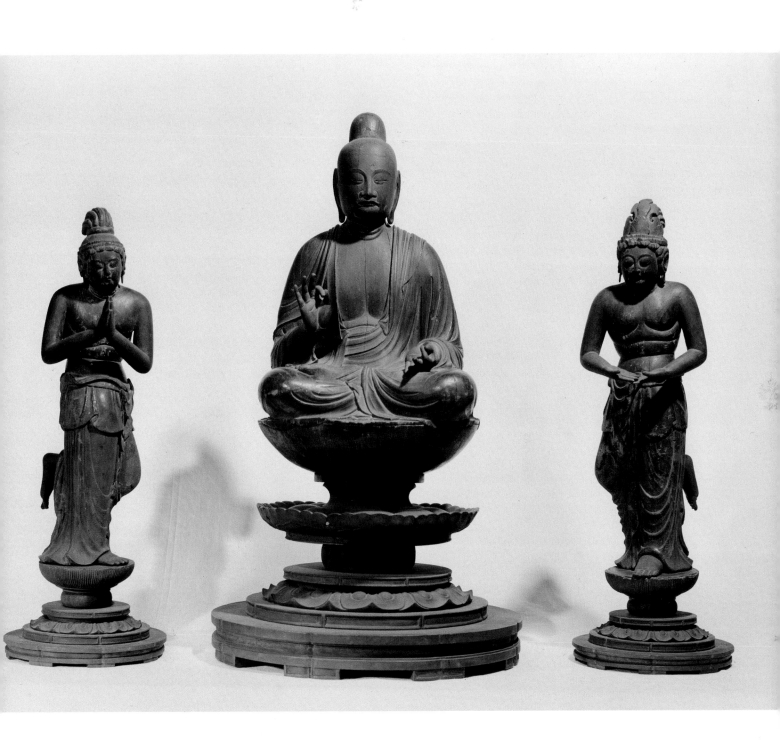

16. Jizō

Heian Period, tenth century
Polychromed wood, single block construction
H. 36 in (90.9 cm)
Kōryu-ji, Kyoto
Important Cultural Property

Heian beliefs about Jizō, a compassionate Bodhisattva, involved his expected appearance on earth after the final *nirvana* of Shaka, the historical Buddha, and before the coming of Miroku, the Buddha of the future. Of special importance was Jizō's presence during this "age of lawlessness" (*mappō* in Japanese) when no Buddha was on earth and chaos therefore would reign. The age of lawlessness was expected to begin in 1052 A.D., about fifteen hundred years after Shaka's death, and to continue until Miroku's coming. As the only deity man could petition in these lawless centuries for relief from pain in this life and after death, Jizō became a very popular deity in Japan, particularly during the eleventh century.

In the mandala paintings of Esoteric Buddhism, Jizō is shown as a richly coiffed and bejeweled Bodhisattva; however, his more familiar representation is as a Buddhist priest who has a shaved head and wears simple robes. In his priestly guise, Jizō is frequently shown holding a *cintāmaṇi* jewel in the left hand and a staff in the right hand. The particular form of the Bodhisattva exhibited by the statue from Kōryu-ji, with the right hand extending downward as the palm turns upward, symbolizes the gesture of charity. Such an attribute commonly appears in Buddhist sculptures from the beginning of the Heian Period.

This Kōryu-ji Jizō is an important early example of the Bodhisattva and displays several characteristics notable in Early Heian sculpture. Carved from a single block of Japanese cypress, the body is heavy, and the fleshiness is especially noticeable in the ridges of the breast and abdomen and in the smooth, swollen thighs that press against the robe. The carving of the drapery covering the lower part of the body combines deep, clearly cut folds and the "rolling wave" pattern that developed in the ninth century.

The head of this Jizō is round and rather large in comparison to the rest of the body. The generously arched eyebrows, long eyes, and precisely shaped lips provide strong rhythmical accents and express Jizō's dauntless resolution. The proportions of the torso are hardly naturalistic, as the shortness of the lower legs and unusual length of the right arm show. Yet perhaps because the left foot pushes slightly forward as the casually draped robes hang quietly to the sides, the sculpture skillfully conveys both movement and stability. The exposed right shoulder is an unusual though not unique feature. In this detail as well as in details of construction, pose, and style, the Kōryu-ji work bears close comparison to a similar Jizō at the Ishō-ji temple in Kyoto.

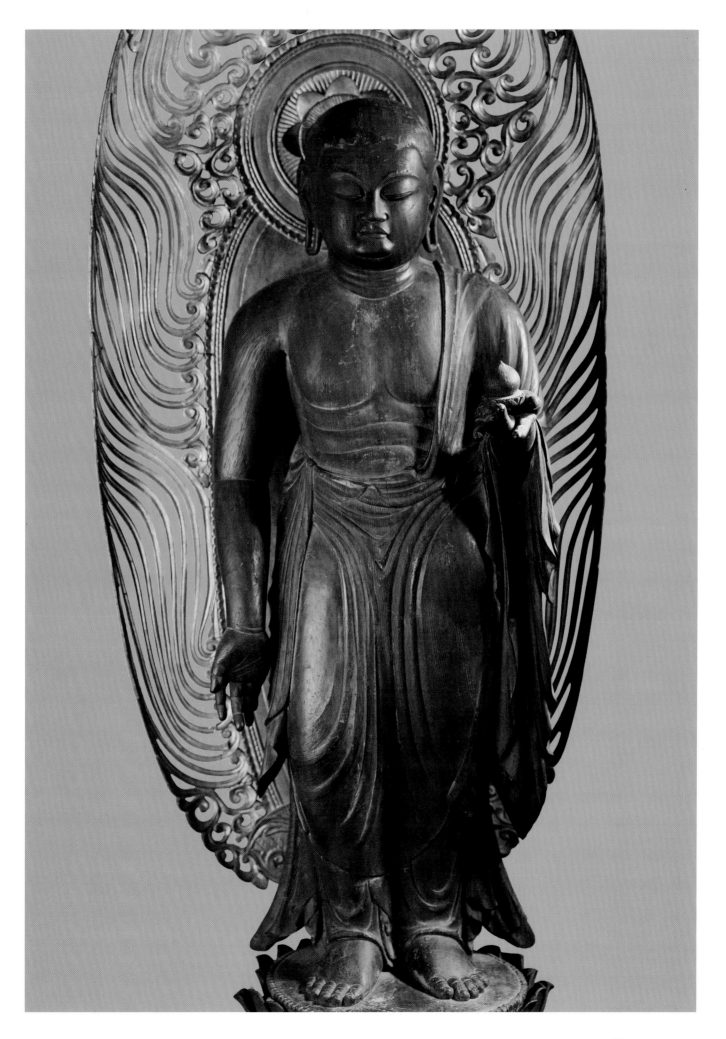

17. Fudō Myōō

Heian Period, tenth century
Polychromed wood, single block construction
H. 32¼ in (81.8 cm)
Hanshū-in, Kyoto
Important Cultural Property

In Shingon or Esoteric Buddhism, five elements—earth, water, fire, wind, and space—formed the Phenomenal World (*Taizōkai* in Japanese, *Garbhadhātu* in Sanskrit). Consciousness or Mind made the Wisdom or Diamond World (*Kongōkai* in Japanese, *Vajradhātu* in Sanskrit), with its five divisions. Each division was represented by a Buddha, and these Buddhas were grouped as the Five Wisdoms or Five Dhyāni Buddhas. Each of the Dhyāni had three forms: a Bodhisattva, representing spirit; a *vajra* or diamond form, representing wisdom and graciousness; and a Myōō or fierce form, representing the Buddha's power against evil. In artistic representations, these Myōō frequently appear in sets and are called the Five Great Myōō (see cat. no. 36).

Among the Five Great Myōō, Fudō is the most powerful, and he always appears at the center of the group. Transmitted to Japan in the Early Heian Period as an Esoteric deity, he quickly became popular, and images of Fudō are numerous in both painting and sculpture.

The Japanese Fudō is the Indian Acala, a name for Śiva, the Hindu god of destruction and renewal. Although no Indian representation of Acala is known, he is said to have been a messenger of the Buddha. From this position, he rose to become a guardian and a militant devotee of the law, and finally he manifested the powers of the Supreme Dainichi (*Mahāvairocana* in Sanskrit).

This sculpture of Fudō conforms closely to his description in Buddhist texts. According to these scriptures, Fudō's plump body is dark blue or black. His terrible face has bulging eyes, and sometimes the left eye squints. His fangs bite his lower lip as an expression of intense emotion. His hair, gathered in a long braid, hangs on the left side of his face. Whether seated or standing, he holds a lasso in the left hand and a sword in the right.

This Fudō from Hanshū-in follows a form of the deity associated with Kūkai and shows several details of the ninth-century sculptural style. Among such characteristics are his wide-open eyes and his protruding teeth which bite into the lower lip. The volume and imposing presence of the sculpture are also typical of single block works at the beginning of the Heian Period. The carving, however, suggests a date later than the ninth century. Indicating a tenth-century date of manufacture are such details as the "rolling wave" drapery pattern, which is treated here with mechanical and totally balanced proportions, and the very fine carving on the bracelet. The sculpture is carved from Japanese cypress, and except for the separately attached hands and feet, the figure is carved from a single block. The surface polychrome has worn away, but a few remaining traces show that the fleshy body was originally painted red, in contradiction to the strict iconographic requirement.

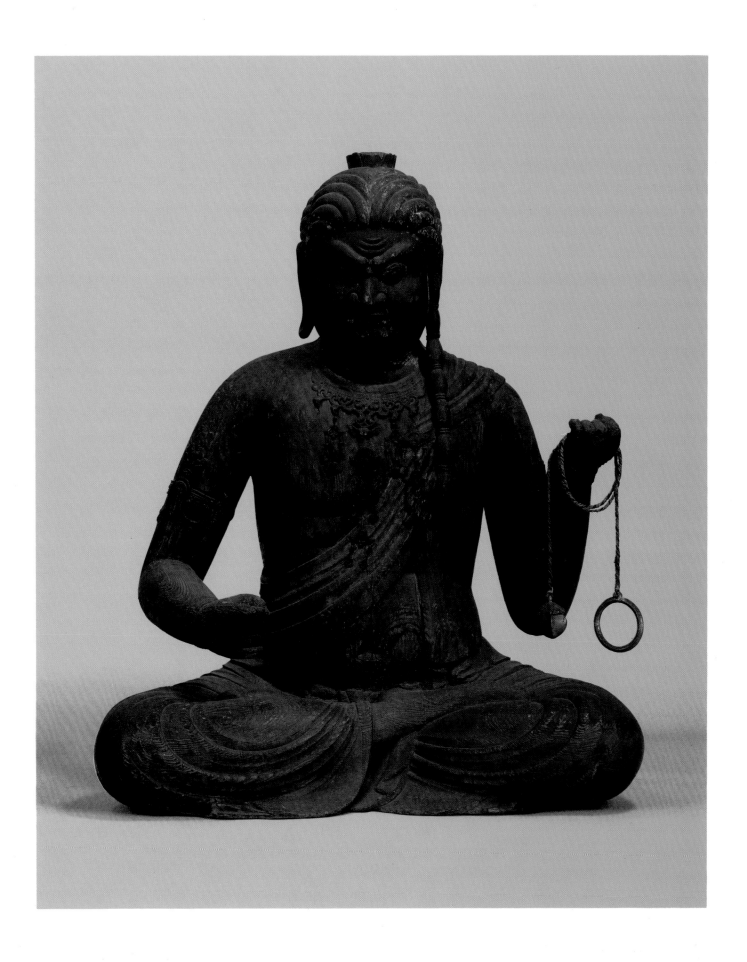

18. Nyoirin Kannon

Heian Period, tenth-eleventh century
Wood, single block construction
H. 19¾ in (49.6 cm)
Daigo-ji, Kyoto
Important Cultural Property

The Nyoirin Kannon, the Bodhisattva who grants desires, is a prominent deity in the Esoteric Buddhist pantheon. The word *nyo-i* refers to the *cintāmaṇi*, the wish-granting jewel, and the term, *rin*, which means "wheel," refers to the turning of the wheel of the law. The Nyoirin Kannon is one of the six "changed forms" of the Bodhisattva Kannon. The deity was widely worshipped after the introduction of Esoteric Buddhism in the Early Heian Period, probably by those who hoped to gain riches and fulfill requests.

Although iconographic drawings frequently depict this god as a Bodhisattva with two arms, the six-armed form was more common in Japan. This Kannon sits in a posture of royal ease. The left leg is folded horizontally to expose the sole of the foot. The right leg, erect, is bent at the knee, the foot resting flat against the pedestal. The right elbow rests on the right knee, the hand touching the cheek, and the left arm is braced against the lotus throne. Among the remaining four arms, one holds the jewel, and others carry additional attributes such as the lotus or a rosary.

Among the Nyoirin Kannon images in Japan, this example bears close resemblance to the ninth-century image at the Kanshin-ji in Osaka, which is a National Treasure. In the ninth-century manner, the figure is made of a solid block of wood with almost no hollowing of the body; the arms were carved separately and attached. The full round face and fleshiness of the body are also typical of the early aesthetic, as is the treatment of the drapery and the mixture of large and small "waves" in the folds of the skirt. However, other details suggest the date of this work as later than the ninth century. The sweet expression of the face, created by the thin, upward curving eyes and slight smile, as well as the generally shallow carving of the facial features and drapery all point to Fujiwara characteristics and a date in the late tenth or early eleventh century for this work.

This superb sculpture has been preserved in excellent condition. The double layered circular halo, most of the lotus pedestal, and the jewelry, including the decorative openwork bronze crown and arm bracelets, are all of the period. The image, worshipped as the *honchi* or Buddhist counterpart of the Shinto god, belonged to the Kiyotakimiya shrine in Kamidaigo. The shrine was built in 1089, and it has been suggested that the sculpture also dates to the late eleventh century. However, judging from the stylistic features of the work, an earlier date is more appropriate.

EXHIBITIONS:
Leningrad, Hermitage Museum, May 13–June 22, 1969; Moscow, Pushkin Museum, July 15–August 24, 1969, *Japanese Sculpture.*

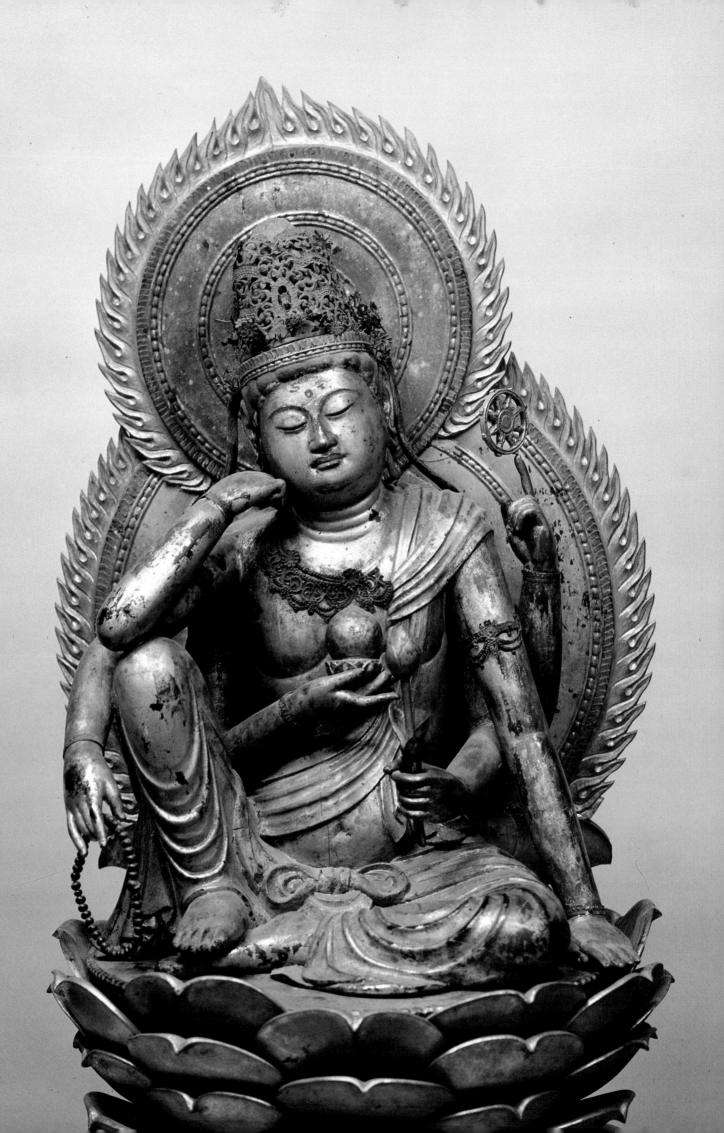

19. Bishamonten

Heian Period, eleventh century
Wood, single block construction
H. 33¾ in (85.3 cm)
Seigan-ji, Kyoto
Important Cultural Property

Bishamonten, Jikokuten, Zōchōten, and Komokuten are the Lokapālas or Guardians of the Four Directions. Bishamonten originated in Indian mythology as Kubera, the Hindu god of wealth and the King of the *Yakṣas,* a class of supernatural beings believed to control human treasure and fortune. One of the first Indian deities to be converted to Buddhism, Bishamonten became a devoted follower of Śākyamuni and is said to have received the name Tamon ("hearing a lot") because he always protected the place the Buddha preached. In Indian and Central Asian Buddhism, Bishamonten has many attributes. A guardian of Buddhist law, he is the Guardian of the North and he is also a god of victory in war and a dispenser of wealth and fortune.

As a Buddhist god, he appears in several other divine groups, such as the Twelve Heavenly Beings (*Jūniten*) and the Twelve Guardian Kings (*Jūnishinshō*). He is also celebrated as an independent deity, with a family which includes his wife Kichijōten as well as his son Zen'nishi Dōji, who also perhaps is Bishamonten as a child.

This image from Seigan-ji represents Bishamonten as an independent deity. Important details of the sculpture include the layered Chinese style armor with its deep folds and crisp details. The animal heads at the top of the sleeves, the demon mask at the waist, and the openwork crown add a rich decorative touch. The pose of Bishamonten here is standard: he tramples a small demon underfoot, his left hand is raised to hold a small pagoda, and the fingers of his right hand curl as though to hold a spear.

Except for the left forearm and the right hand, the entire sculpture including the demon was carved from a single block. The sculpture shows no trace of polychrome, and perhaps because the Heian Period admired directly cut, fresh wood sculpture, the surface was left plain in the manner of *danzō* images popular in the first half of the eleventh century.

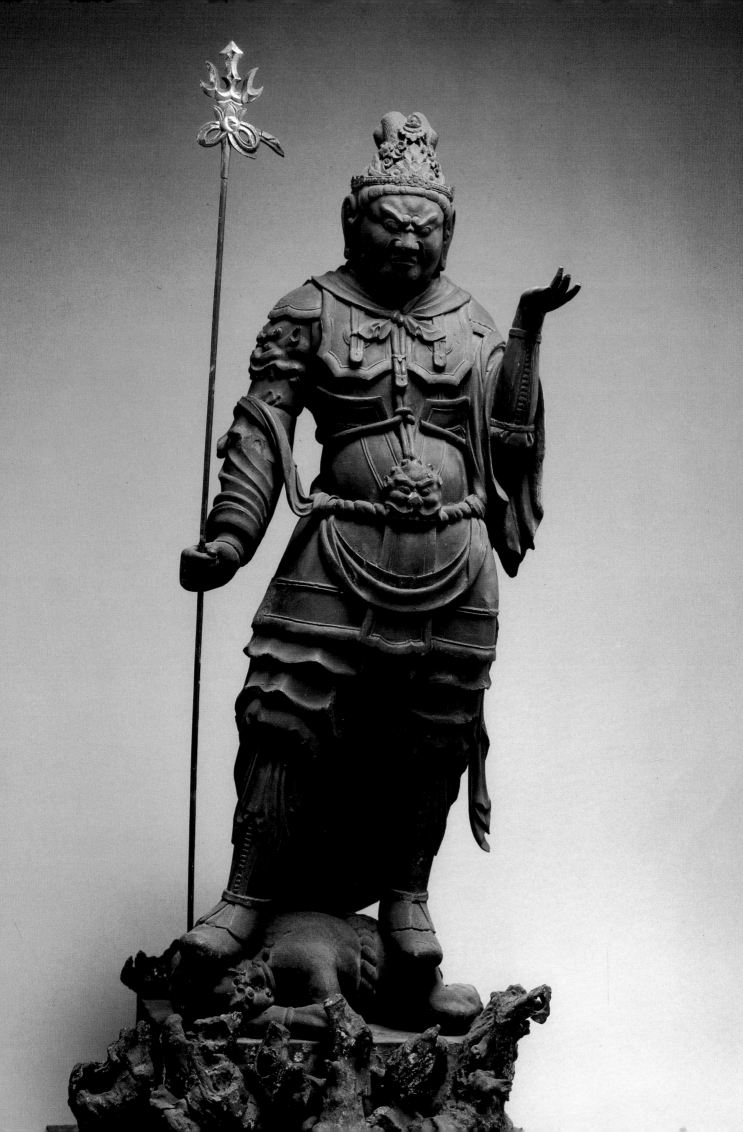

20. Bodhisattva on Clouds

Heian Period, 1053 A.D.

Polychromed wood, joined block construction

H. North 25, 24¼ in (61.5 cm)

 South 4, 23¾ in (60.6 cm)

 South 20, 30½ in (77.3 cm)

Byōdō-in, Kyoto

National Treasure

In the mid-eleventh century when the Fujiwara family was the most powerful force in the court, Fujiwara Yorimichi (990–1074), who was prime minister, had a villa and pleasure resort built on the banks of the Uji river and called it the Byōdō-in. The main hall of the Byōdō-in is surrounded by a pond, and it faces east. It is a beautiful structure with a broad roof, deep eaves, and distinctive architectural features, such as open wings that project to the sides and back and give a feeling of lightness and grace. This building is also called the Phoenix Hall. Though two gilt bronze phoenixes are placed at the ends of the ridgepoles, the name actually derives from the shape of the building, which is likened to a large bird with outstretched wings.

The Byōdō-in contains the most important example of a complete sculpted scene of Amida *raigō*, that is, the descent of the Buddha Amida to greet the soul of the dying devotee. In the temple a large seated gilt wood statue of Amida sixteen feet high is centered on the altar. Above the head hangs a canopy of carved open-work wood; on the sides a host of angelic Bodhisattvas float on clouds playing musical instruments. Painted in mineral colors, the doors and plank walls surrounding the altar showed scenes of Amida's paradise, as well as a complete scene of the *raigō*. Although these paintings have suffered damage, they include scenes of the four seasons, the natural landscape of Uji, and human figures that comprise early examples of the Heian *yamato-e* style.

The fifty-two Bodhisattva figures in sculpted wood are divided into two groups and hang in two layers on the upper walls of the hall on either side of Amida. The Amida statue faces east, and the Bodhisattva musicians occupy all of the north and south walls, as well as portions of east and west corner walls. The sculptures are therefore numbered and identified according to their position, and the three figures included in this exhibition are representative pieces from the group. North 25 sits with its right leg raised, holding a lotus pedestal in front of the seat. The small lotus pedestal represents a dais for the dying soul, and in painted and sculpted *raigō* scenes, this Bodhisattva is commonly identified as Kannon. South 4 kneels with both legs together, and plucking at a long-stringed instrument called a *koto;* South 20 dances, posed with a scarf in both hands, the body twisted and the right foot raised in a rhythmical composition. Not only are these gestures beautiful, but they also indicate a deep spiritual ecstasy that accompanies flying through the air on clouds. The attitude of the figures is clearly discernible even from a distance, not only because the gestures are large, but because greater importance is placed on the composition of each figure than on the depiction of the details. Also, when one looks at these pieces from below, the shape and details of each figure change according to the viewpoint and the portion that is visible.

These charming Bodhisattvas are among the exquisite achievements of Fujiwara art. The folds of the garments are shallow, and the sense of volume in the figures is restrained. Yet the gentle expressions, the fluid lyricism of the drapery, and the decorative boldness of the clouds made these sculptures supreme master-works in the history of Japanese art. Although there are no records about the manufacture of these sculptures, it is believed that the fifty-two Bodhisattva on Clouds were made at the same time as the central image of the Byōdō-in, the famous Amida Nyorai by Jōchō. The material used is Japanese cypress, and the basic form of each figure, including the clouds but excepting the arms, is made from one to two pieces of wood, depending on the shape. The method used is the split and join technique *(warihagi)*. The head and body are

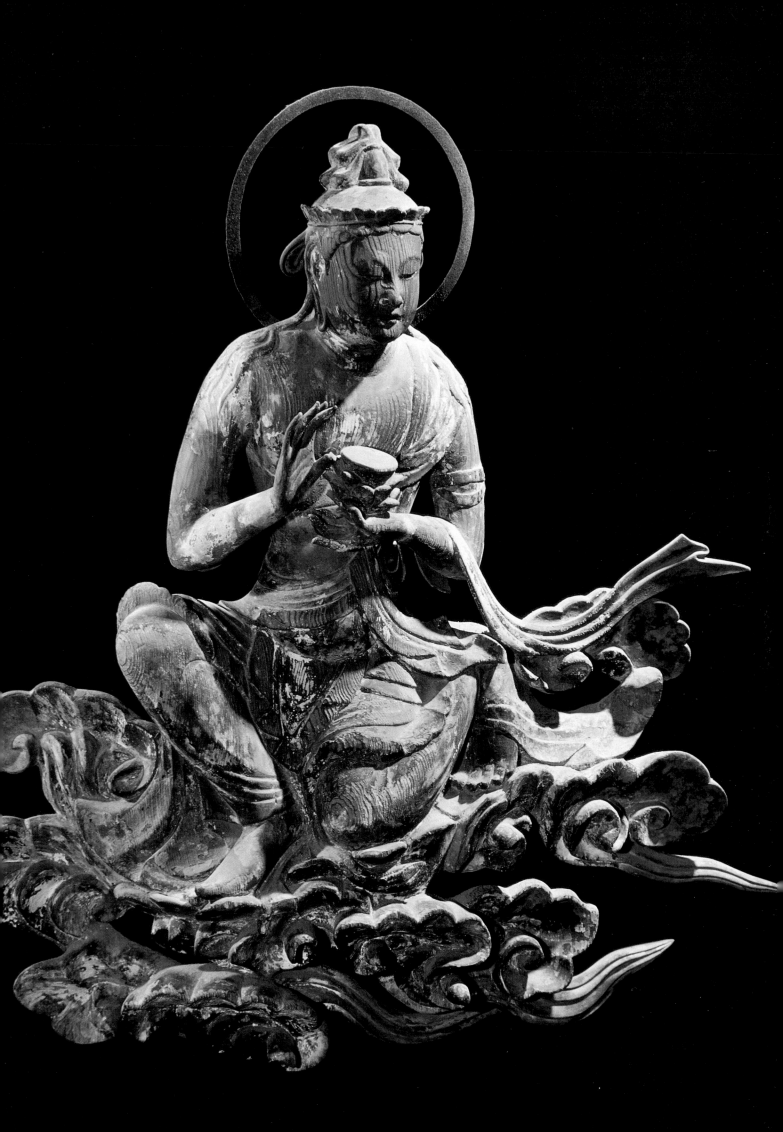

20. Bodhisattva on Clouds

made separately, hollowed out, and then fitted together. The surface was coated with lacquer and painted; then cut gold was applied as decoration. The halos are separate additions in bronze, and nails are embedded in the backs to secure the sculptures to the walls.

On North 25, the cords behind the ears and ear lobes, the hair, the fingers of both hands, the scarves, and clouds are replacements. On South 4, the entire arms, the musical instruments, the ribbons hanging from behind the ears to the shoulders, and the tips of the clouds are replacements. On South 20, the ribbons behind the ears, both arms, the scarves, and the tips of the clouds are replacements. The original polychrome has disappeared and the sculpture surfaces are now bare wood.

REFERENCES:
Mōri Hisashi, "Hōō-dō unchū gunzō no shudai" ("The Motif of the Group of Images on Clouds at the Phoenix Hall"), *Bijutsushi* 3, 1951. Mizuno Keizaburō, "Moku zō unchū kuyō bosatsu" ("Wood Bodhisattva on Clouds"), in Maruo Shozaburō, ed., *Nihon chōkokushi kiso shiryō shusei (A Collection of Source Materials for the History of Japanese Sculpture)* vol. 7, Tokyo, 1969, pp. 27–28, 33, 42–43. Nishikawa Shinji, *Amida-dō to Fujiwara chōkoku (Amida Temples and Fujiwara Sculpture)*, Genshoku Nihon no Bijutsu vol. 6, Tokyo, 1969, pp. 68–69. Mizuno Keizaburō, *Daibusshi Jōchō (The Master Sculptor Jōchō)*, Nihon no Bijutsu 164, Tokyo, January 1980.

EXHIBITIONS:
Paris, Musée National d'Art Moderne, April 15–June 1, 1958; London, Victoria and Albert Museum, July 1–August 15, 1958; The Hague, Gemeentemuseum den Haag, October 1–November 15, 1958; Rome, Palazzo delle Esposizione, December 15, 1958–February 1, 1959, *Art Treasures from Japan*. Los Angeles County Museum of Art, September 29–November 7, 1965; Detroit Art Institute, December 5, 1965–January 16, 1966; Philadelphia Museum of Art, February 13–March 27, 1966; Toronto, The Royal Ontario Museum, April 24–June 5, 1966, *Art Treasures from Japan*. Leningrad, Hermitage Museum, May 13–June 22, 1969; Moscow, Pushkin Museum, July 15–August 24, 1969, *Japanese Sculpture*. Zürich, Kunsthaus, *Kunstschätze aus Japan*, August 30–October 19, 1969; Cologne, Museum für Ostasiatische Kunst, *Kunstschätze und Tempelschätze aus Japan*, November 15, 1969–January 1, 1970.

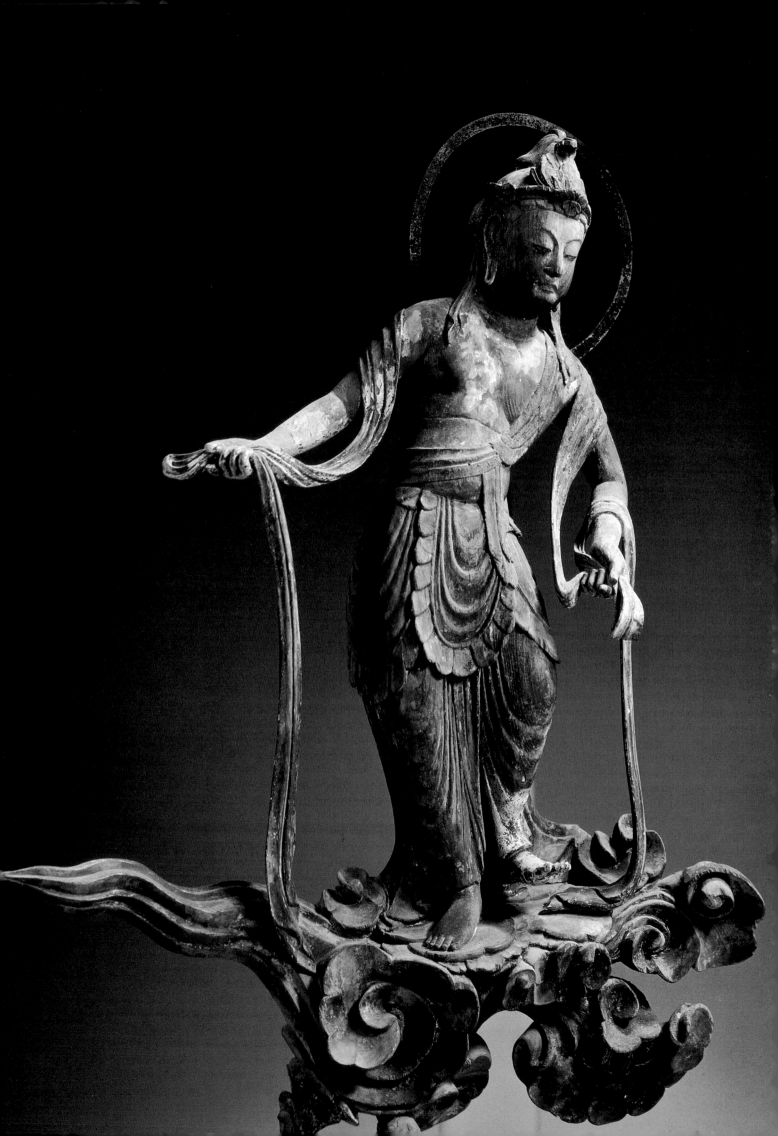

20. Bodhisattva on Clouds

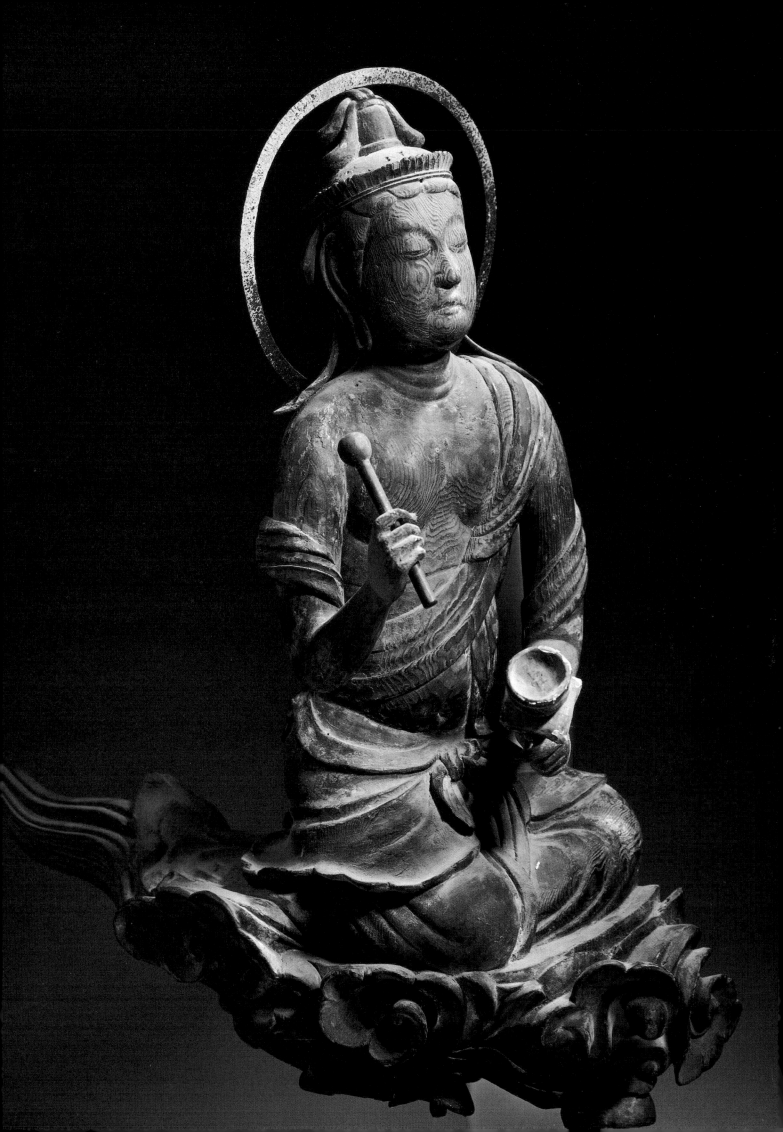

21. Amida

Heian Period, eleventh century
Wood, single block construction
H. 17 in (43.3 cm)
Chōfuku-ji, Shiga Prefecture

This seated image of Amida, like the standing Kannon figure from Renzō-in (cat. no. 22), was finished so that chisel marks are very plainly visible on the surface. Because these works give the impression of having been cut with an ax, they are popularly called *natabori* or "ax-cut" sculptures. It was commonly thought that this type of statuary was simply unfinished because it appears to be the rough-cut *(arabori)* stage in the working of a single block wood sculpture. However, the pattern of chisel marks on a rough surface was apparently prized and appreciated as a special effect. Thus, something that may have begun as an unfinished work gradually came to be regarded as a separate, established style. It has also been suggested that the origin of *natabori* images may be traced to the practice of carving standing Buddha images from living trees growing on mountain tops. Certainly one major advantage in making a *natabori* sculpture is the economy implied in saving both the labor and expense that a completely finished piece requires.

Natabori images did not appear in the large, affluent temples in the capital. They were found instead in provincial areas and were especially numerous in eastern Japan, called the Kantō, in which modern Tokyo is located. This Amida is an unusual example of a *natabori* image made in the Kansai area, close to the traditional capitals. A fine image dating to about the middle of the eleventh century, the Amida is especially interesting for its sweet, gentle demeanor, a feature that firmly associates it with the dominant stylistic trends of the day.

A variety of hard, fine-grained wood that would leave firm marks was used for *natabori* statues. This sculpture was carved almost entirely from a single block of Japanese nutmeg; only the hands were carved separately and attached. The features of the face, body, and clothing were consciously designed by the cuts of the chisel. The face and upper part of the body were cut with a narrow curved blade, the lines calculated to suggest modeling. The drapery and hair were cut in the same manner but with a wider blade, the lines conforming to the shape of the body the way cloth would drape. The surface is left completely plain. These *natabori* statues are very simple, but they demonstrate a superior level of carving and a particularly Japanese love of wood that is very special.

REFERENCES:
Wakimoto Sokurō, "Arabori butsuzō ron" ("A Study of *Arabori*—roughly carved—Sculpture"), *Bijutsu Kenkyū* 32, August 1934, pp. 14–22. Wakimoto Sokurō, "Zoku arabori butsuzō ron" ("A Continuing Study of *Arabori*—roughly carved—Sculpture"), *Bijutsu Kenkyū* 34, October 1934, pp. 12–18. Maruo Shōzaburō, "Yoshino, Uda, Asuka junrei" ("A Pilgrimage to Yoshino, Uda, and Asuka"), *Gasetsu* 49, January 1941, pp. 40–52. Kuno Takeshi, "Natabori to mikanseizō" ("Natabori and Unfinished Statues"), *Bijutsu Kenkyū* 203, March 1959, pp. 1–13.

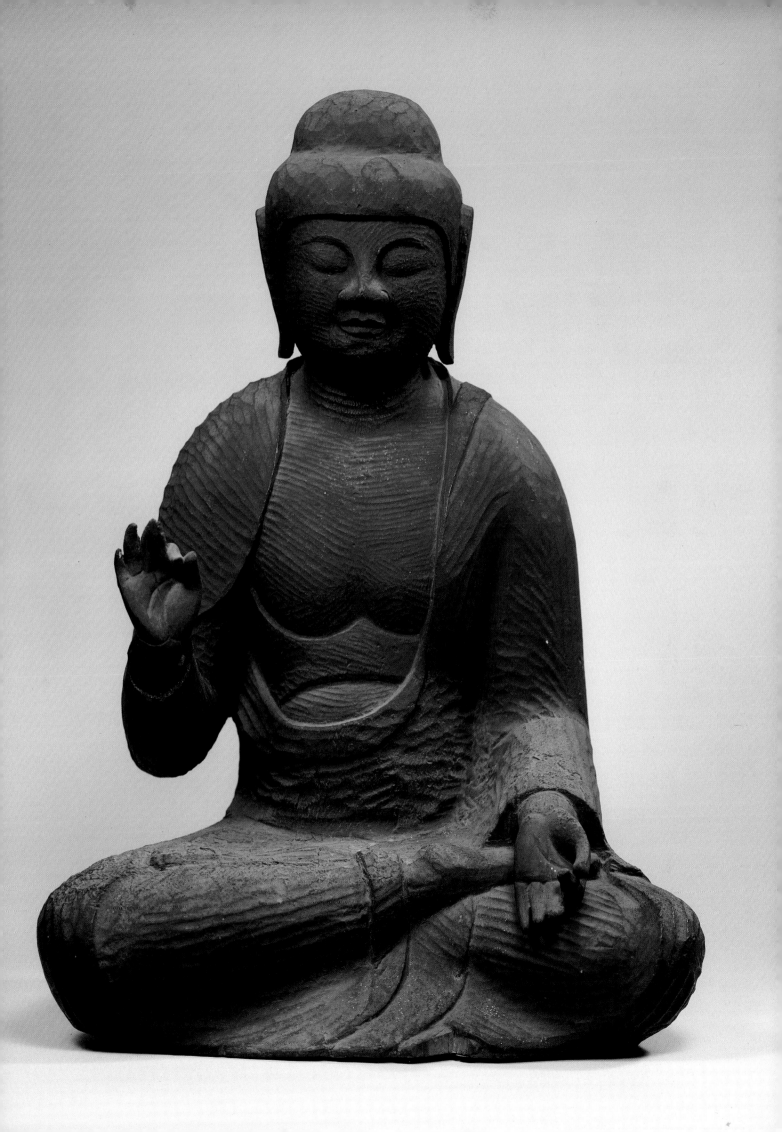

22. Kannon

Heian Period, eleventh century
Wood, single block construction
H. 41½ in (105.5 cm)
Renzō-in, Chiba Prefecture

This statue, a fine example of a *natabori* image, dates to the Late Heian Period. Aside from parts of each arm, the entire image is carved from a single block of Japanese nutmeg. The surface is completely plain except for details of hair, eyebrows, and beard drawn in ink. The style of this work is somewhat different from the *natabori* Amida Buddha from Chōfuku-ji (cat. no. 21). The modeling of the face of the Kannon is flatter, and the wide chisel marks on the fleshy parts of the body, as well as on the clothing, are consciously arranged for decorative effect. Nevertheless, the mid-eleventh century date of production is thought to be appropriate for both.

The strong rustic flavor indicates that the Kannon was made in the provinces, far from the influence of workshops in the capital. However, rough passages in this sculpture, such as details of the face and the odd proportions of the arms to torso, contribute to the lively individuality of this *natabori* image.

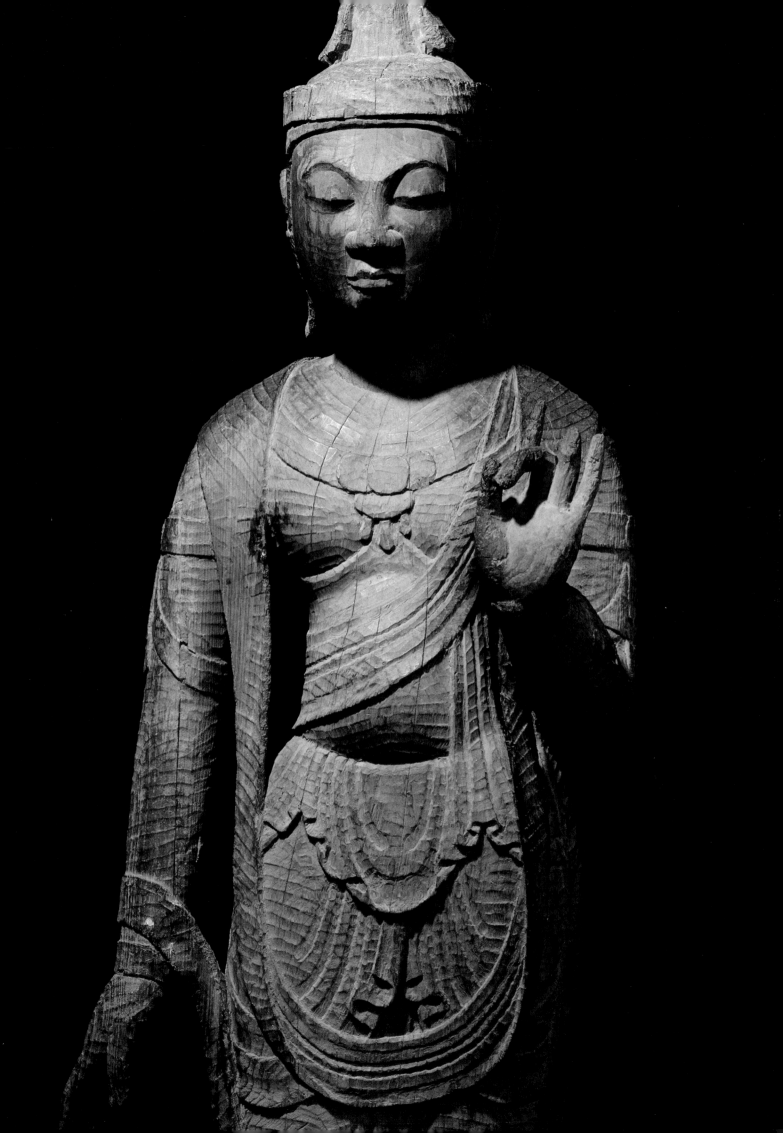

23. Bonten and Taishakuten

Kamakura Period, thirteenth century
Polychromed wood, joined block construction
H. Bonten, 42 in (106.5 cm); Taishakuten, 41 in (104.9 cm)
Takisan-ji, Aichi Prefecture
Important Cultural Property

These two divinities are Hindu gods who were assimilated and transformed into Buddhist gods. Bonten is familiar to students of Indian religion as Brahmā, one of the three great gods of Hinduism. As a primary Hindu deity, Brahmā is the creator of the universe. As a Buddhist divinity, he is said to be endowed with great wisdom, and his mission is that of a protector of Buddhist teaching. In India Taishakuten is Indra, the greatest of the ancient Vedic gods. Retaining his identity as a mighty warrior when converted to Buddhism, Indra became a guardian of the law and a deity popular for his munificence.

In Buddhist iconography Bonten and Taishakuten frequently form a pair of attendants to another divinity. At Takisan-ji, they flank an image of Kannon Bosatsu. The forms of these attendants correspond to the statues of Bonten and Taishakuten, which are in the Lecture Hall of Tō-ji temple in Kyoto, dated to 839. This famous ninth-century pair follows the Esoteric iconography introduced by Kūkai. Bonten has four heads and four arms; he is dressed in a skirt but the upper torso is nude. Taishakuten, on the other hand, is a two-armed figure dressed in armor. Both statues have a third eye placed vertically in the forehead.

The thick color paints on the Bonten and Taishakuten images are a modern restoration. Judging, however, from the style of the images and that of the other statuary in the same temple, these works seem to reflect a transitional period in Unkei's career. An important early project in Unkei's oeuvre is the group of statues made for the Jōraku-ji in Kanagawa Prefecture. Dated to 1189, the five statues—namely, an Amida Triad, a Bishamonten, and Fudō Myōō—exhibit a skillfully produced youthful vigor. In comparison to the Jōraku-ji statues, the Takisan-ji sculptures display an increased decorative feeling apparent in the drapery and a more advanced sense of movement in the composition of each form. Moreover, the stern expression on the face of Taishakuten heralds the appearance of a similarly dark, remote feeling created by the Miroku Buddha at the Hokuen-dō of Kōfuku-ji, which is a product of Unkei's late years.

Temple records state that the Kannon image was made as the main icon of the temple, then called Sōjizen-ji, in 1201 by Unkei and his son Tankei in order to pray for the repose of Minamoto Yoritomo after his death. According to scholars, the style of this Bonten and Taishakuten is appropriate to a 1201 date, and in turn, confirms the verity of the literary sources.

These two statues are made of Japanese cypress used in a basic split and join technique. The body of each figure is composed of two pieces of wood forming front and back halves that are joined on the side. The interiors are hollow, but the walls are left rather thick to permit deep cutting of the surface.

REFERENCES:
Matsushima Ken, "Takisan-ji Shō-Kannon, Bonten, Taishakuten zō to Unkei" ("Unkei and the Images of Shō-Kannon, Bonten, and Taishakuten at Takisan-ji"), *Bijutsushi* 112, 1982, pp. 131–145.

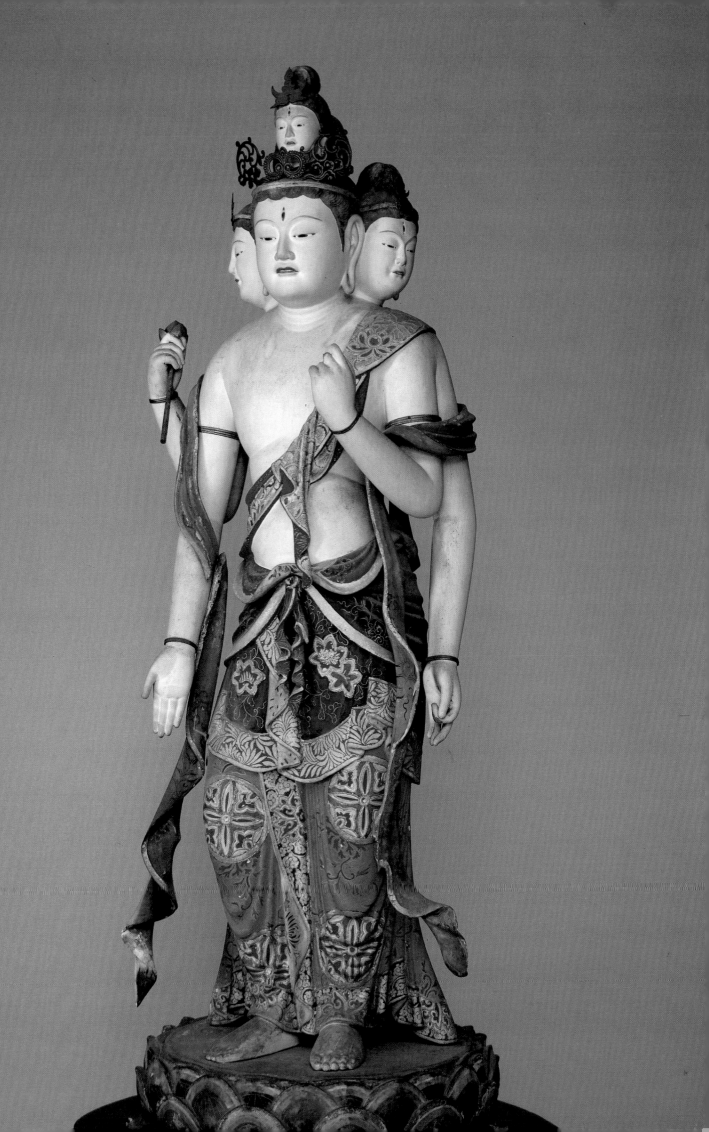

23. Bonten and Taishakuten

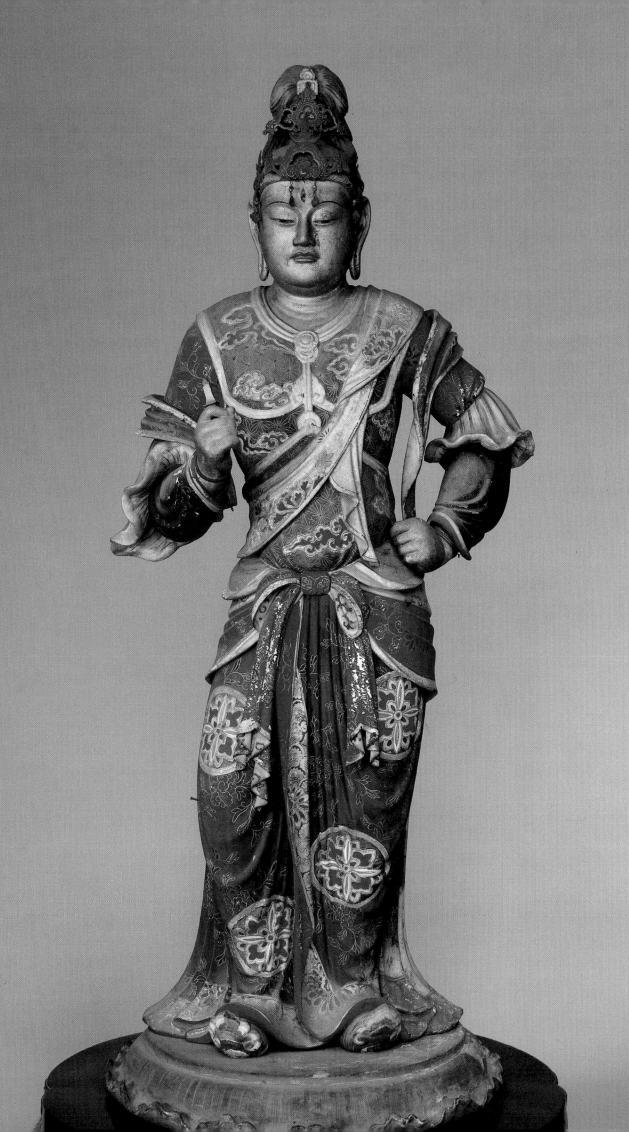

24. Dragon and Sheep, (Two of the Twelve Generals)

Kamakura Period, thirteenth century
Polychromed wood, joined block construction
H. Dragon, 30½ in (77.3 cm); Sheep, 27½ in (69.7 cm)
Tokyo National Museum
Important Cultural Property

The Twelve Generals are a group of armor-clad warrior attendants to the Buddha of Healing, Yakushi Nyorai. Believed to represent twelve parts of Yakushi, they express themselves as twelve vows to protect the law. The Twelve Generals appear to menace or threaten their opponents by ferocious scowls and brandishing weapons. In Japan statues of the group are extant from the eighth century. From about the twelfth century, these guardians became associated with the twelve animals that represent the twelve hours of the day. It became customary to add representations of these twelve animals to the top of the head of each warrior.

The two statues included in this exhibition are from a group of statues that were formerly in the possession of the temple Jōruri-ji in Nara. Although Jōruri-ji is now famous as an Amida temple, it was originally dedicated to the Buddha of healing. It is believed that the Twelve Generals were among the treasures dispersed when the temple fell into ruin in the late nineteenth century. The set of twelve figures is still extant, but the figures are now divided into several collections, including the Seikadō in Tokyo and the Tokyo National Museum.

The warrior called Dragon has the head of a dragon emerging from the top of his own head. The left hand holds the sheath of a sword, and the right hand grasps the handle in a gesture of pulling the sword from the sheath. The figure called Sheep was identified by a sheep's head on top of his own, which is now lost. The pose of this figure is upright and firmly balanced on widely spaced legs, his hands placed on the handle of a long spear, which is missing.

This set of the Twelve Generals has been traditionally ascribed to Unkei. Although the attribution cannot be confirmed, the pieces are clearly works of his studio and dated to the early part of the period. The soft fleshiness of the figures gives the impression of vitality and youth. The disposition of the armor, skirts, and scarves is natural but accompanied by an attractive but moderate decorative quality. Other features, however, such as the proportions of broad, powerful shoulders to short arms and legs, is a step removed from Unkei's classical balance. Thus these pieces reveal an interest in the expressions of movement and changes of form that gains favor with later sculptors.

Both of these sculptures are made of Japanese cypress. In spite of their small size, the pieces were assembled from several pieces of wood in the standard joined block technique. The eyes are crystal, and the polychrome and the gold lacquer decoration were applied over a layer of cloth pasted over the bare wood.

REFERENCES:
Matsushima Ken, "Jōruri-ji kyūzō jūni shinshō zō" ("Twelve Divine Warriors formerly owned by the Jōruri-ji"), *Bukkyō Geijutsu*, May 1974, pp. 74–75. Kaneko Hiroaki, "Den Jōruri-ji kyūzō no jūni shinshō zō ni tsuite" ("On the statues of Twelve Heavenly Generals formerly owned by Jōruri-ji Temple"), *Museum* 359, February 1981, pp. 4–21.

EXHIBITIONS:
San Francisco, M. H. de Young Memorial Museum, *Art Treasures from Japan*, September 6–October 5, 1951. Honolulu Academy of Arts, *Art Treasures from Japan*, February 15–March 31, 1957. New York, The Asia House Gallery, *The Evolution of the Buddha Image*, May 6–June 30, 1963. Los Angeles County Museum of Art, September 29–November 7, 1965; Detroit Art Institute, December 5, 1965–January 1, 1966; Philadelphia Museum of Art, February 13–March 27, 1966; Toronto, The Royal Ontario Museum, April 24–June 5, 1966, *Art Treasures from Japan*.

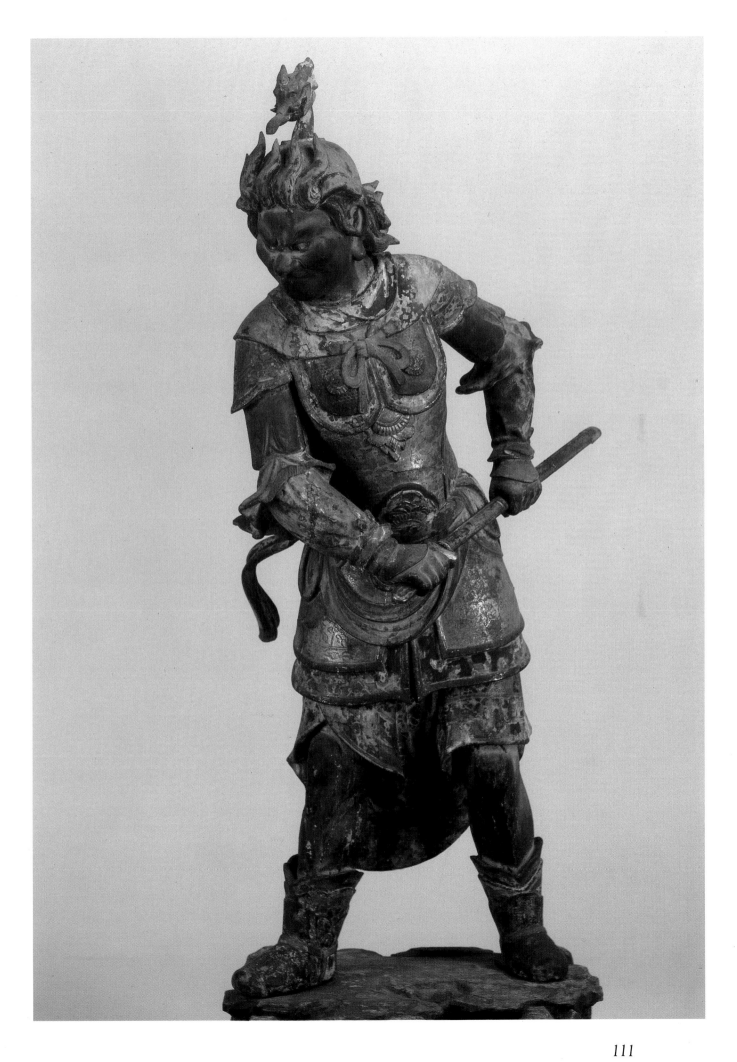

24. Dragon and Sheep, (Two of the Twelve Generals)

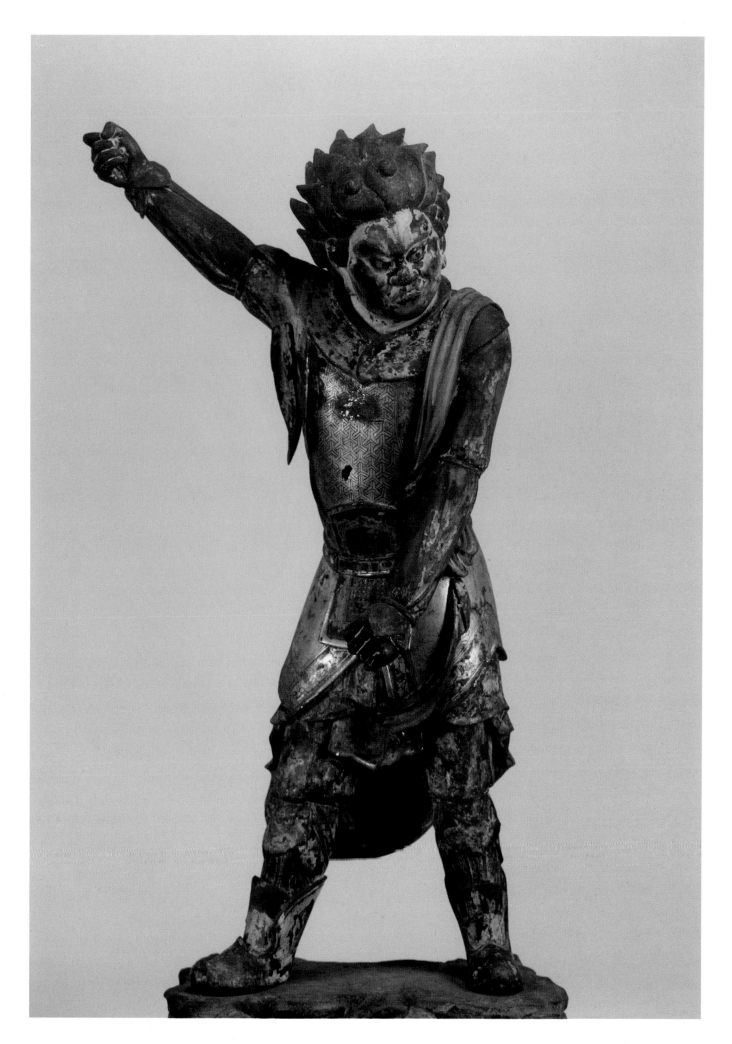

113

25. Amida

By Kaikei (fl. 1185–1220)
Kamakura Period, thirteenth century
Lacquered wood, joined block construction
H. 39½ in (100.1 cm)
Saihō-in, Nara
Important Cultural Property

This lovely statue of the Buddha of the Western Paradise is typical of many that were made in response to the widespread popularity of Pure Land Buddhism from the thirteenth century. The image stands with the left foot stepping forward, his hands forming the gesture of "welcoming to paradise" *(raigō-in)* which signifies Amida's descent from heaven to greet the soul of a faithful devotee at death.

Kaikei is one of the most important sculptors of the Kamakura Period. Early in his life he was associated with the Nara Busshi who, under the direction of Kōkei, produced many important works for the Tōdai-ji and Kōfuku-ji in Nara. One of the most impressive commissions undertaken by the group was the pair of colossal Ni-ō statues guarding the Great South Gate of Tōdai-ji and completed by Unkei and Kaikei in 1203. From the late twelfth century, however, Kaikei's career took an independent turn, and he became famous for the development of a unique style. A major stimulus to his work at this time was his association with a religious group supervised by the renowned priest, Chōgen (1121–1206). After the destruction of some of the great Nara temples during the battles between the Taira and Minamoto families, Chōgen spearheaded a drive to restore the buildings and their sculpture. From 1194 for a period of about ten years, Kaikei was entrusted with a number of commissions connected with the restoration project. This kind of work provided Kaikei the opportunity to develop an independent style based on clear, realistic compositions, which gradually changed to express a delicate, refined beauty. The extant works by Kaikei, which include some twenty pieces that range in date from 1189 to 1221, are numerous enough to provide clear evidence of the changes in Kaikei's style.

The years from 1208, when he received the rank of *hōgen*, into the 1220s, is the final period of Kaikei's career. Although the sculpture is not dated, we know from a signature reading *Kōshō hōgen Kaikei* inscribed on the right foot of this statue that this sculpture is a product of his later years. The correctly balanced proportions, the clear outlines, and consciously designed drapery patterns are features that correspond to other dated works, such as the set of Ten Disciples at the Daihōon-ji in Kyoto, which was made between 1216–20.

This Amida was made of Japanese cypress used in the joined block construction method. The head and body consist of front and back halves joined on the sides. Crystal inserts make the eyes; the hair is painted dark blue. Under the surface tarnish is a coating of lacquer. The sculpture is in excellent condition with only minor damage to the fingers of both hands. The original pedestal and mandorla are lost.

REFERENCES:
Mizuno Keizaburō, "Amida Nyorai ryūzō" ("A Standing Image of Amida Buddha"), *Nara Rokudaiji Taikan (Survey of the Six Great Temples of Nara)* vol. 13, Tōshōdai-ji 2, Tokyo, 1972, pp. 70–71.

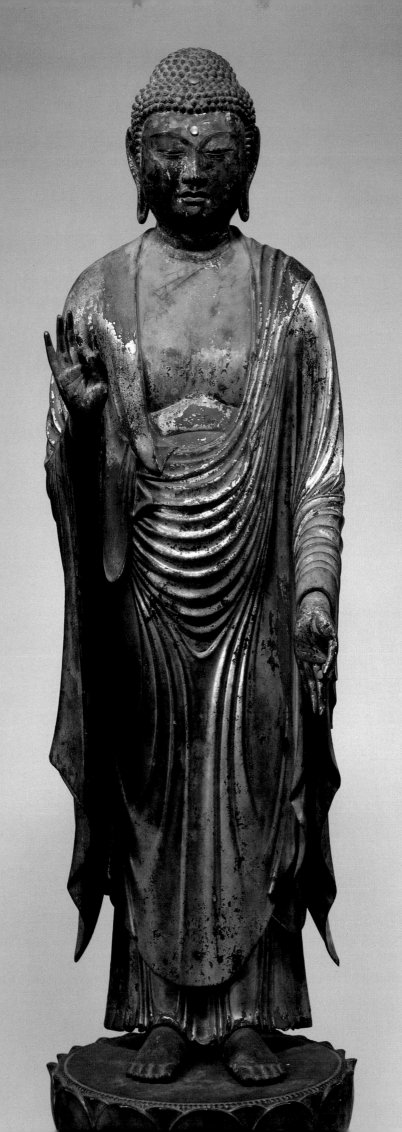

26. Ankoku Dōji

Kamakura Period, thirteenth century
Polychromed wood, joined block construction
H. 43½ in (110.5 cm)
Hōshaku-ji, Kyoto
Important Cultural Property

During the Heian Period, Pure Land Buddhism, which taught that after death the devout joined Amida Buddha in his heavenly Pure Land, enjoyed widespread popularity. Also then popular was the accompanying belief in the philosophy of the Six Roads. This philosophy held that all living beings were reborn into one of six realms of existence. Judgment of the life on earth determined the level of rebirth. These realms were in descending order: Heavenly Beings, Men, Ashura, Animals, Hungry ghost, and Hell.

If mankind descended into Hell, they were confronted with their sins and judged by ten Kings of Hell, who presided over the court appearances of each sinner. The sinner after death faced one of the Kings of Hell on each of the following days: 7th day, 27th, 37th, 47th, 57th, 67th, 77th, 100th day, one year, three years.

From the Kamakura Period, paintings of the Kings of Hell were common. The Kings were frequently represented in sets of ten paintings, with each King shown seated and accompanied by his assistants, Shimei and Shiroku. Dragged by demons, the sinner is shown appearing before the King as Shimei and Shiroku announce the sins committed in his earthly life.

A number of sculptural representations of the Kings of Hell dating to the Kamakura Period are extant, but the sculptures generally show only the King and his attendants. The statue here of Ankoku Dōji is from a group of figures belonging to Hōshaku-ji, which include Emma-Ō (Yama), the King of Hell; the attendants Shimei and Shiroku, who hold square plaques and brushes; and Ankoku Dōji, who is paired with a figure called Guseijin.

Ankoku Dōji is dressed as a clerk in a simple high-necked garment worn over pantaloons. He is seated with one leg suspended on a chair that is spread with an animal skin. His mouth is firmly closed while the eyebrows are raised in a knowing glance. He holds a brush in his right hand, and the left hand holds a long wooden plank. His small hat has propeller-like flaps projecting at the sides. His companion, Guseijin (see fig. 17), forms an interesting contrast to Ankoku Dōji; Guseijin sits holding a scroll in both hands, his eyebrows drawn together and his mouth open, as though he were reading out aloud.

It is unusual to have a King with four attendants. The Ankoku Dōji-Guseijin pair wear slightly different dress from the Shimei and Shiroku in the same set but the two clearly represent the customary assistants of the King. The particular symbols of the pair—one holding a long wooden plank and a brush, and the other reading from an open scroll held in both hands—appear in an iconographic drawing of Emma-Ō in the *Kakuzenshō*, which shows the figures seated on stools and wearing the same garments and hats. The one with the plank and brush is identified as Shimei, while the figure with the scroll is Shiroku.

The Ankoku Dōji is arresting by his wily facial expression and his sturdiness. Exaggerated gestures give life to the plump face. The sculpture is made of Japanese cypress; the head and body are composed of several pieces of hollowed wood, according to the conventional methods of joined block construction. The eyes are crystal inserts. The surface was once finished with polychrome which is now almost completely lost, and the fingers and parts of the sleeves of the garment show evidence of numerous repairs. By an unknown artist, this sculpture is a major work from the first half of the thirteenth century.

It has been suggested that this Ankoku Dōji-Guseijin pair may be the work of In school sculptors (see cat. no. 29). The shallow folds of the clothing, the thinness of the wood at the edges of the sleeves, the restrained and conservative handlings are all characteristics of this school. It is known that two sculptors active in the early thirteenth century, Inhan and Inun, made an Eleven-headed Kannon for the Hōshaku-ji temple in 1233, and it is thought possible that the Kings of Hell are also products of the same time.

116

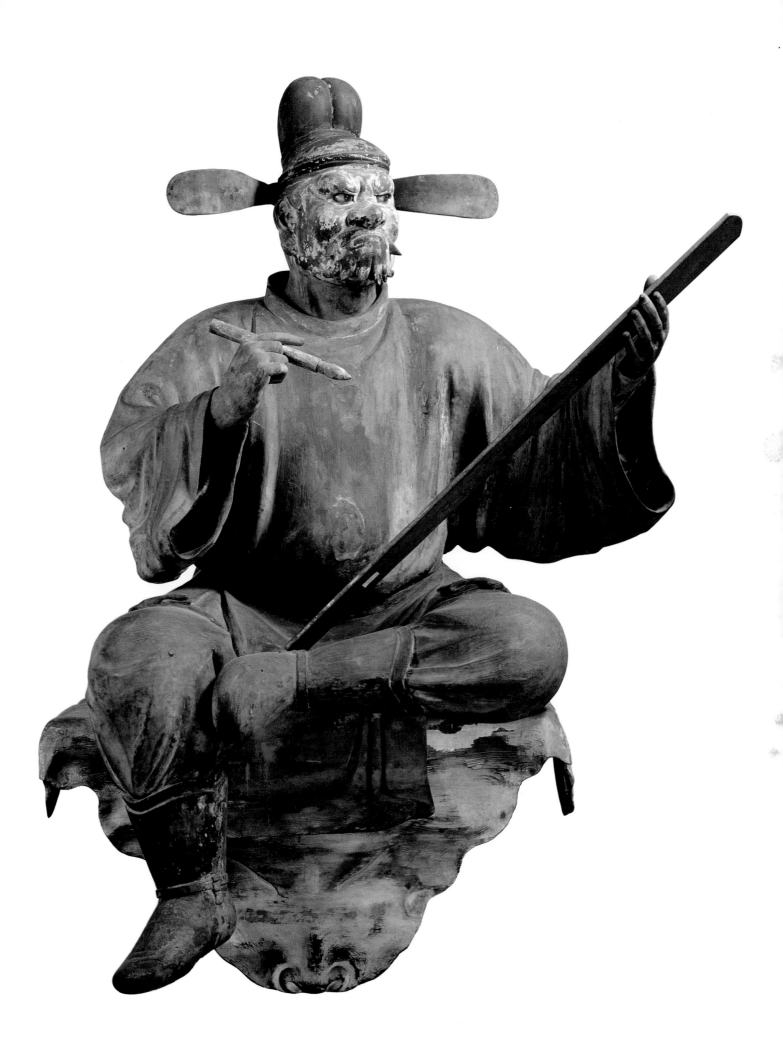

27. Shōtoku Taishi

By Keizen (active mid-thirteenth century)
Kamakura Period, 1247 A.D.
Polychromed wood, joined block construction
H. 55¼ in (140.9 cm)
Tenshū-ji, Saitama Prefecture
Important Cultural Property

This image of a youthful nobleman, his brow wrinkled in an expression of intense concern, is an imaginary portrait of the great Prince Shōtoku at the age of sixteen. Particular features of this portrait—the hair tied in bundles above the ears, the priest's surplice worn over a long, high-necked cloak, and the long handled incense burner held in the hands—are standard to a type of Shōtoku portrait called the filial piety form (kōyō in Japanese). Other forms of Shōtoku include a mantra chanting form (nama butsu), which portrays the Prince as an infant, and a prince regent form (sesshō), which shows him as an adult holding a scepter. The filial piety form of the Prince is believed to be based on a passage recorded in the collection of Shōtoku legends of 917, called the Shōtoku taishi den ryaku. According to this legend, the sixteen-year-old Prince nursed his ailing father, the Emperor Yōmei (r. 585–87), and refusing food and water prayed for his father's recovery.

From the seventh through the fourteenth century, the memory of Shōtoku Taishi remained a dominant ideal in Japanese culture. The cult associated with him grew to such an extent that he was deified and worshipped during the Kamakura Period as a form of the Bodhisattva of compassion, Kannon. The Tenshū-ji sculpture is one of many that were produced during the thirteenth century when faith in Shōtoku reached an especially intense level. According to an inscription inside the image, this sculpture was commissioned by Mōri Suemitsu to pray for the repose of his parents in paradise. Mōri, the fourth son of Ōoe Hiromoto (1148–1225), who was an advisor to Minamoto Yoritomo, held a post in the Kamakura Bakufu but entered the priesthood in 1219.

The inscription inside the statue dates this work to the fifth year of the Kongan era, which is 1247, and states that it was made by a master sculptor named Keizen. Nothing is known about this artist, and to date, no other sculptures by him are identified. However, because he uses the character kei in his name, he was undoubtedly a member of the Kei school, the most prominent group of sculptors active during the Kamakura Period. From a stylistic viewpoint as well, this work conforms to Kei school canons. The face of Shōtoku has a severe, masculine expression, and the body conveys volume. The treatment of the drapery is especially notable because the large, deeply cut drapery folds bear close comparison to the Muchaku and Seshin portraits created by Unkei in 1212 for the Hokuen-dō of Kōfuku-ji. Compared to Unkei's sculptures, which are the masterworks of the period, the Shōtoku portrait by Keizen exhibits a feeling of inert solidity and a loss of plasticity. However, these characteristics are typical of thirteenth century works made in the Kantō area around Kamakura. The quality of execution and the inscription make this work one of the most important of the period.

The sculpture is made of Japanese cypress. The head and trunk of the body are composed of four separate parts joined in front and back and down the sides. The sculpture is hollow; the eyes were inserted with crystal; the bundles of hair and pedestal are later replacements.

REFERENCES:
Sugiyama Jirō, "Tenshū-ji Shōtoku taishi zō" ("Statue of Prince Shōtoku at Tenshū-ji Temple"), Bijutsushi, July 1958, pp. 15–23. Matsushima Ken, "Keizen saku Shōtoku taishi zō, Tenshū-ji" ("A Standing Image of Prince Shōtoku by Keisan"), Kokka 1001, June 1977, pp. 43–44.

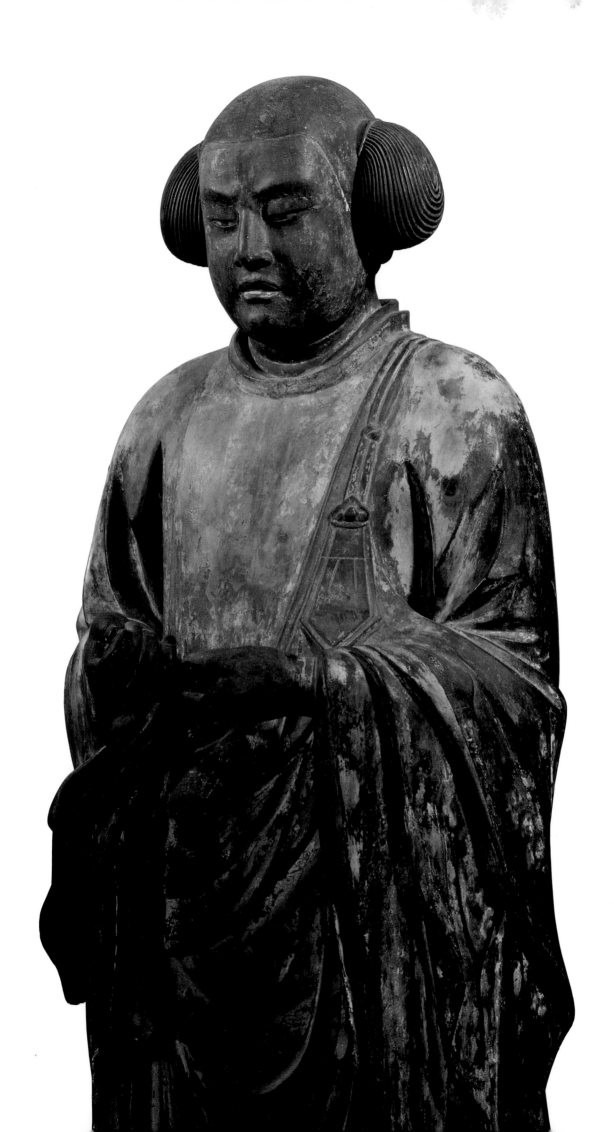

28. Portrait of a Priest

Kamakura Period, second half of the thirteenth century
Polychromed wood, joined block construction
H. 32¼ in (87.8 cm)
Tōfuku-ji, Kyoto
Important Cultural Property

This life-size sculpture of a priest, who wears a monk's surplice, and whose hands are held in *añjali-mudrā*, is a distinctive and individualistic portrait. In the absence of any inscription or literary sources, the precise identify of the sitter is not clear. However, because the right eye of the figure squints, it is thought that the sculpture was created as a realistic portrayal of the first abbot of the Zen temple Tōfuku-ji, Enji Ben'en (1201–80), who is known posthumously as Shōichi Kokushi. Enji Ben'en suffered with an eye disease, and he lost the sight of his right eye in 1253 when he was fifty-two. The meditative posture is unusual for a Zen master. The typical Zen portrait is the *chinzō*, which depicts the sitter in a chair, his robe entirely covering the front of the legs. This departure from standard form complicates the identification of the sitter.

The sculpture conveys impressive fortitude. The thick fleshiness of the figure is faithfully represented, and especially from the side, the figure is majestic and imposing. The broad, undulating folds of the robe also contribute to the sense of largeness and power. The modeling of the face is very individualistic, not only because of the eyes, but also of the heavy nose, lips, and high cheeks. The face is that of a man around fifty, and the expression is both masculine and sensitive.

The technical features exhibited by this statue are characteristic of a number of excellent portrait sculptures from the second half of the thirteenth century. The wood is Japanese cypress. The head is composed of a back and front half, and the front torso, including the arms, is made of four pieces of wood joined along a center line. The back is made of two parts, and the legs are carved from a single piece. The interior is hollowed, and crystal eyes are inserts.

In its present state the statue appears to be a dark color. It is thought that the bare wood surface was covered with cloth to which a coating of dark lacquer was applied before a final layer of pigments was added. The general construction method and certain other details, such as the thickness of the plank covering the hollow in the back and the raised plank that closes off the interior of the image on the bottom, bear close correspondences to Kei school sculptures of similar date. Therefore this outstanding work appears to be a product of the most important workshop of the period.

REFERENCES:
Tanabe Saburōsuke, "Tōfuku-ji no Kamakura chōkoku" ("Kamakura Period Sculpture at Tōfuku-ji"), *Museum* 296, 1975, pp. 7–9.

EXHIBITIONS:
Cologne, Museum für Ostasiatische Kunst, January 12–March 11, 1979; Zürich, Helmhaus Museum, April 1–May 6, 1979; Brussels, Musées Royaux d'Art et d'Histoire, May 24–June 25, 1979, *Plastik aus Japan.*

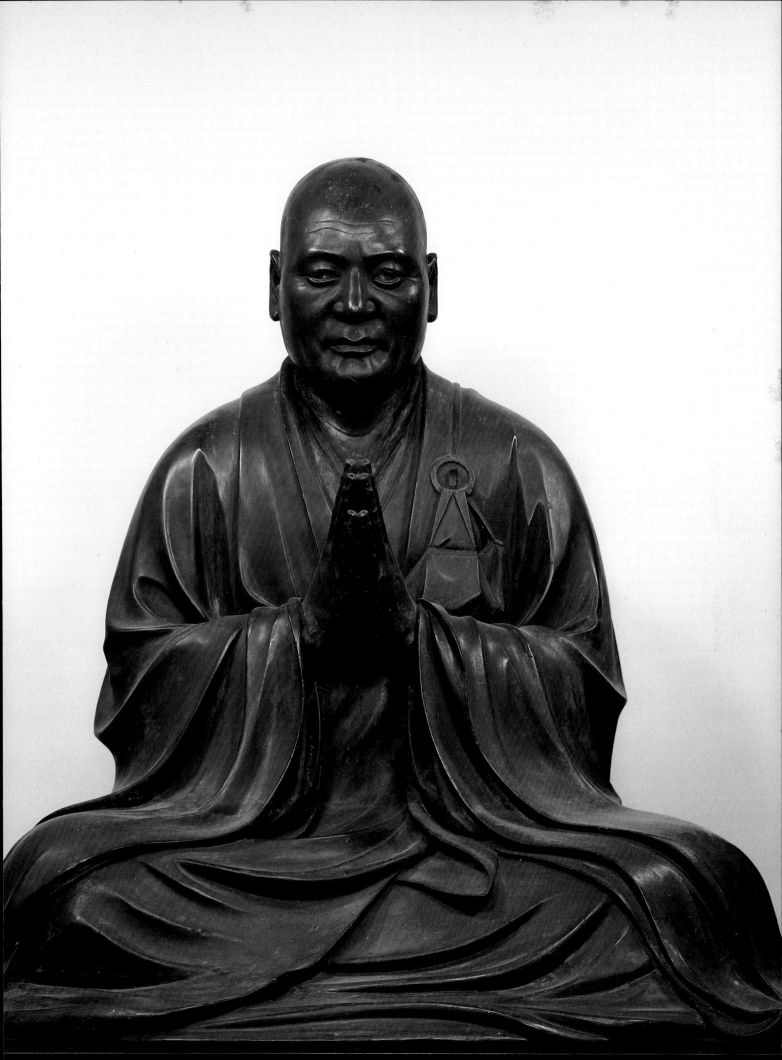

29. Prince Siddhartha

By Inchi (active mid-thirteenth century)
Kamakura Period, 1252 A.D.
Polychromed wood, joined block construction
H. 21½ in (54.2 cm)
Ninna-ji, Kyoto
Important Cultural Property

Siddhartha is the name for Shaka, the historical Buddha, prior to his enlightenment and preaching. The young prince sits in a meditative posture dressed in richly decorative garments. The *ūrṇā*, a curl of hair in the center of the forehead, here represented by a crystal, and the long earlobes, are among the thirty-two marks that signify the superhuman qualities appropriate to a Buddha or Bodhisattva. Because tying the hair into a bundle above each ear was an ancient hairstyle for Japanese children, this particular form for a youthful figure is regarded as original to Japan. Especially because of the hairstyle and of the Chinese garments he wears, this image was long identified as a filial form of Prince Shōtoku (see cat. no. 27), which was a popular image during the Kamakura Period.

During a repair in the early part of this century, a sheet of paper found inside the statue identified the sculpture as a representation of Siddhartha. This enlightening document is also important for naming the sculptor as Inchi and for recording the date of the work as the fourth year of the Kenchō era, or 1252.

The In school of sculptors was one of the Kyoto-based groups whose origins can be traced to the workshops of the eleventh-century master Jōchō. This group is associated with a conservative style, one that preserved the bland, refined beauty of the previous Heian Period and stood apart from the mainstream of artistic development during the early Kamakura Period. Indeed, while it is common to encounter In school artists in the fourteenth century, this statue of Siddhartha is a rare example of a signed In school work from the thirteenth century. Aside from this work, the sculptor Inchi is otherwise unknown in the history of Japanese art, but it is thought that he may have been one of the many artists involved in the repair and restoration of another major temple in Kyoto, the Rengeō-in, which was taking place at the same time (see cat. no. 30).

The face of this Siddhartha has full cheeks and delicate features that convey the impression of an aristocratic youth. The way the folds of the drapery conform to the body expresses a realism appropriate to the period. The Chinese-style garment is also conspicuous for its decorative quality in the scalloped collar and sleeves, which suggest the assimilation of Sung Chinese influences. This sculpture is a beautiful work of art and is in no way inferior to Kei school sculptures of the same time.

The image is assembled from joined blocks of Japanese cypress. Crystal eyes are inserted and the surface of the figure was first lacquered, painted and then decorated with cut and pasted gold foil.

REFERENCES:
Shimizu Masumi, "Inchi saku Shitta taishi zō" ("A Seated Image of Prince Siddhartha by Inchi"), *Kokka* 1001, June 1977, pp. 9–10.

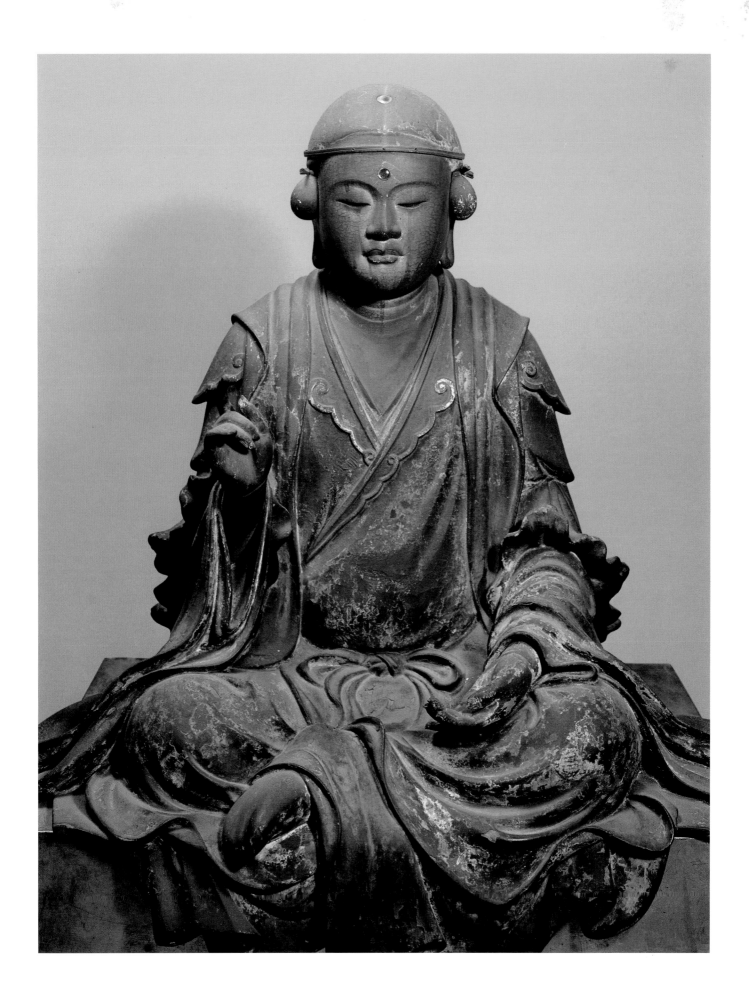

123

30. Misshaku-kongō and Naraen-kengo

Kamakura Period, mid-thirteenth century
Polychromed wood, joined block construction
H. Misshaku-kongō, 66¼ in (167.9 cm)
 Naraen-kengo, 64¼ in (163.0 cm)
Myōhō-in, Kyoto
National Treasure

These two handsome, half-nude deities are part of a set of thirty sculptures belonging to the Rengeō-in, a subtemple of the Myōhō-in. These deities derive from ancient Indian origins. Misshaku-kongō, called Vajrapāni in Sanskrit, is in some texts a reference to Indra. Naraen-kengo is a form of a god Viṣṇu, a benevolent deity who is the Preserver in the Hindu trinity. In China and Japan, Misshaku-kongō and Naraen-kengo are more commonly known as *kongō rikishi,* or "vajra wielding strong men," and when paired, they are the Ni-ō, a form of fierce guardians who stand watch beside temple gates. A survey of the statues indicates that the contrapposto poses, the ribboned topknot on a smooth head, and the distinction between an open-mouthed figure called "Ah" and a closed-mouthed figure called "Un" are consistent characteristics over the centuries.

The main hall of the Rengeō-in is dedicated to a Thousand-armed form of the Bodhisattva Kannon. The hall is a long structure that contains 1001 statues of the Thousand-armed Kannon as well as the set of attendants called the Twenty-eight Bushū. Built in 1164 at the request of the senior retired Emperor Goshirakawa (1127–92), the temple burned in 1249, reducing most of the building and sculpture to ashes. A restoration of the temple began immediately, and this massive project, which required the carving of almost a thousand new statues, involved most of the sculptors living in the city of Kyoto at that time.

Although the name Twenty-eight Bushū suggests a fixed number of statues, the Rengeō-in set consists of thirty statues that include some of the most remarkable examples of Kamakura realism. The Ni-ō included here are stunning masterworks. They strike angry poses, and their skirts and scarves swing in response to the directions of their movement. They are very muscular, with sinew and blood vessels carved to stand out clearly on their taut bodies.

In spite of their individualized faces, these two statues were purposefully designed as a pair. The treatment of the bodies is most refined because the chief aim of the sculptor was the beauty of form. Although many of the thousand Bodhisattva figures created for the temple during the restoration are inscribed with artist's names, curiously the set of thirty attendants is not inscribed, and the exhibited statues are neither firmly dated nor attributed. Though a number of theories concerning the production of the group have been suggested, it seems most appropriate to regard these works as having been produced as a group during the restoration. The thirty statues within the set are of uneven quality which suggests a number of different

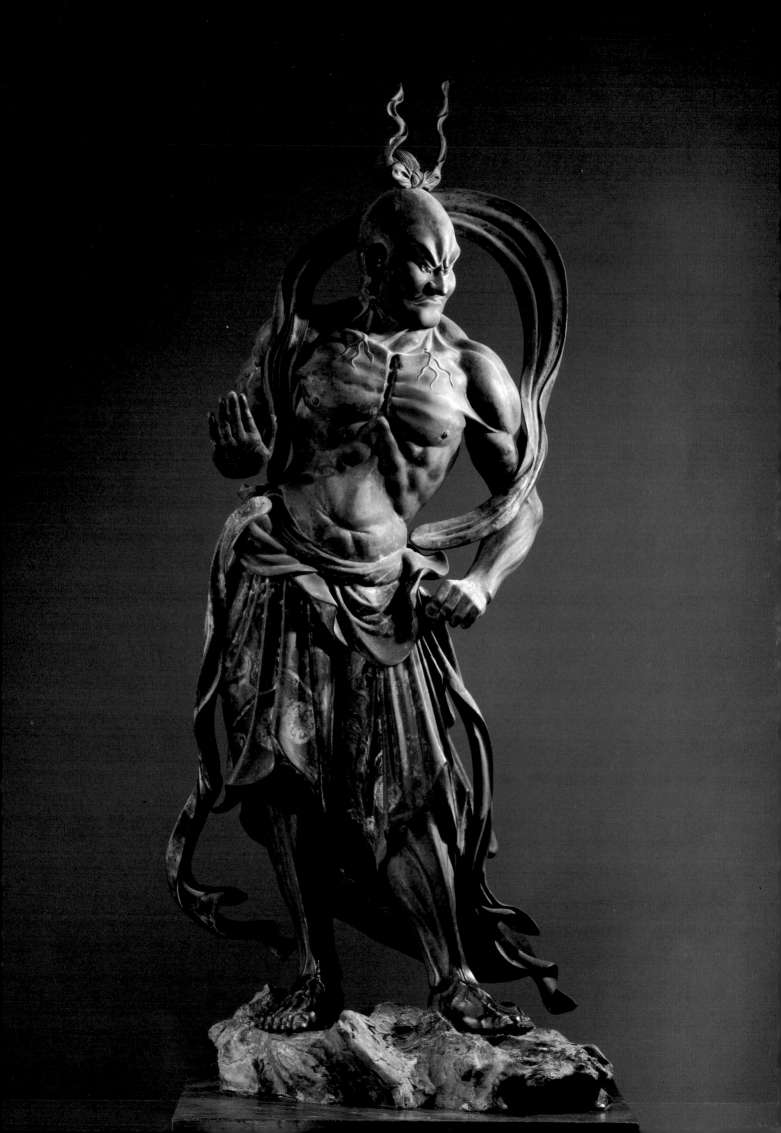

30. Misshaku-kongō and Naraen-kengo

hands. However, the best pieces, including this Ni-ō pair, exhibit elegant, elongated bodies and a suppression of busy details in order to emphasize overall design. Such features are associated with the work of Tankei in his last years, and the set to which these Ni-ō belong is often attributed to his supervision.

The sculptures were produced in the joined block technique using Japanese cypress. The walls of these statues are thin, as the hollow was cut very deep. The statues are painted, and the eyes are crystal. The fingers, parts of the scarves, and the pedestals are later restorations.

REFERENCES:
Kobayashi Takeshi, "Daibusshi hōin Tankei" ("Tankei, a Buddhist Sculptor of the 13th Century; His Life and Work"), *Yamato Bunka* 12, December 1953, pp. 11–21. Maruo Saburōsuke, *Rengeō-in hondō, sentai senjū Kannon bosatsu shūri hōkokusho* (*Restoration Report on the Main Hall of the Rengeō-in and the 1000 Statues of Kannon Bosatsu*), Kyoto, 1961. Mōri Hisashi, "Rengeō-in hondō no chōkoku, Nijūhachi Bushū, Furaijinzō" ("The Sculpture of the Rengeō-in, the Twenty-eight Bushū and Wind and Thunder Gods"), and Nishida Masaaki, "Nijūhachi Bushū no kanshō" ("An Appreciation of the Twenty-eight Bushū") in: Akamatsu Toshihide, ed., *Sanjūsangendō*, Kyoto, 1961, pp. 99–102 and 103–108, respectively. Tanabe Saburōsuke, "Kamakura chōkoku no tokushitsu to sono tenkai—Tankei yoshiki no seiritsu o chūshin ni" ("The Characteristics and Development of Kamakura Period Sculpture—with special reference to the establishment of the Tankei style"), *Kokka* 1000, May 1977, pp. 33–45. Kurata Bunsaku, *Ni-ō zō (Ni-ō Statues)*, Nihon no Bijutsu 151, Tokyo, December 1978.

EXHIBITIONS:
San Francisco, M. H. de Young Memorial Museum, *Art Treasures from Japan*, September 6–October 5, 1951. Paris, Musée National d'Art Moderne, April 15–June 1, 1958; London, Victoria and Albert Museum, July 1–August 15, 1958; The Hague, Gemeentemuseum den Haag, October 1–November 15, 1958; Rome, Palazzo delle Esposizione, December 15, 1958–February 1, 1959, *Art Treasures from Japan*. Los Angeles County Museum of Art, September 29–November 7, 1965; Detroit Art Institute, December 5, 1965–January 16, 1966; Philadelphia Museum of Art, February 13–March 27, 1966; Toronto, The Royal Ontario Museum, April 24–June 5, 1966, *Art Treasures from Japan*. Zürich, Kunsthaus, *Kunstschätze aus Japan*, August 30–October 19, 1969; Cologne, Museum für Ostasiatische Kunst, *Kunstschätze und Tempelschätze aus Japan*, November 15, 1969–January 11, 1970. Staatliche Museum zu Berlin, May 3–June 16, 1974; Dresden, Staatliche Kunstsammlungen, July 1–August 14, 1974, *Japanische Kunst aus drei Jahrtausenden*.

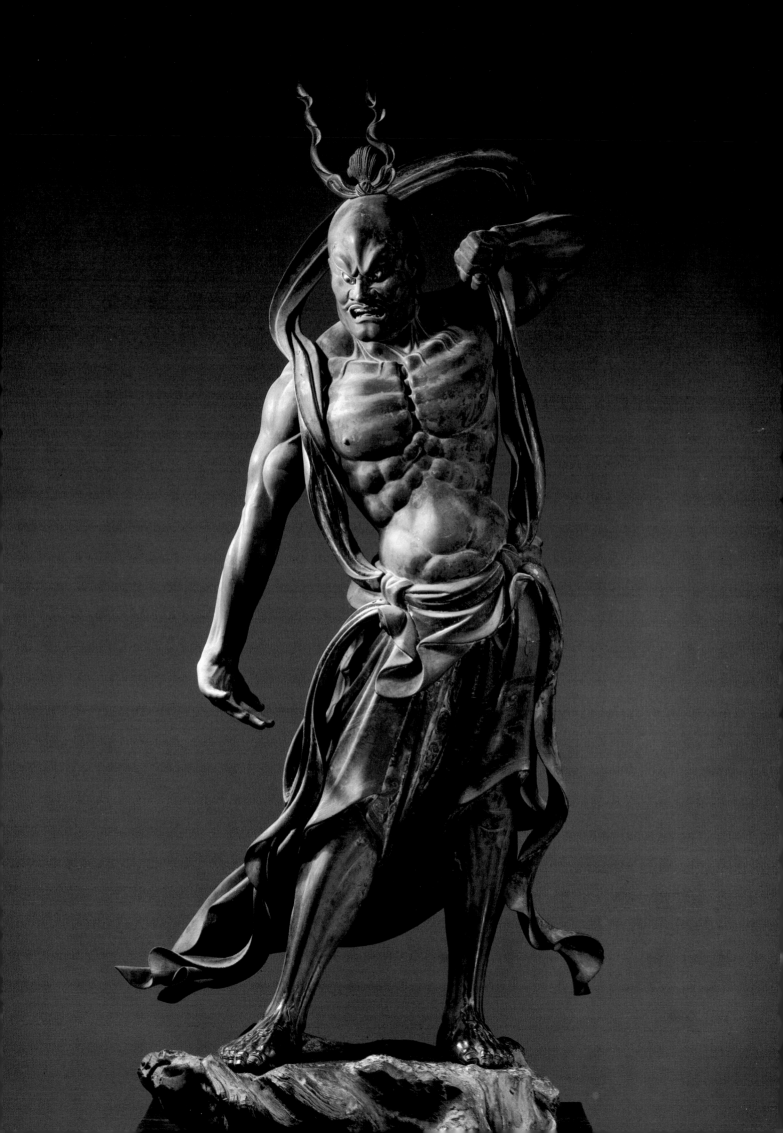

31. Portrait of a Priest (Taira Kiyomori?)

Kamakura Period, thirteenth century
Polychromed wood, joined block construction
H. 32½ in (87.7 cm)
Rokuharamitsu-ji, Kyoto
Important Cultural Property

The vivid realism of Kamakura sculpture is emphatically expressed in the many portraits from the period. The majority of portrait sculptures made in Japan are idealized statues created as objects of worship. From the beginning of the Kamakura Period, the Kei school of sculptors in particular took an interest in producing individualized works that reveal expressive facial features and suggest the age and character of the sitter. Realistically rendered portraits by Kōkei and Unkei of famous early monks are among the great sculptures of the early Kamakura Period. Other types of portraits that add variety to the form include sculptures of living priests, which were carved from life, secular lay portraits, the *chinzō* portraits of Zen masters, and portraits that express movement. The portrait included here belongs to the last category. This statue of a priest was designed to face to the right. He holds a sutra with both hands and tilts it toward the light that penetrates from the right. The loose robe, open in front to expose the neck and chest, conveys a relaxed and comfortable feeling. The nose, high cheeks, and chin are sensitively modeled. The head leans forward, the eyes glancing upward, and the thick lips appear to be murmuring a line of scripture. These qualities all contribute to the individuality and sense of activity in the portrait.

No records exist to confirm the identity of the sitter. The suggestion that this sculpture was intended to portray Taira Kiyomori (1118–81), the great leader of the Taira clan and the dominant military figure of the late twelfth century, arises because the Rokuharamitsu-ji was built on land belonging to the clan. Moreover, because the interest of the sculptor was in expressing a psychological mood, the dark and gloomy impression the work leaves seems appropriate to the fate of Kiyomori. A proud and arrogant man, Kiyomori successfully established control over the entire country, but in his last days he had to face military opponents, illness, and the destruction of his entire family. Although this sculpture could not have been a living portrait of Kiyomori, this outstanding work attests to the sense of tragedy the name of Kiyomori inspires.

The statue is hollow; the head and body of the statue are composed of two blocks of Japanese cypress joined at the center. The layers of lacquer and pigments have largely flaked off, and particularly on the face, the bare wood surface is visible. The scroll and the pedestal are later replacements.

REFERENCES:
Nishikawa Kyōtarō, "Kamakura jidai no shōzō chōkoku to sono tokushitsu" ("Portrait Sculpture in the Kamakura Period and Its Characteristics"), *Kokka* 1001, June 1977, pp. 31–41.

EXHIBITIONS:
Montreal, Expo Art Gallery, *International Exhibition of Fine Arts*, April 28–October 27, 1967.

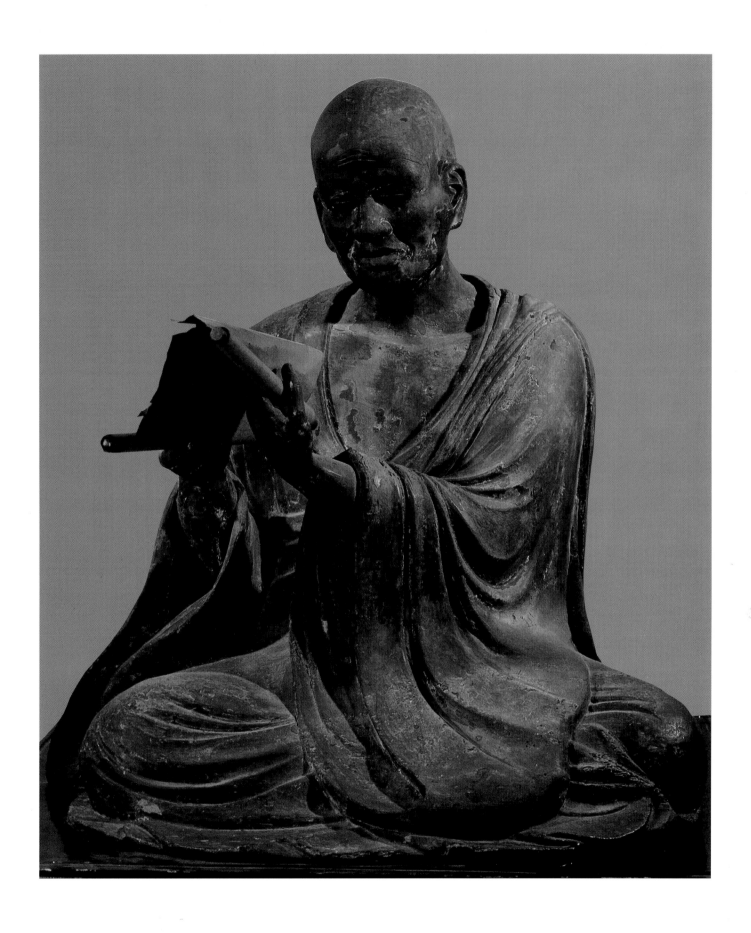

32. Kichijōten

Kamakura Period, thirteenth century
Polychromed wood, joined block construction
H. 26¾ in (67.6 cm)
Onjō-ji, Shiga Prefecture
Important Cultural Property

In Japanese Buddhism, Kichijōten is the goddess of wealth and beauty. She derives from the Indian Brahmanic divinity Śrī Lakṣmī, who is associated with Kubera, the god of wealth. In Japan, faith in Kichijōten became widespread during the Nara Period, possibly because her promises of prosperity assured her popularity. Images of Kichijōten in painting and sculpture are common from the eighth century when she became the principal image at a New Year's ceremony called kisshō keka, which attempted to sweep away calamity and invite good fortune.

Kichijōten is traditionally shown with a full, fleshy body, and plump, round face, and she wears magnificent garments and jewelry characteristic of a lady of the T'ang court. Like the famous painting of Kichijōten at Yakushi-ji, which dates to the eighth century, she commonly holds the "wish granting" jewel in her left hand, while the right hand holds a lotus flower or makes the vara-mudrā of charity. Because the jewel and the vara-mudrā are displayed by the Onjō-ji Kichijōten from the thirteenth century, it appears that the iconographic features remained relatively constant throughout the centuries.

The round, full face of this image, the ample fleshiness of the torso, and the proud, elegant pose recall the classic style of the Late Nara Period. The gown is, however, a clue to the thirteenth-century date of this statue. The full sleeved robe, which overlaps in front, has a wide shawl-like collar with a scalloped edge draped around the goddess's shoulders. This style of dress is found in Japan only on sculptures of female deities in the Kamakura Period, and is indicative of the influence of Sung Chinese art on the sculpture of the period. A second indication of the date of this statue is the realism of the face. The stable, dignified form befits a religious image, but the face suggests that the sculptor intended to create a work which expresses the personality and character of a real woman.

Made of Japanese cypress, the sculpture is composed of two hollowed pieces that form the back and front and are joined on the sides. The sculpture is polychromed, and the eyes are crystal inserts.

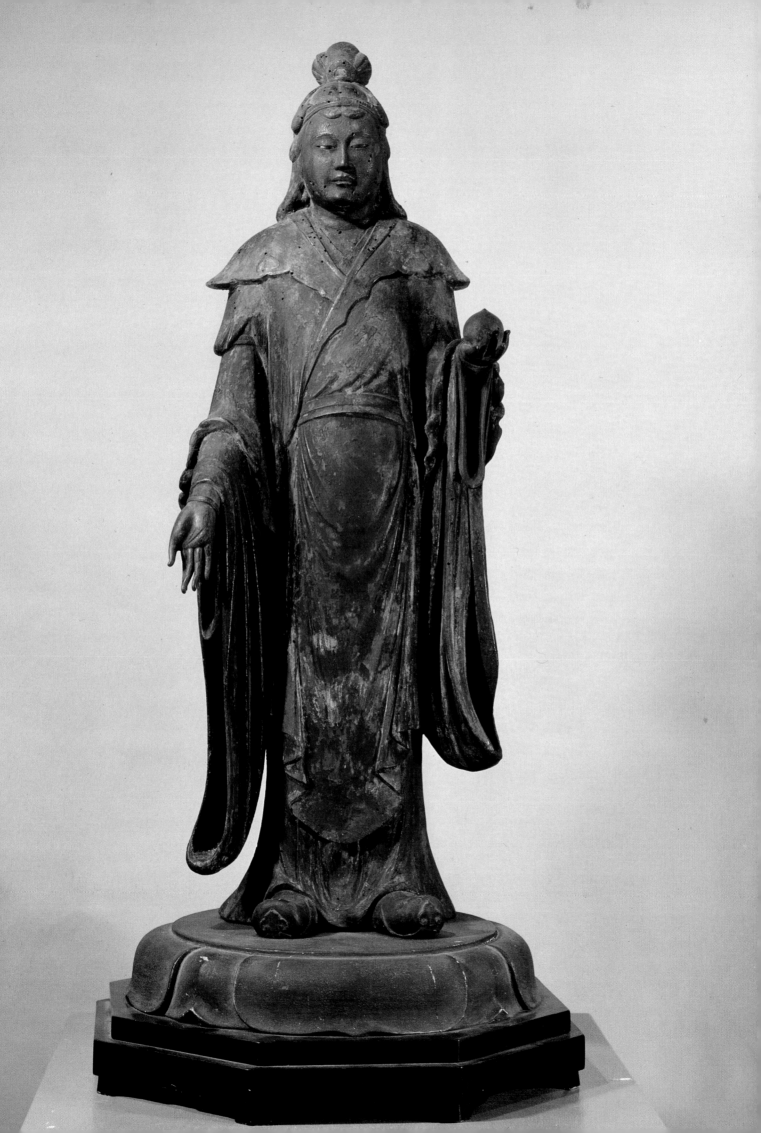

33. Miroku Bosatsu

Kamakura Period, thirteenth century
Wood, joined block construction,
H. 42¼ in (107.0 cm)
Hayashikōjicho, Nara

The numerous mentions of Miroku, the Bodhisattva of the future, in Buddhist texts establish that this deity is the most prominent of all the Bodhisattvas. Unlike Fugen, Monju, and Kannon, all of whom are doctrinal in origin and represent idealized existence, Miroku originates in a historical person who became a disciple of Shaka. Having been transformed into a Bodhisattva, Miroku is said to reside now in the Tuṣita Heaven, where he is to remain for 584 million years after the death of Shaka. After this incalculable length of time, he is to be reborn as a Buddha and descend to earth to save mankind.

Miroku has been worshipped from the early establishment of Buddhism in Japan, and frequent among his many representations in art are his images as the Bodhisattva in Meditation (see cat. no. 2) and as the Buddha of the future (cat. no. 10).

In the late twelfth and thirteenth centuries, belief in Miroku as a potential savior residing in heaven became widespread. Although faith in a Miroku heaven never enjoyed the popularity of the Pure Land heaven of Amida Buddha, paintings of Miroku *raigō* (i.e., of Miroku's descending to earth to greet the dying) attest to belief in his heaven. Like Amida *raigō* paintings, Miroku *raigō* depicts the deity on a cloud, descending through the sky with a host of small Bodhisattvas as attendants. Sculpted images, such as this figure from Hayashikōjicho, also reflect this concept of Miroku. The statue is posed with both knees slightly bent, the left leg stepping forward and the hips turned slightly to the right. In the *raigō* manner, he is placed on a cloud for his descent from heaven.

The face of this statue resembles the work of Kaikei, especially in the emphatic contours of the large eyes and the nose. However, the thicker modeling and the distant, worldly expression differ from Kaikei's refined delicacy. Lack of refinement also characterizes the body and clothing, which in treatment suggest a mannered copy of a Kaikei formula.

This work in Japanese cypress is constructed by the joined block technique standard to the period, and the statue is hollow. The eye inserts are crystal, and the surface of the statue was originally finished with gold dust and lacquer, over which *kirikane* patterns were applied. This work is in excellent condition, and the pedestal is also thought to date from the period of manufacture of the statue.

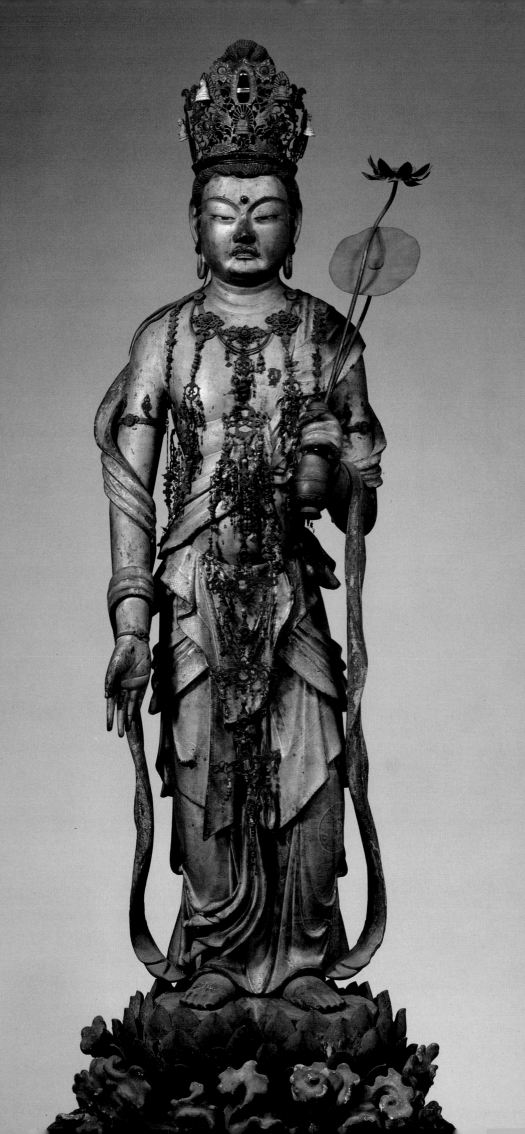

34. Attendants to Jikokuten and Zōchōten

By Kōen (1207–85?)

Kamakura Period, 1267 A.D.

Polychromed wood, joined block construction

H. Attendant to Jikokuten, 12¾ in (31.9 cm)

 Attendant to Zōchōten, 13 in (32.1 cm)

Tokyo National Museum

Important Cultural Property

These small but lively statues are part of a rare set of sculptures representing attendants to the Four Guardian Kings, who rule the four quadrants of the universe. Bishamonten rules the North, Zōchōten the South, Jikokuten the East, and Kōmokuten the West. The Four Guardian Kings were introduced to Japan in the early period of Buddhist development, and they remained popular deities throughout the ages. The appearance of their own attendants is also established in the iconographic texts of the Esoteric Buddhist or Shingon sect, though the number of the character of these attendants was not fixed. The attendants were frequently drawn from lower class deities who were devotees and protectors of the law, and they were sometimes composed of familiar divinities, such as the Eight Heavenly Beings who arranged themselves in pairs of attendants to each of the Kings.

The two sculptures in the present exhibition originally belonged to a set of statues in an Esoteric temple in Nara, the Shingon-dō of Eikyū-ji. The set is now dispersed into three collections, and the attendants here exhibited are from the Tokyo National Museum. The attendant to Kōmokuten, the guardian of the West, is in the Seikadō in Tokyo; the fourth figure, the attendant to Tamonten, is in the Atami Museum in Shizoka. Although none of these four statues is named, each has an inscription on the bottom of their dais stating that they were made as a group by the sculptor Kōen in 1267 (Bunei 4th year).

Kōen, a grandson of Unkei, was active as a sculptor throughout the second half of the thirteenth century. The first record of his name appears in the restoration of the Rengeō-in in 1251 and connects him with the carving of a large Thousand-armed Kannon as the main icon for the temple.

These small sculptures reflect both the stylistic attitudes of the Kei school and the fine craftsmanship of a master sculptor. Each figure is designed to stand gripping a long spear, and each wears loose, long-sleeved jackets and heavy boots. The attendant to Jikokuten also wears pantaloons, and the torn right boot of the Zōchōten attendant exposes his toes. The scowling faces depict a barbarian type.

The modeling of the bodies is generous, and the clothing suggests deep naturalistic folds. Each figure was assembled from hollowed blocks of Japanese cypress. The head and body form halves that are joined on the sides. The eyes are crystal, and a split was inserted at the neck of each statue. The wood surface was lacquered before the sculptures were painted. Although the pigments have faded, the colors that remain show very skillful application. Part of each rock-like pedestal is modeled with clay.

REFERENCES:

Nishikawa Kyōtarō, "Kōen saku Shitennō zō kenzoku zō ni tsuite" ("The Statues of the Attendants to the Shitennō by Kōen"), *Museum* 137, August 1962, pp. 21–24. Nishikawa Shinji, "Kōen kenkyū josetsu" ("Introduction to the Study of Kōen"), *Tokyo Kokuritsu Hakubutsukan kiyō 3 (Bulletin of the Tokyo National Museum³)*, Tokyo National Museum, 1968.

EXHIBITIONS:

Cologne, Museum für Ostasiatische Kunst, January 12–March 11, 1979; Zürich, Helmhaus Museum, April 1–May 6, 1979; Brussels, Musées Royaux d'Art et d'Histoire, May 24–June 25, 1979, *Plastik aus Japan*.

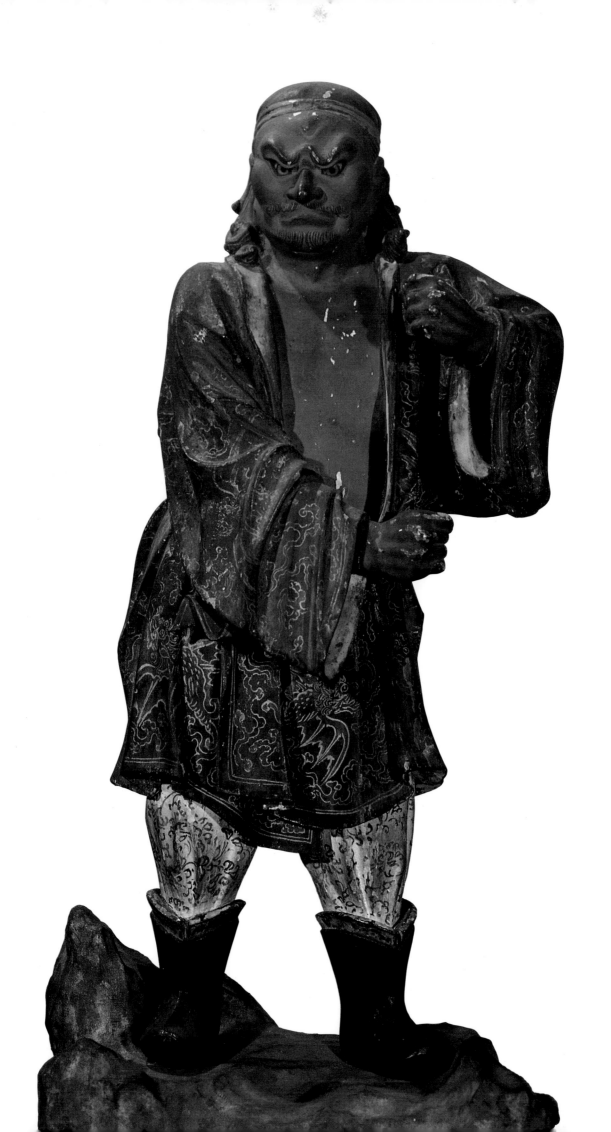

34. Attendants to Jikokuten and Zōchōten

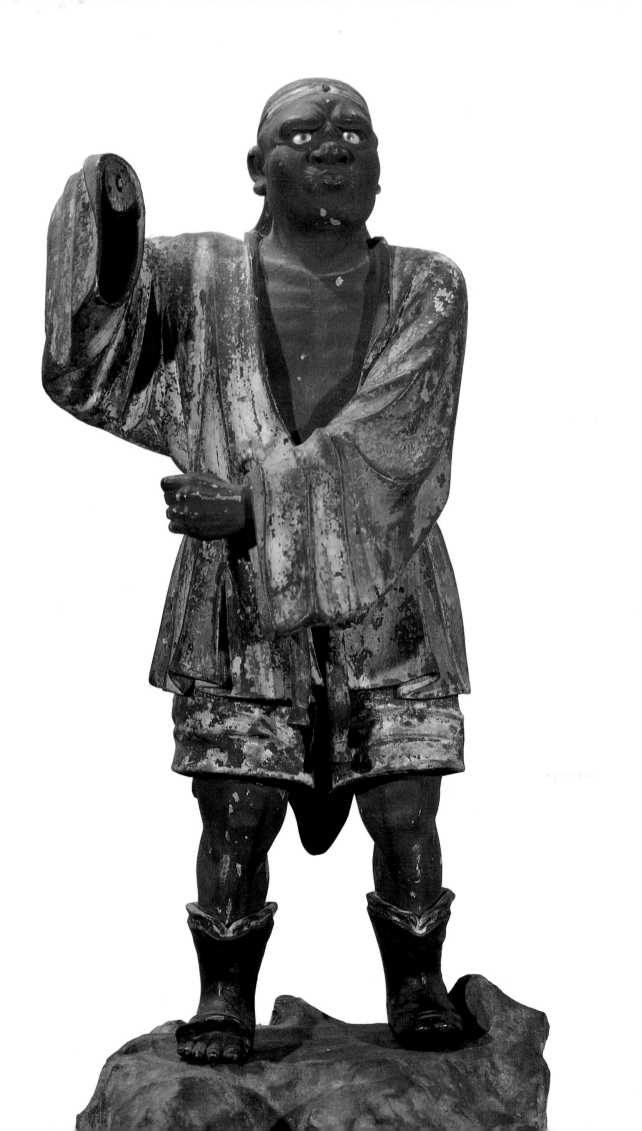

35. Shaka

By Genkai (active late thirteenth century?)
Kamakura Period, 1273 A.D.
Lacquered wood, single block construction
H. 31 in (77.5 cm)
Nara National Museum

This highly stylized image of the Historical Buddha represents a spectacular type of image that became very popular in the Kamakura Period. Shaka stands still and erect, the right hand forming the gesture of "do not fear" while the left hand makes the sign of charity. The hair is carved in a neat pattern of circular coils. He wears a full robe that covers both shoulders and falls in a richly decorative pattern of close folds and gathers. The body seems thin and abstract, yet the sculpture was designed so that the underlying torso and hips show through the robe.

The particular style exhibited by this Shaka is modeled after a Chinese Sung Dynasty sculpture that belongs to the Seiryō-ji in Kyoto. A priest from Tōdai-ji named Chōnen (938–1016), who visited Chinese temples during the early Sung Period, returned to Japan in 986 with this sculpture and installed it in the Seiryō-ji. The Seiryō-ji Shaka became very popular, perhaps because of its exotic appearance and perhaps also because of a legend associated with it. During the lifetime of the Historical Buddha, he once visited his mother, the Queen Māyā, who was in the Tuṣita Heaven. The King Udayana missed the Buddha so intensely that he sent a sculptor to heaven to carve a likeness of Śākyamuni in sandalwood. The style represented by the Seiryō-ji Shaka is said to be the same as King Udayana's image, which was copied repeatedly throughout the ages.

In the age of piety that followed the introduction of this style to Japan, it enjoyed great popularity, and almost a hundred sculptures of this type are still extant. This Seiryō-ji type Shaka was carved from a single block of Japanese nutmeg. The eyes and the *ūrṇā* are made of crystal. No hollow was cut into the interior of the body, but a cavity was cut into the back of the head which permitted the crystal eyes to be inserted and provided space for holding sacred objects.

Although the general style of this figure is readily recognizable as a Seiryō-ji type Shaka, this statue is not a faithful reproduction of the Sung original. The head of this statue is disproportionately large for the body. The youthful, cheerful expression has a realistic quality of an actual person rather than the abstracted face of an idealized god. The treatment of the hair and drapery is more exaggerated than in the Chinese original and reflects the stylistic tendencies of the age. According to an inscription in ink on the pedestal, this sculpture was made in 1273 by an artist named Genkai, who is otherwise unknown.

REFERENCES:
Mōri Hisashi, "Seiryō-ji Shaka zō hensen kō" ("Changes in Seiryō-ji Style Shaka Images"), *Bukkyō Geijutsu* 35, August 1958, pp. 1–23. Matsuura Masaaki, "Mokuzō Shaka Nyorai ryūzō" ("A Standing Wood Image of Shaka Buddha"), *Nara Kokuritsu Hakubutsukan Meihin Zuroku (Catalog of Treasures from the Nara National Museum)*, Nara National Museum, 1979.

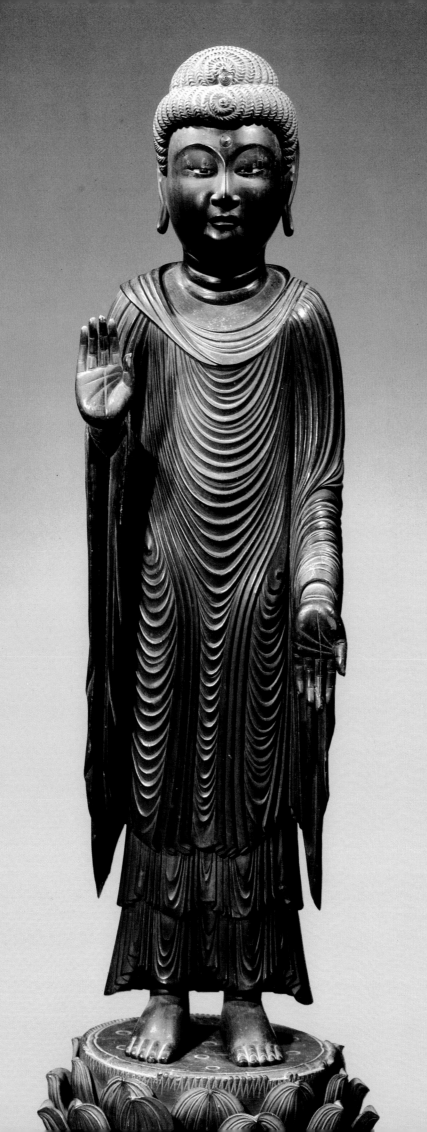

36. Five Great Myōō

Kamakura Period, fourteenth century
Polychromed wood, joined block construction
H. Fudō 26½ in (67.9 cm) [Attendants, 14½ in (36.7 cm); 15½ in (39.7 cm)]
 Gōzanze 32 in (80.9 cm)
 Gundari 32½ in (82.4 cm)
 Daitoku 18½ in (47.0 cm)
 Kongō Yasha 34 in (86.4 cm)
Enryaku-ji, Shiga Prefecture
Important Cultural Property

A fierce form of the Five Wisdom Buddhas, the Five Great Myōō belong to the Diamond World and are prominent deities in Esoteric Buddhism (see cat. no. 17). Fierce poses and angry expressions indicate the power of the Myōō to vanquish all demons. The Five Great Myōō were worshipped from an early period in Japan. A group dating to 839, from the set of twenty-one statues made for the Lecture Hall at Tō-ji in Kyoto, is the earliest extant example. Several other examples survive from the Late Heian Period, such as a set at the Daikaku-ji in Kyoto, but this set from Enryaku-ji dating to the early fourteenth century is the only one known from the Kamakura Period.

In this set, the central image represents Fudō in his characteristic form. One eye squints, fangs emerge at the corners of his mouth, his right hand holds a sword, and his left hand holds a lasso with metal tips. His two small attendants seated on rock pedestals are Kongara Dōji and Seitaka Dōji, the most frequently depicted pair of his eight youthful attendants. The Dōji appear in both painting and sculpture. The most famous sculptural set of the eight Dōji is the group made by Unkei, which belongs to the Kongōbu-ji on Mount Koya.

The Five Great Myōō are arranged with Fudō in the center, and around Fudō the other four deities are placed at the cardinal points. On the east is the Myōō Gōzanze (Trailokyavijana in Sanskrit), whose status equals Fudō's. When the two are paired as attendants to Dainichi Nyorai, Gōzanze customarily has eight arms, as in this representation, though he is also depicted with two or four arms. He is also identifiable because he tramples underfoot Daijizaiten, who is a form of Visnu, and his consort Umā.

Gundari (Kuṇḍalin), the Myōō on the south, has the power to remove all obstacles. Mentioned in Buddhist texts as early as the seventh century, he became a member of the Five Myōō group at an early date. His identifying characteristic is the snakes wrapped around his arms and legs. These snakes are said to represent mankind's foolishness, prejudices, laziness, and passions.

Daitoku (Yamāntaka), the Myōō at the west, is also said to be a form of the Bodhisattva Monju. Daitoku has six heads, six arms, and six legs, and he wears a jeweled crown and rides a water buffalo. In Japan both seated and standing depictions of Daitoku occur, but the seated form is more common. This deity was especially popular with Japanese warriors who prayed for victory in battle.

Kongō Yasha (Vajrayakṣa), the Myōō of the north, is sometimes replaced in Buddhist scriptures by the Myōō Usushima. Judging from his name, Kongō Yasha was originally an Indian Yakṣa, a semi-divine class of spirit demons who became followers of Buddhist law. Kongō Yasha has great power, and his origins are very ancient. He has six arms and three faces. He is further recognizable by the five eyes on his primary face, four of them arranged in a double layer, which creates a strange blinking effect.

All the figures display a competent, detailed carving technique and a well-balanced composition. The drapery is realistically depicted to show movement. These sculptures are made of Japanese cypress. In each work, the head and torso are made of two pieces of wood joined together, and the arms and legs are inserted separately. The crystal eyes of the statues are typical of Kamakura works. Although the surfaces of these pieces have darkened, traces of the polychrome and *kirikane* decoration remain.

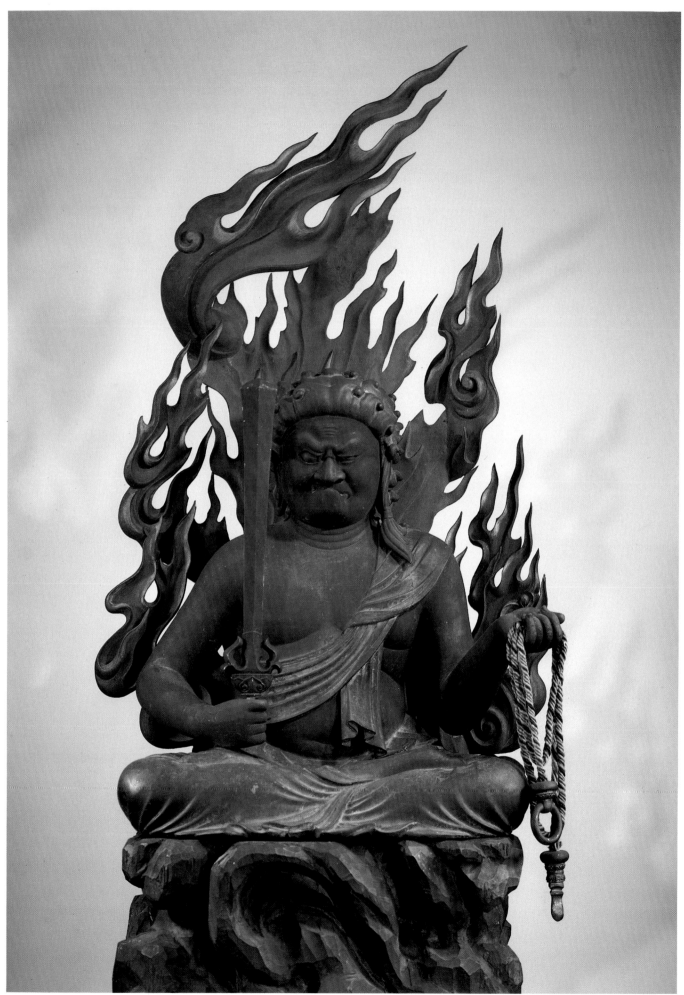

Fudō

36. Five Great Myōō

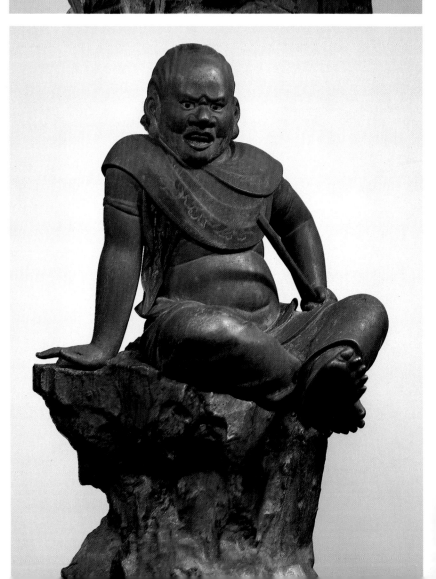

Kongara Dōji

Seitaka Dōji

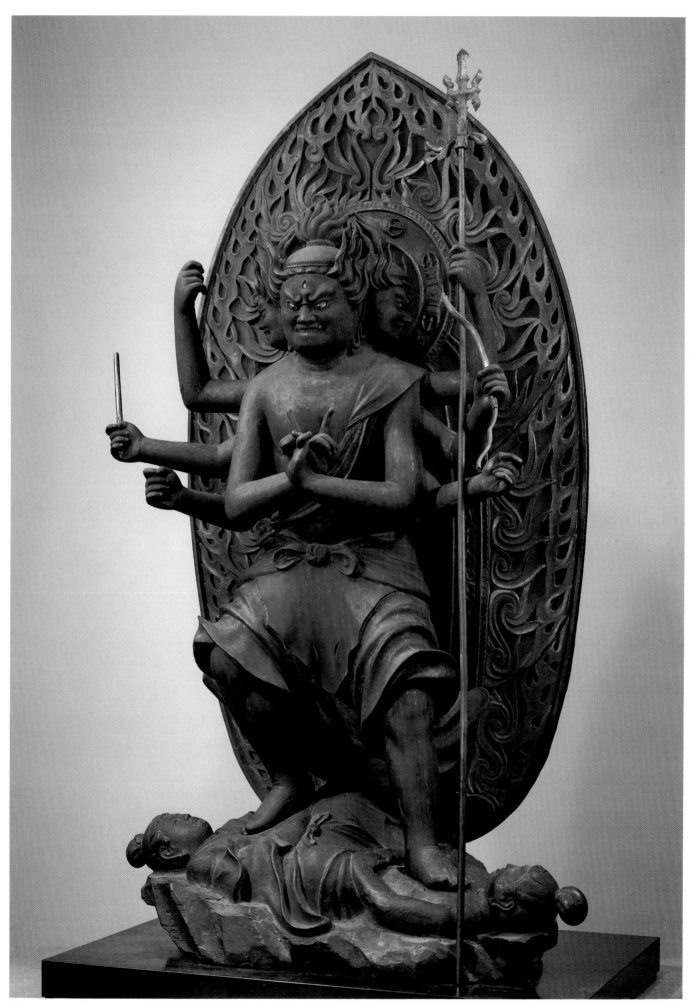

Gōzanze

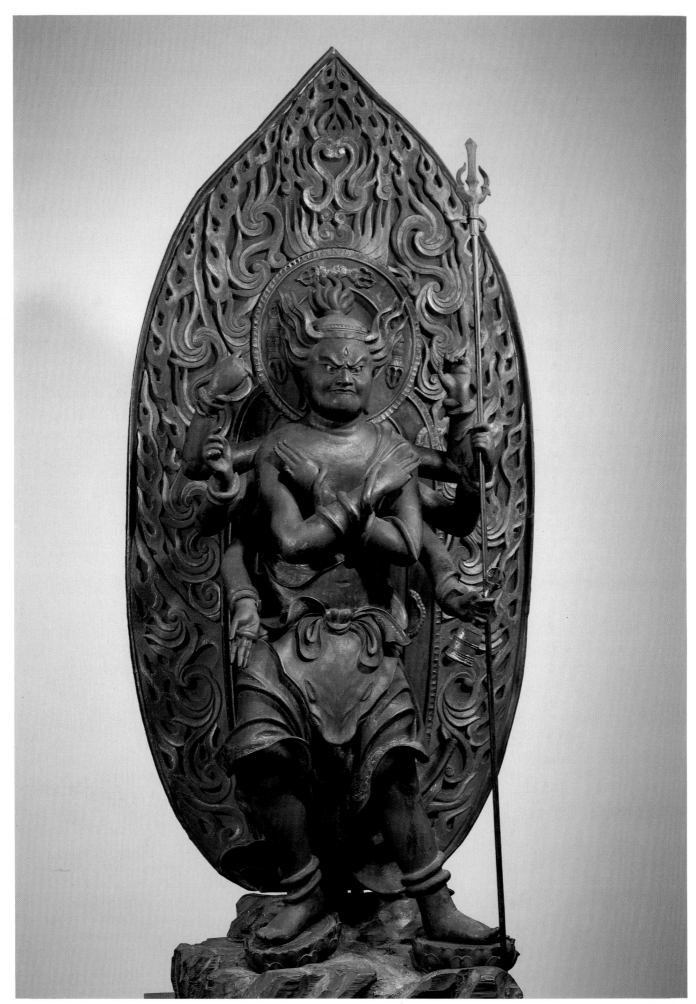

Gundari

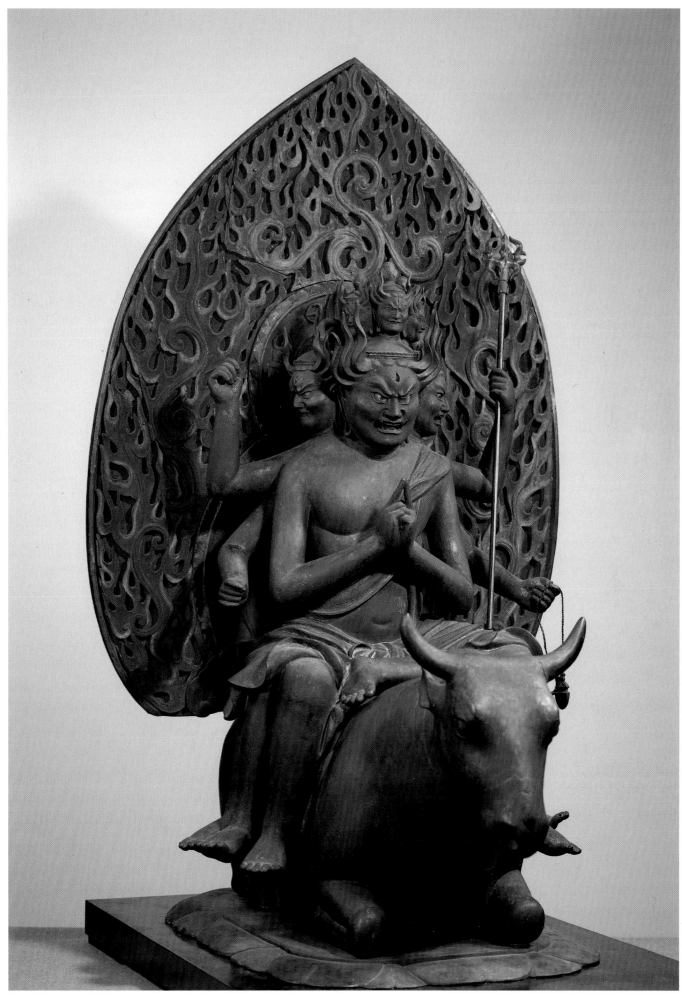

Daitoku

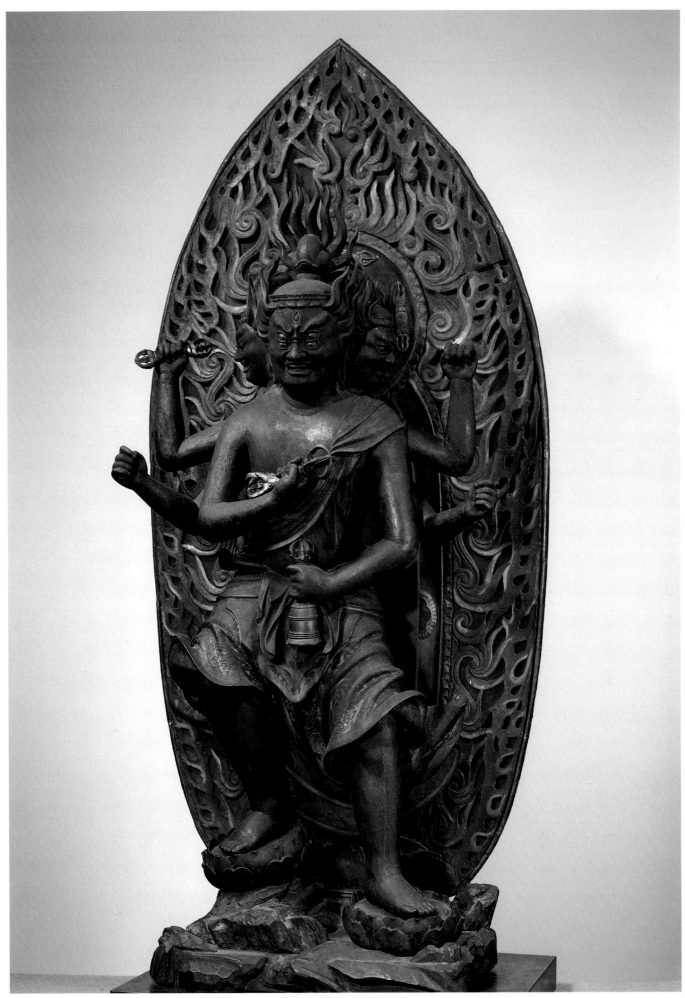

Kongō Yasha

Selected Bibliography

Akiyama, Terukazu and Matsubara Saburō. *Buddhist Cave Temples. Arts of China*, vol. II. Translated by Alexander Soper, vol. 2. Tokyo, 1969.

Ganlier, Simone, et al. *Buddhism in Afghanistan and Central Asia*, Part II. *Iconography of Religion* XIII, 14. Leiden, 1976.

Kidder, J. Edward, Jr. *Masterpieces of Japanese Sculpture.* Tokyo, 1961.

Kuno, Takeshi. *A Guide to Japanese Sculpture.* Tokyo, 1963.

Kuno, Takeshi, ed. *Kantō chōkoku no kenkyū (A Study of the History of Japanese Sculpture in the Kantō District).* Tokyo, 1964.

Kurata, Bunsaku. *Butsuzō no mikata: gihō to hyōgen (A View of Buddhist Images: Technique and Expression).* Tokyo, 1965.

———. *Hōryū-ji: Temple of the Exalted Law. Early Buddhist Art from Japan.* New York, 1981.

Moran, Sherwood F. "The Statue of Muchaku, Hokuen-dō, Kōfuku-ji: A Detailed Study." *Arts Asiatiques* 1, (1958), pp. 49–64.

———. "Structural Features of Clay Sculpture of the Nara Period." *Artibus Asiae*, vol. XXIII, 1, (1960), pp. 36–41.

———. "The Statue of Amida." *Oriental Art*, vol. VI, 2, (1960), 4, (1960).

———. "Ashura, a Dry Lacquer Sculpture of the Nara Period." *Artibus Asiae*, vol. XXVII, (1966), pp. 91–133.

Mōri, Hisashi. *Sculpture of the Kamakura Period.* Translated by Catherine Eickmann. New York, Tokyo, 1974.

———. *Japanese Portrait Sculpture.* Translated and adapted by W. Chie Ishibashi. Japanese Arts Library, Tokyo, 1977.

Murase, Miyeko. *Japanese Art: Selections from the Mary and Jackson Burke Collection.* New York, 1975.

Noma, Seiroku. *The Arts of Japan, Ancient and Medieval.* Translated by John M. Rosenfield. Tokyo, 1966.

Rosenfield, John M. "Studies in Japanese Portraiture: The Statue of Gien at the Oka-dera." *Ohio University Review* 5, (1963).

———. "Studies in Japanese Portraiture: The Statue of Nichira." *Oriental Art*, n.s. 10, 2, (1964), pp. 92–99.

———. "Studies in Japanese Portraiture: The Statue of Vimalakīrti at Hokke-ji." *Arts Orientalis* 6, (1966), pp. 213–222.

———. "The Sedgwick Statue of the Infant Shōtoku Taishi." *Archives of Asian Art* 22, (1968–1969), pp. 56–79.

Rowland, Benjamin, Jr. *The Evolution of the Buddha Image.* New York, 1976.

Saunders, E. Dale. *Mudra.* New York, 1960.

Sawa, Takaaki. *Art in Japanese Esoteric Buddhism.* Translated by Richard L. Gage. New York, Tokyo, 1972.

Siren, Osvald. *A History of Early Chinese Art. Sculpture and Architecture*, vol. III–IV. New York, 1970.

Snellgrove, David L., ed. *The Image of the Buddha.* Tokyo, Paris, 1978.

Soper, Alexander. *Literary Evidence for Early Buddhist Art in China.* Ascona, Switzerland, 1959.

Sullivan, Michael. *The Arts of China.* London, 1973.

Tokyo National Museum. *Sculpture. Pageant of Japanese Art*, vol. III. Tokyo, 1953.

Tokyo National Museum. *Heian jidai no chōkoku (Japanese Sculpture of the Heian Period, 9th - 12th Centuries).* Tokyo, 1971.

Tokyo National Museum. *Kamakura jidai no chōkoku (Japanese Sculpture of the Kamakura Period, Late 12th - Early 14th Centuries).* Tokyo, 1975.

Varley, H. Paul. *Japanese Culture.* New York, Washington, 1973.

Warner, Langdon. *The Craft of the Japanese Sculptor.* New York, 1936.

———. *Japanese Sculpture of the Tempyō Period: Masterpieces of the Eighth Century.* Cambridge, 1964.

Willetts, William. *Foundations of Chinese Art from Neolithic Pottery to Modern Architecture.* New York, 1965.

Index

Photo Credits

The publishers gratefully acknowledge the generous
cooperation of the following companies and institutions in
providing color transparencies for this catalogue.

Agency for Cultural Affairs
Asuka-en
Bijutsu-in
Gakken Co. Ltd.
Iwanami Shoten, Publishers
Kōdansha International
Kyoto National Museum
Mainichi Shimbunsha
Nara National Museum
Shogakukan Publishing Co. Ltd.
Tokyo National Museum